HOLLYWOOD
DRESSED & UNDRESSED

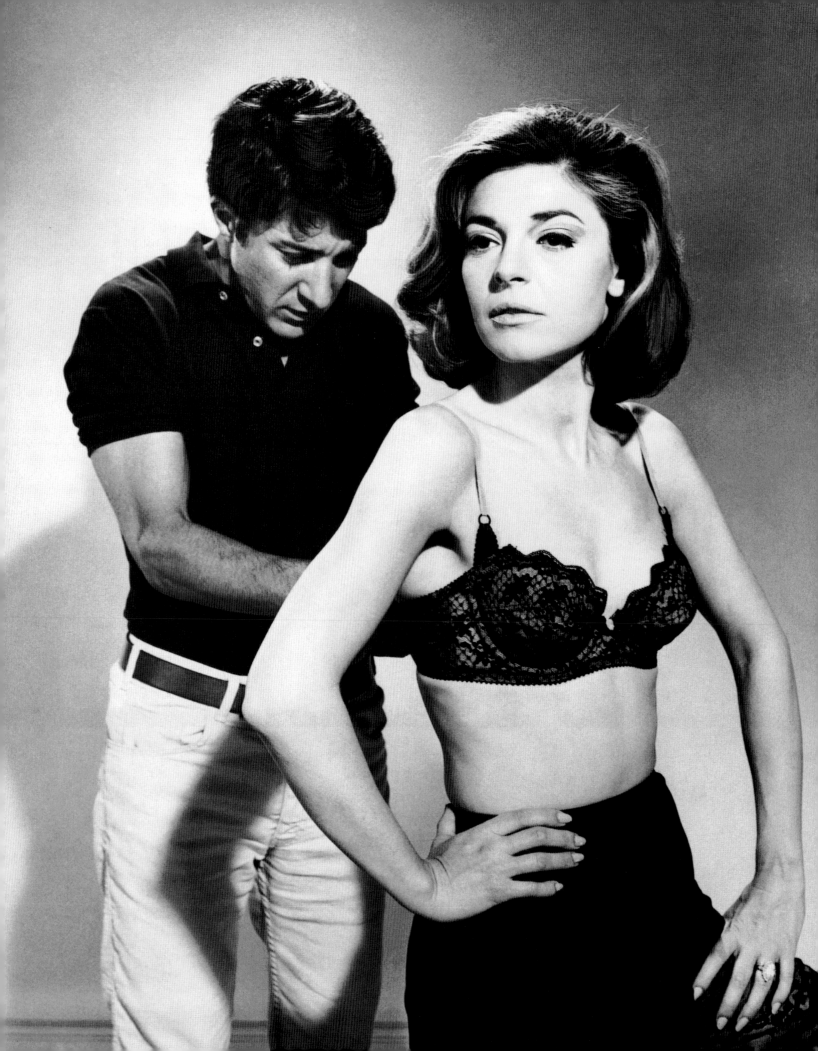

Hollywood

DRESSED & UNDRESSED

A CENTURY OF CINEMA STYLE

Sandy Schreier

WITH COMMENTARIES BY **BETTE MIDLER**, **ISAAC MIZRAHI**, AND **LORETTA YOUNG**

PHOTOGRAPHS FROM THE KOBAL COLLECTION

RIZZOLI
NEW YORK

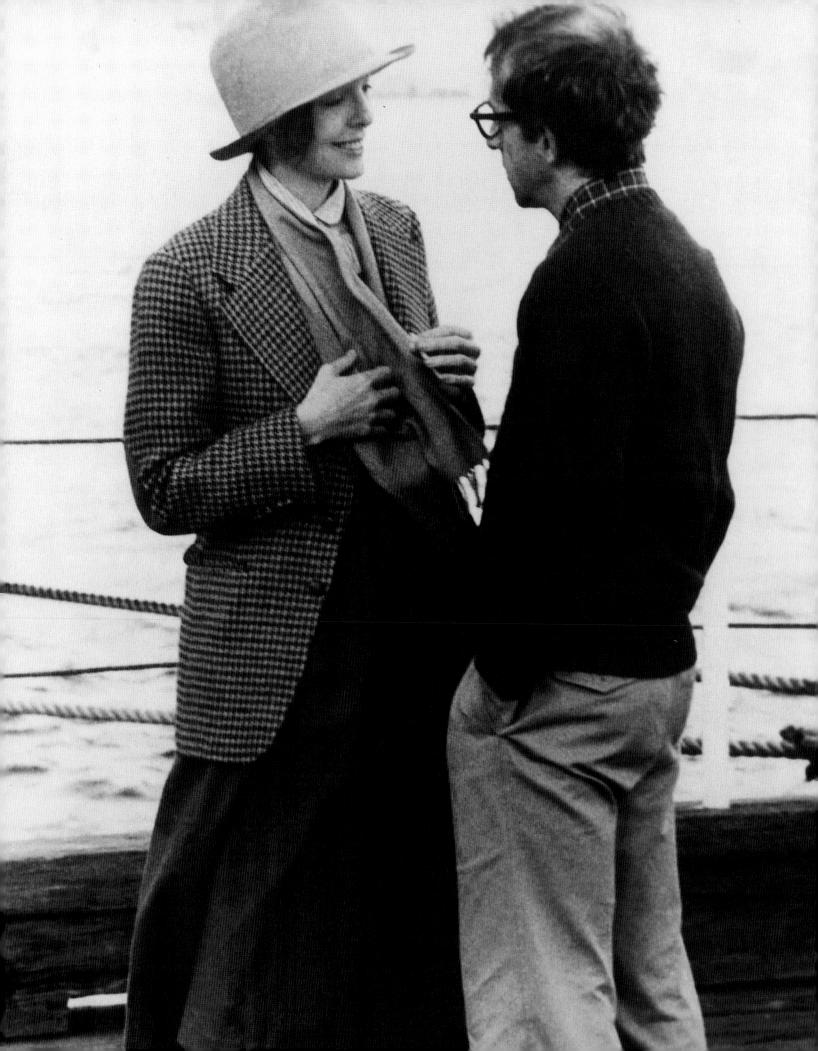

Front Jacket: LOUISE BROOKS, THE CANARY MURDER CASE, 1929.

Title Spread: (left) DUSTIN HOFFMAN, ANNE BANCROFT, THE GRADUATE, 1967; (right) JEANETTE MacDONALD, MAURICE CHEVALIER, LOVE ME TONIGHT, 1932.

Frontispiece: (left) DIANE KEATON, WOODY ALLEN, ANNIE HALL, 1977, RUTH MORLEY, RALPH LAUREN The public's love affair with television produced a dry spell in movie fashion trends. Diane Keaton (real name Diane Hall), playing the title role in this film, wore oversized and uncoordinated clothes mixed with her own antique pieces and plenty of accessories: tortoiseshell glasses, vests, and fedora hats. Joan Kaner, currently senior vice president and fashion director of Neiman Marcus, was fashion director of Macy's in the seventies. She recalls the enormous popularity of the "Ms. Hall" shops where Annie Hall fashions were sold. (right) CLARK GABLE, CLAUDETTE COLBERT, IT HAPPENED ONE NIGHT, 1934.

Page x: Costume designer Adrian with Joan Crawford, 1932.

First published in the United States of America in 1998
by Rizzoli International Publications, Inc.
300 Park Avenue South, New York NY 10010

Library of Congress Cataloging-in-Publication Data

Schreier, Sandy.
 Hollywood dressed & undressed : a century of cinema style /
Sandy Schreier with commentary by Bette Midler, Isaac Mizrahi, and
Loretta Young ; photographs from the Kobal Collection.
 p. cm.
 Includes bibliographical references.
 ISBN 0–8478–2110–2 (pb)
 1. Fashion in motion pictures. I. Kobal Collection. II. Title.
PN1995.9.C56S37 1998
791.43'026—dc21 98–22367
 CIP

Designed by Joel Avirom and Jason Snyder
Design Assistant: Meghan Day Healey

Printed and bound in Italy

This book would not have been possible without the support of the following people: Caroline Milbank, Cindy Sirko, and Suzanne Hines, my fashion confidantes, who share their knowledge and offer encouragement.

To the people who have given their help and shared their talent: Bette Midler, Isaac Mizrahi, Loretta Young, Dilys Blum, Hamish Bowles, Mary Ballard, Simon Doonan, Marcia Ely, Lisa Gabor, Dale Gluckman, Titi Halle, Joan Kaner, Jody Kohn, Richard Lambertson, Satch LaValley, Elmore Leonard, Chris Lione, Richard Martin, Gideon Phillips, Amy M. Spindler, Valerie Steele, and Donna Terek.

To the creative community of talented costume designers who have taken their time to help: Deena Appel, Colleen Atwood, Milena Canonero, Bob de Mora, Jean-Pierre Dorleac, Gloria Gresham, Betsy Heimann, Michael Kaplan, Santo Loquasto, Mona May, Ruth Meyers, Deborah Nadoolman, Patricia Norris, Aggie Guerard Rodgers, Ann Roth, Deborah L. Scott, Marlene Stewart, Marilyn Vance, Theadora Van Runkle, Mary Vogt, Albert Wolsky, and Mary Zophres.

To the memory of Edith Head, Jean Louis, Dorothy Jeakins, Helen Rose, and Irene Sharaff, who remembered it all and shared it with me.

To the memory of Stephen de Pietri, Keith Haring, Colin Higgins, and Frank Olive, who inspired me and who loved life, art, fashion, and film and had so much more to give.

To the people who made this book a reality: Megan McFarland, my editor and stress tab; and Bob Cosenza, who knows everything; and David Morton, Cathaline Cantalupo, Joel Avirom, and Cheryl Thomas.

And most importantly, I dedicate this book to my husband, "the saint."

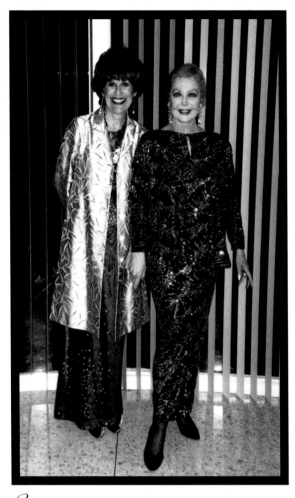

Sandy and Loretta Young Louis, California, 1998

To be a part of any young girl's "dreams" is always interesting, sometimes charming. But to learn that I was a part of this particular young girl's dream—Sandy Schreier's—was very exciting, because it meant that I was a tiny spark in this woman's brilliantly shining star today—a part of her inspirations. A touch of me is somewhere in there with her.

Sandy once asked me when I first became aware of fashion and of style. One day during a costume fitting at Irene's when I was about 15, my mother got tired of hearing me suggest to Irene that I thought the rose would look better on the shoulder instead of at the waist. Finally my mother said, "Gretch, if you are going to pay Irene's prices, don't you think you should let her design the dress?!" From then on I began to look, listen, and learn from each and every designer I've ever worked with, and I have been privileged to have had the biggest and the best as teachers, from Adrian to Irene and, of course, Jean Louis, who later became my husband.

Thank you, dear Sandy, for this book and for all of your accomplishments.

—Loretta Young Louis

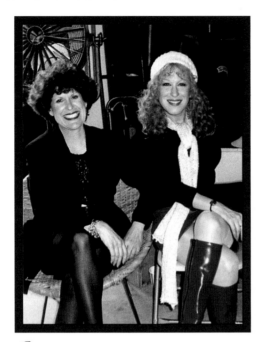

In the course of my career I have worn wonderful, often hilarious costumes, and the hold that a costume has on the imagination of an actor cannot be overestimated. Often an actor has no idea of who he is about to become until he wears the costume for the first time.

Thank God for Sandy Schreier. She has amassed a collection of couture that has to be seen to be believed. Her knowledge of both fashion history and Hollywood costuming is extraordinary. She reminds us how movies affected our lives and how the creativity and craftsmanship of the early costumes will never be equaled again.

This book brings great joy and great inspiration.

—Bette Midler

*S*andy and Bette Midler
on the set of STELLA, 1990

American fashion history begins in Hollywood. (It was a ghost town before.) Whether the dialogue was dominated by fashion or by Hollywood is the greatest unsolved mystery.

If there is one American fashion historian who can put it all into perspective, it's Sandy. What is a fashion historian? I'm afraid it doesn't come from years of highfalutin' study and degrees from Yale. It comes from Sandy's lifelong obsession with collecting and researching fashion and Hollywood costuming. Sandy, herself the great unsung movie star—who better to write this book?

—Isaac Mizrahi

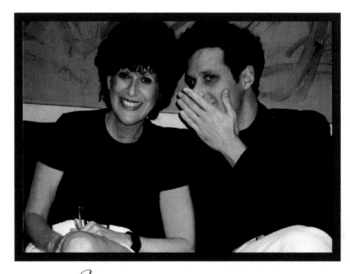

*S*andy and Isaac Mizrahi, suburban Detroit, 1996

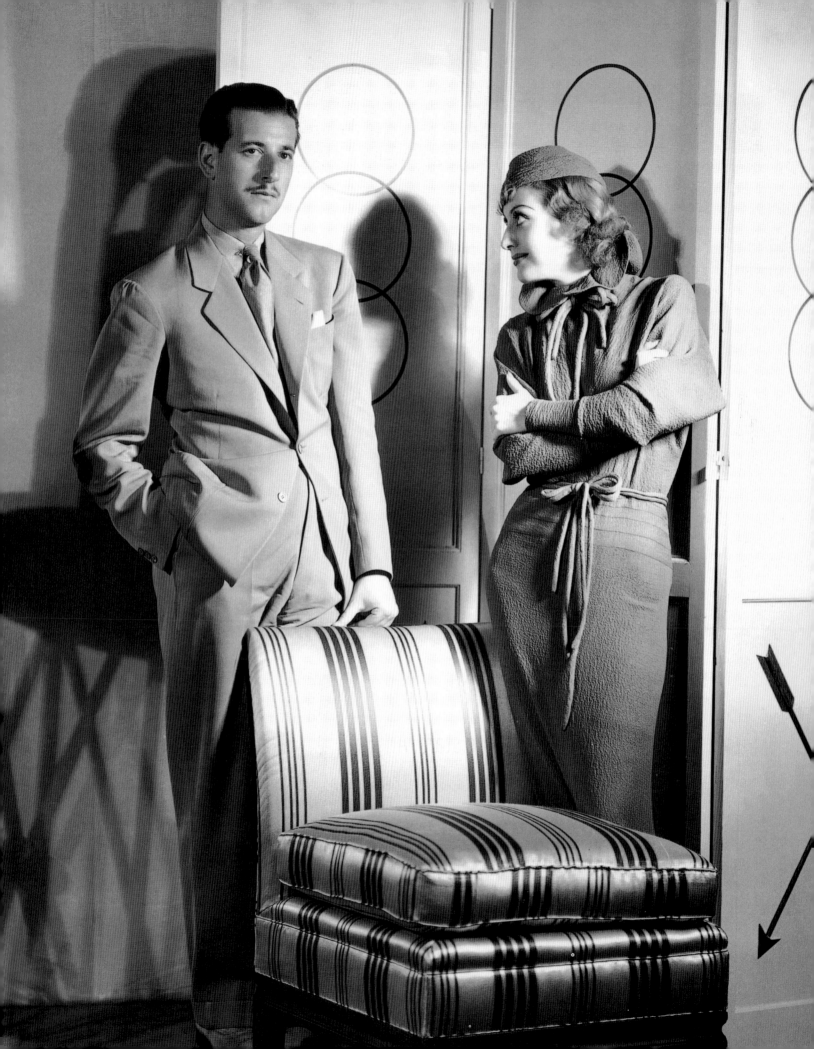

When I grow up, I want to be a movie star."

I've said that for as long as I can remember, but not until

recently did I realize that I hadn't really wanted to act—

what I wanted instead was to wear beautiful clothes: the

kind I saw on the silver screen.

Going to the movies became a religious experience for me.

My parents took me to movie houses that looked like Egyptian

temples, where I worshipped the idols

on the screen: the movie stars. And so

began my obsession with beautiful

clothes and playing dress-up.

*S*andy and Sophia Loren, 1980s

*S*andy and future husband Sherwin, 1950s

I indulged this passion on special Saturdays when my dad, who was the furrier at Russeks, a branch of the New York-based specialty store, took me to work with him. I loved the furs, but most of all I adored the gorgeous gowns and jewels.

I always admired high-fashion clothes, whether worn by real people, models in fashion magazines, or movie stars on the screen. How I became the collector of more than ten thousand pieces of French couture, American fashion, and Hollywood costume, however, is another story— I guess fashion is in the genes. Not only was my father a furrier, but my grandmother was a seam-stress who designed and made identical dresses for my sisters and me—sometimes to my great chagrin as I entered my teenage years, as I looked very different from my friends and individuality was far from respected in the fifties.

The advent of television brought my fan-tasies closer to home. Now, dressed up in Mother's finest Russeks creations, I could hide in any closet in our house and twirl out like Loretta Young, whom I idolized, when relatives and friends arrived. As I grew older, dressing up became more than a game: I dressed the Motown gang for appearances and studied every issue of *Vogue* and *Harper's Bazaar* that I could find at Daddy's new fur salon. *Women's Wear Daily* became my bible, and whatever the design-ers said became the law of the land. Strange names crept into my vocabulary: Schiaparelli, Chanel, Mainbocher, just to name a few. Dresses that appeared in the movies became etched in my memory long before cable and video made it possible to see these creations over and over again.

Years after Elizabeth Taylor wore those gorgeous gowns in A PLACE IN THE SUN (1951), I copied one of them and wore it to my high school prom. I went to Mumford High in Detroit, the school that made costume history in 1984 thanks to the Mumford sweatshirt worn by Eddie Murphy in BEVERLY HILLS COP. The PLACE IN THE SUN dress turned out to be lucky for me: my prom date eventually became my husband, and we've been married for more than forty years. Maybe Liz should have kept the dress.

To preserve my sanity and keep my creative juices flowing in the years after I got married and had four babies, I turned to designing, modeling, and styling. Some of my creative endeavors reached the pages of *Vogue* and came to the attention of Yves Saint Laurent when he first came to the United States in the sixties; I was asked to design the accessories for his fashion

show. At the same time, I took my designs to Henri Bendel's in New York, a specialty store that appreciated new young designers. Many of those who first designed for Bendel's later achieved fame and fortune, among them Kenneth J. Lane and Joel Schumacher, now one of Hollywood's most successful directors. I also worked with the most creative window display artists of the time, such as Stephen de Pietri, who was the first to hire a very tall and very young "freeze" model for his windows—the then-unknown Geena Davis.

Along the way I became a one-person collection depot for beautiful clothes, saving and preserving both vintage couture and costume. Hollywood's interest in "old" clothes was as negligible as the public's. Wearing new clothes was an important status symbol—a far cry from Victorian times, when even couture was remade for younger sisters and passed down through generations. Hollywood's costume budgets allowed for new designs; old costumes were not often recycled. And, according to my parents, the "old clothes" I collected had germs—we would all become infected, they warned, and die.

Today, resale and "nearly-new" shops have great cachet, the prestige originally associated with celebrities such as Barbra Streisand, who in the sixties was appearing at the Caucus Club in Detroit and hanging out at vintage boutiques; and Jackie Kennedy, who in the seventies was buying antique piano shawls to wear as evening wraps. Today, auctions of couture, vintage, and celebrity clothing have taken the public by storm.

Individuality arrived in the sixties, and I was glad. Now I could wear Mary Quant and Rudi Gernreich and vintage furs found in the back of my father's new fur salon. I had survived by modeling for Vidal Sassoon and also by designing. My creations were now being worn by the Supremes, who were singing and dancing and looking like

the Hollywood I loved. The movies had grown "tired"; television was keeping us at home, and the glitter that once defined Hollywood was now adopted by music groups and emulated on the street by real people. Eventually, soap opera stars personified glitter and glamour, the culmination of which was the glitzerama overkill of "Dynasty." The public was no longer wearing the kinds of clothes that Jean Harlow, Joan Crawford, and Marilyn Monroe had worn, but rather those they saw on music groups and television stars.

My interest in Hollywood costuming peaked when I was asked to appear on the television program "The 1 O'Clock Movie" in 1980. The original host was Bill Kennedy, a real-life

Vidal Sassoon and Sandy, 1969

*S*andy and Albert Wolsky, 1995

movie star, who had appeared mostly in Bette Davis films such as NOW VOYAGER. One of my first interviews was with the great designer Jean Louis; then, to get a broader perspective on the importance of his costumes, I interviewed some of the stars he dressed, including Lana Turner.

I quickly learned about the power of Hollywood design—but only when worn by the public's favorite stars: Jean Harlow's slinky satin dresses; Dorothy Lamour's sarong; and anything worn by Audrey or Marilyn. The power of Hollywood film around the world, the image of the stars and their clothing as influences on the public's buying habits, can be compared to today's marketing strategies by Calvin Klein or Ralph Lauren.

I love the couture: the artistry of the designs, the fabrics, the handwork, beading, and embroidery. Couture is unquestionably a true art form, but when asked whether Hollywood or Paris has most influenced the general public, I answer that it is most definitely Hollywood, because of two words: *star power*. Adrian, the costume designer responsible for almost all of the early movie trends, answered the question best: "It took Paris three hundred years to become the fashion capital of the world . . . it only took Hollywood twenty-five."

My audiences were more interested in who wore what and why rather than in the subtleties of fabric, stitching, and cut. Sadly enough, when a Hollywood costume starts a fashion trend, the costume designer never gets the credit—unlike Calvin or Ralph or Donna Karan. It is as though John Travolta had selected his own SATURDAY NIGHT FEVER suit or Garbo had designed her own hats. My stage and television audiences recognize Joan Crawford's shoulder-padded suits, but they have never heard of the person who created that look. The exception among designers was Edith Head, who appeared on a television show called "Art Linkletter's Houseparty." She also had a working agreement with Vogue Patterns, promoting their product while touring the country with a fashion show of her costumes. Edith's stories were delicious, and her audiences ate them up . . . at least I did. I had the good fortune to interview her many times and visit her on the Universal lot, where she stepped out of her office door every time a tour bus passed to wave at her fans, and encouraged me to do the same.

Edith explained the complexity of the costume designer's role: dressing not only the stars and the supporting actors, but also the extras, which in many cases means thousands of people. In 1982, for example, Betsy Heiman was costume designer for her first film, HIGH ROAD TO CHINA, with Tom Selleck. The movie was shot on location in Eastern Europe, where the factory workers spoke only Serbo-Croatian and Italian. Despite the challenges, she designed and

they produced sixteen hundred twenties-style costumes for the actors and extras.

When time and budget do not allow for custom work, costume houses are used to dress the extras. Oscar-winning designer Albert Wolsky said:

> I made all the principal clothes on BUGSY, but there were twenty-five hundred to three thousand extras and no budget, time, or necessity to make clothes for them. For months we put together a whole warehouse of clothes to dress them and I looked at every single extra who crossed that screen. I care a great deal about extras, because they're like scenery. They set the tone. You can't just create the period with your principals; it also has to be extras.

Screenwriters who use clothing details to enhance their characters are especially concerned that their written words are translated effectively to the screen. In both his books and his screen-plays, Elmore "Dutch" Leonard's characters add color to the locales. On the set of OUT OF SIGHT (1998), I witnessed a costume conversation between Dutch and star George Clooney, as the novel's author carefully checked out the star's attire . . . you can be sure that I did the same.

There has been a resurgence of interest in Hollywood costuming: museum exhibitions have broken attendance records, and television docu-mentaries, such as the AMC special "The Hollywood Fashion Machine," have been repeated frequently due to their popularity. One of the designers who appeared with me on that show was Isaac Mizrahi, who said, "For an American designer, Hollywood is probably the most important source of inspiration." Robert

Altman's film READY-TO-WEAR and Mizrahi's UNZIPPED appeared at local theaters in the mid-nineties and created media frenzy . . . but the greatest media blitz occurs every year when the world's attention is focused on the Oscars—and mainly on what the stars wear. Tom Ford, designer for Gucci, said that "Hollywood is now more influential in fashion than New York or Europe. It sets the beauty standard for the world" (*WWD*, 1997). And Lisa Gabor, style editor of *IN STYLE* magazine, commented, "Our readers are influenced by what Hollywood wears on screen and off. Stars are highly aware of their images, whether at benefits or award shows or around town."

This book contains the fiction, fact, and fantasy of Hollywood: stories about yesterday, told to me by many of the great designers and stars now gone, and stories of today, generously shared with me. In her earlier films, Gloria Swanson whetted the public's appetite for the glamour of the silver screen. Her costumes became the stuff my dreams were made of . . . and still are today.

*E*lmore Leonard, Sandy, and George Clooney, 1998

OF ℋOLLYWOOD

Movies are where we learn about life: how to act, how to behave, and how to dress and undress. Movies have become America's eighth-largest industry, and although Hollywood has never manufactured clothes for the public, its influence on fashion trends in the early days of film did not occur by chance. At that time the latest Hollywood styles were not only seen on the screen; they were also featured in fan magazines and newsreels. Movies and clothing manufacturers worked together to promote these trends so that stores, both large and small, could introduce line-for-line copies of movie costumes at the same time a film was released.

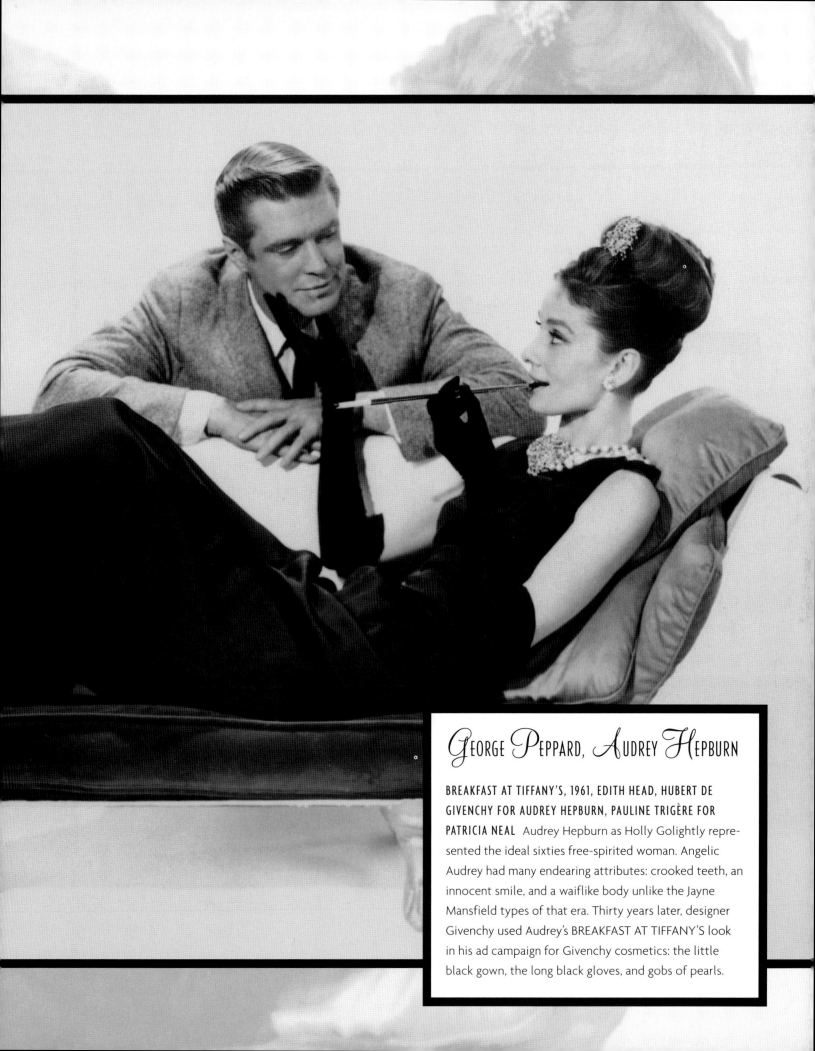

George Peppard, Audrey Hepburn

BREAKFAST AT TIFFANY'S, 1961, EDITH HEAD, HUBERT DE GIVENCHY FOR AUDREY HEPBURN, PAULINE TRIGÈRE FOR PATRICIA NEAL Audrey Hepburn as Holly Golightly represented the ideal sixties free-spirited woman. Angelic Audrey had many endearing attributes: crooked teeth, an innocent smile, and a waiflike body unlike the Jayne Mansfield types of that era. Thirty years later, designer Givenchy used Audrey's BREAKFAST AT TIFFANY'S look in his ad campaign for Givenchy cosmetics: the little black gown, the long black gloves, and gobs of pearls.

In both the silent films and early talkies, it was common for actors to set trends. The studios spent fortunes teaching the stars about attitude, weight control, and poise—sometimes ignoring health precautions—to insure a "perfect" look in the wearer's clothes. Costume designers worked overtime to create the aura of round-the-clock glamour, also creating the movie stars' at-home wardrobes.

Costume designer Edith Head, Hollywood's most prolific designer, reflected on the Golden Age of costuming: "Then a designer was as important as a star—when you said Garbo, you thought Adrian; when you said Dietrich, you thought Banton. Their magic was part of selling a picture."

Today's movie trends are few and far between, since costume dollars do not equal or exceed the film's entire budget, as in days gone by. In fact, unless the film has a superstar lead that will insure enormous box office receipts, the costume budget is almost nonexistent.

Modern stars are more influential in the fashion arena off screen than on. In the past, designers dressed high-profile socialites, but now, dressing the stars is their best advertisement. Nicole Kidman's couture dress by John Galliano for Dior was seen around the world at the 1997 Academy Awards and then appeared on Nicole in every major magazine and newspaper. Before the Oscars, the trend for Oriental-inspired clothes and accessories was making a small wave mostly with the fashion elite, but after Kidman's appearance at the Oscars, that look hit the big time. Copied by dressmakers for their socialite clientele, it was subsequently knocked off by manufacturers at every price point.

Nicole, Madonna, Demi Moore, Rita Wilson, and Kate Capshaw, among others, often frequent

the couture shows in Paris as well as the New York shows and are courted by major designers because of their glamour, prestige, and press potential. Amy M. Spindler, fashion editor of the *New York Times,* commented on the influence of today's stars: "With the exception of Madonna and Courtney Love, movie stars are not projecting their own style . . . they're wearing runway style. Instead of the stars influencing the fashion designers, it's the designers influencing them."

Although Hollywood's designers create costumes for characters in a screenplay rather than clothing for the general public, movie trends that go public sometimes just happen. Costume designer Milena Canonero commented: "If you capture a trend, it's already there. It's in the air."

Marilyn Monroe's SEVEN YEAR ITCH dress was not custom, but off-the-rack, yet it has become one of the greatest movie icons. Reintroduced every few years by the Bloomingdale's stores, it always appears with a current hemline and is always called "The Marilyn Monroe" dress. It will live forever. But then, so will Marilyn!

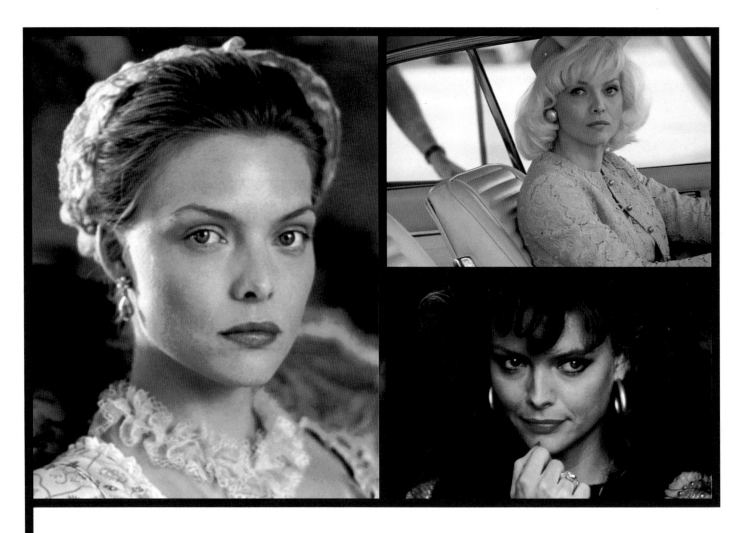

Michelle Pfeiffer

The three faces of Michelle illustrate the artistry of the costume designers, hairstylists, and makeup artists of Hollywood. ABOVE: DANGEROUS LIAISONS, 1988. COSTUME DESIGNER: JAMES ACHESON; MAKEUP: JEAN-LUC RUSSIER; HAIR STYLISTS: PIERRE VAD AND MALON ROSSIGNOL TOP RIGHT: LOVE FIELD, 1992. COSTUME DESIGNER: COLLEEN ATWOOD; MAKEUP: NAOMI DONNE; HAIR STYLIST: ALAN D'ANGERIO BOTTOM RIGHT: MARRIED TO THE MOB, 1988. COSTUME DESIGNER: COLLEEN ATWOOD MAKEUP: BERNADETTE MAZUR; HAIR STYLIST: ALAN D'ANGERIO

Theda Bara

SALOME, 1918 Theda Bara was the first big film star and her look became one of the first Hollywood-inspired trends. In the 'teens, she played both Salome and Cleopatra and became known as The Vamp. Her red lips, darkly outlined eyes, and "come hither" looks were mysterious and sexy, the opposite of the ladylike appearances of that time. One of Theda Bara's first films, A FOOL THERE WAS (1915), was subtitled KISS ME MY FOOL, and that expression became the "make my day" of the 'teens. Because of her role as Cleopatra, her fans thought that she was Egyptian, but in reality her name was Theodosia Goodman and she was from Cincinnati, Ohio.

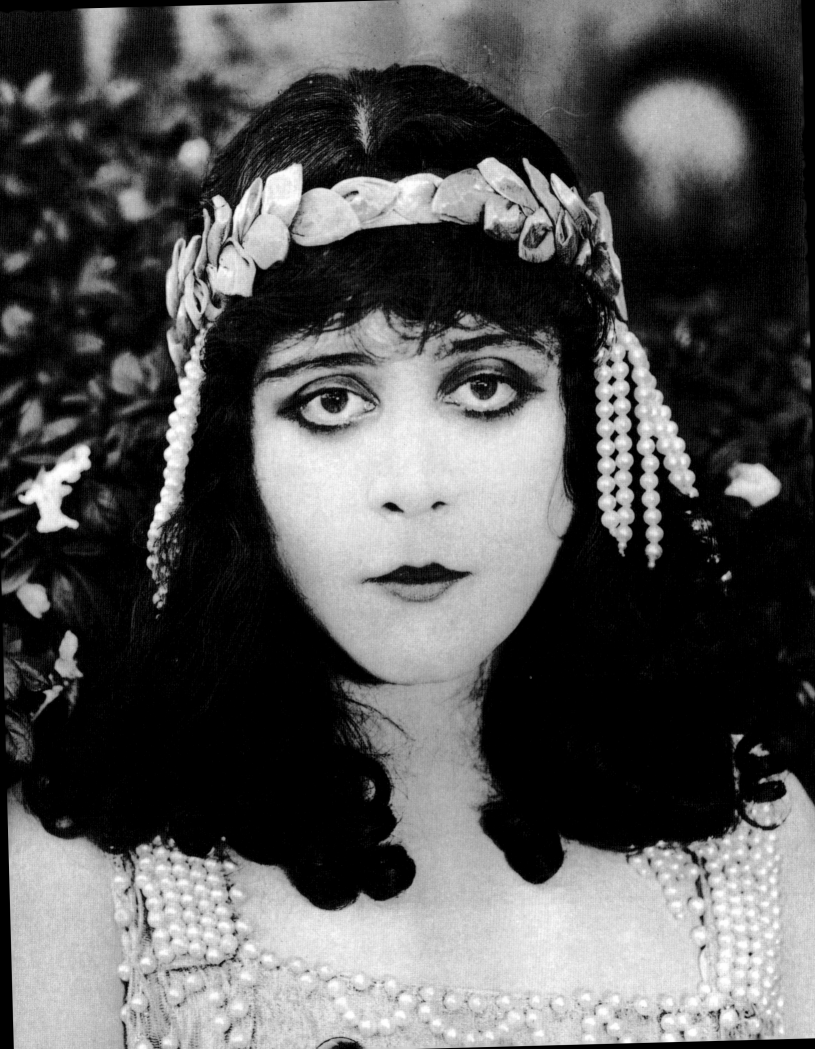

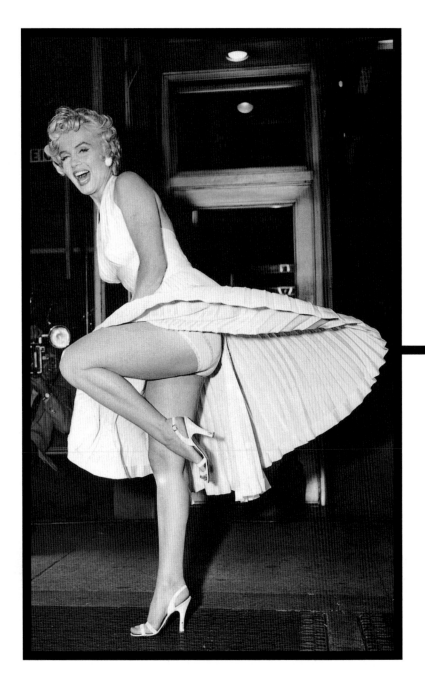

Marilyn Monroe

THE SEVEN YEAR ITCH, 1955, TRAVILLA This photograph is worth a thousand words. The story about this shot breaking up the marriage of Marilyn Monroe and Joe DiMaggio is not true. It's said that every time Marilyn's skirt blew into the air, her fans got an eyeful of her bare bottom, which infuriated Joe. He was angry, but her bottom wasn't bare! The dress was off-the-rack, but it has become one of the greatest movie icons. When near death, designer Travilla requested that instead of being cremated, his remains be pleated—just like Marilyn's famous dress.

Louise Brooks

THE CANARY MURDER CASE, 1929, TRAVIS BANTON Louise Brooks's hair style, called The Lulu after her role as a nymphomaniac in PANDORA'S BOX (1928), became quite the rage, although it was not the first Hollywood hair trend. In the early twenties, dancer/actress Irene Castle shocked the public when she cut her hair into a bob. When she appeared on the screen with her husband, Vernon, her slim-hipped, flat-chested look inspired Americans to shape up. Women started fad dieting for the first time to look like Irene.

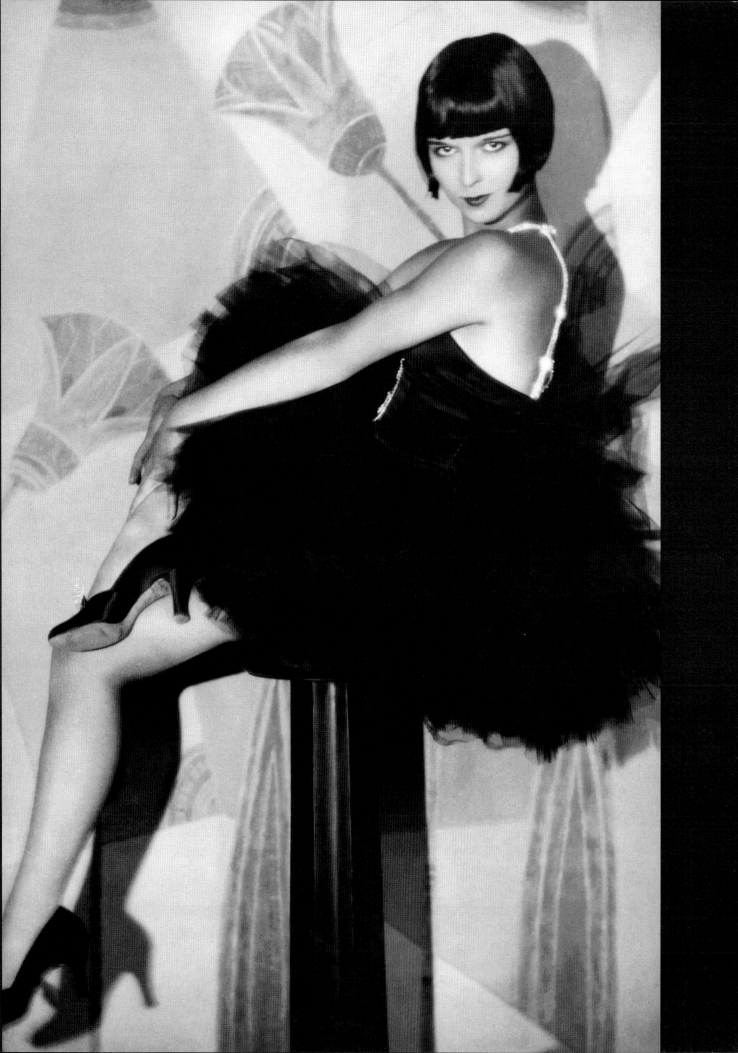

Bo Derek

'10', 1979, PAT EDWARDS Bo Derek's braided hair, an
ethnic look, triggered a mainstream trend. This film's
other big trend of the late seventies was the sound of
Ravel's *Bolero*, setting the mood for this sexual romp.
A half-million posters of Bo wearing beads and bathing
suit were sold within four weeks after the film opened.

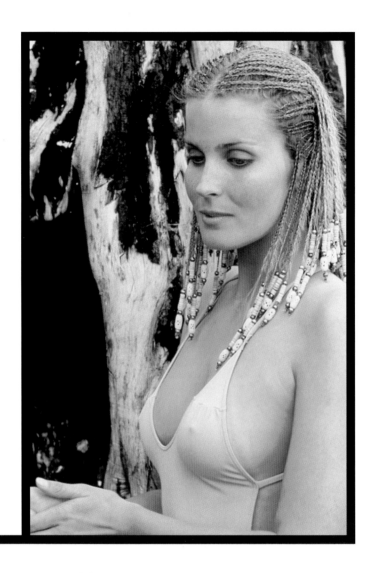

Kim Basinger

L.A. CONFIDENTIAL, 1997, RUTH MYERS Film noir is about
style: mood, mystery, nicotine, and, in this case, nos-
talgia. Kim Basinger plays a Veronica Lake look-alike,
from hair to clothes. THE LADY EVE—style dresses that
originally camouflaged Barbara Stanwyck's figure
faults made Lake, who was diminutive in stature, look
longer and leaner. Designer Myers said that Kim's
perfect body needed no camouflage, although her
underpinnings consisted of a merry widow corset to
enhance her fifties-type femininity. Kim went home
with the costumes—and the Oscar in 1998 for Best
Supporting Actress.

Katharine Hepburn

1941 Kate Hepburn created her own look. As a young star on the MGM lot, she ignored the "dress code" and chose to wear pants, much to the consternation of her boss, Louis B. Mayer. One day, as Mayer approached and reproached her for wearing pants, she dropped her drawers and marched off carrying the evil ones slung over her shoulder.

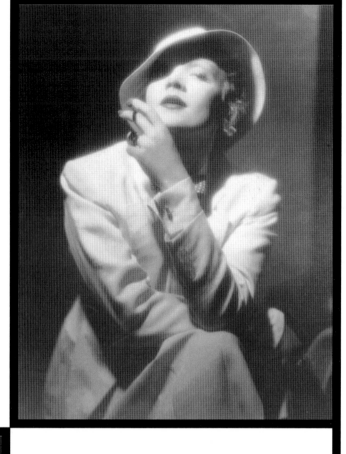

Marlene Dietrich

1934 Marlene Dietrich chose to wear masculine-looking clothes on screen as well as off. Her look created by Travis Banton was a sensation. Dietrich was arrested in Paris in the thirties for wearing men's pants. Talk about arrested development!

Greta Garbo

THE KISS, 1930, ADRIAN Greta Garbo's slouch hat was a new look that revolutionized the millinery industry. In their first collaboration, A WOMAN OF AFFAIRS (1928), originally titled THE GREEN HAT, Adrian dressed Garbo in a plaid-lined trench coat and a slouch hat. Women and retailers loved the look, and so did Garbo.

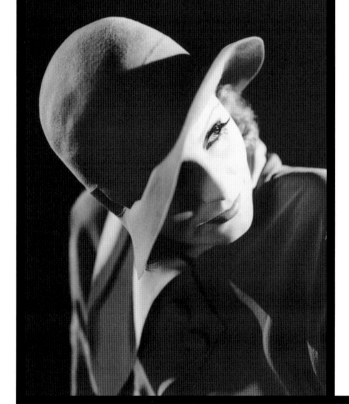

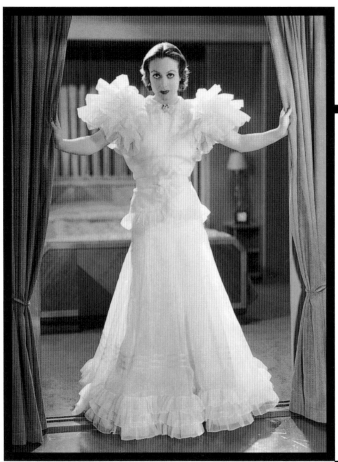

JOAN CRAWFORD

LETTY LYNTON, 1932, ADRIAN Those shoulder-padded suits worn by Crawford and everyone else all began with this dress, copied by Macy's in New York City and sold to thousands of movie fans after the film opened (the number changed with every report). When asked if Joan's shoulders were enlarged to slim her broad hips, Adrian's widow, Janet Gaynor, said that when Adrian entered Joan's dressing room for the first time, he took one look at her and said, "You have the shoulders of Johnny Weissmuller" (Hollywood's Tarzan), and proceeded to enhance them.

JEAN HARLOW

THE BEAST OF THE CITY, 1932, ADRIAN Although one always thinks of Jean Harlow wearing slinky satin dresses trimmed with feathers, her day clothes were copied more often. Cut on the bias and clinging to every curve, these dresses were difficult to wear unless one's body looked similar to Harlow's. . . . A dream is just a dream.

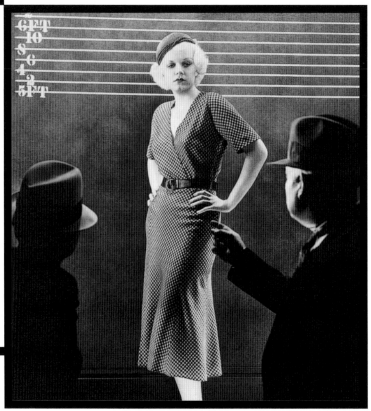

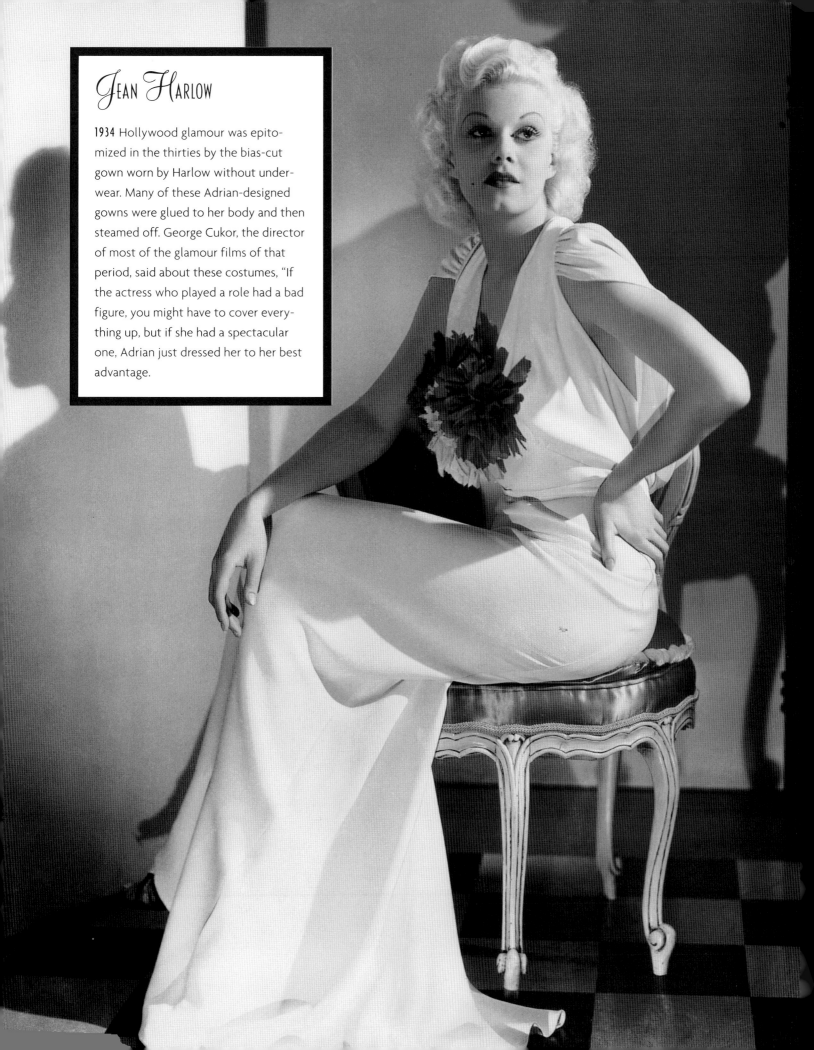

Jean Harlow

1934 Hollywood glamour was epitomized in the thirties by the bias-cut gown worn by Harlow without underwear. Many of these Adrian-designed gowns were glued to her body and then steamed off. George Cukor, the director of most of the glamour films of that period, said about these costumes, "If the actress who played a role had a bad figure, you might have to cover everything up, but if she had a spectacular one, Adrian just dressed her to her best advantage."

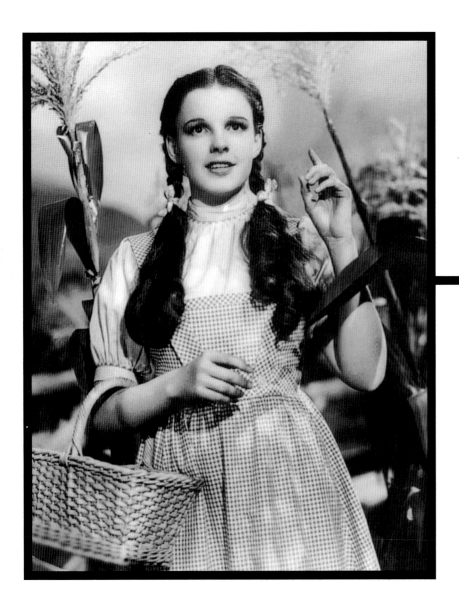

Judy Garland

THE WIZARD OF OZ, 1939, ADRIAN Adrian began using his favorite fabric, gingham, for Judy in WIZARD. He called it the all-American fabric. The style of Judy's dress helped camouflage her budding bosom, and early costume shots always showed her long hair pulled to the front to cover her chest. Fifteen-year-old Judy was a tad "Over the Rainbow" to play eleven-year-old Dorothy.

Cary Grant, Katharine Hepburn, James Stewart

THE PHILADELPHIA STORY, 1940, ADRIAN Adrian repeated the gingham motif on swimwear as well as evening gowns. Although Katharine Hepburn does not seem the gingham type, when she wore this dress the trend took off. The following summer, gingham covered the shores of both coasts. And in the mid-forties, Adrian made custom clothes not only for stars, but also for the general public. His salon in Beverly Hills always included gingham.

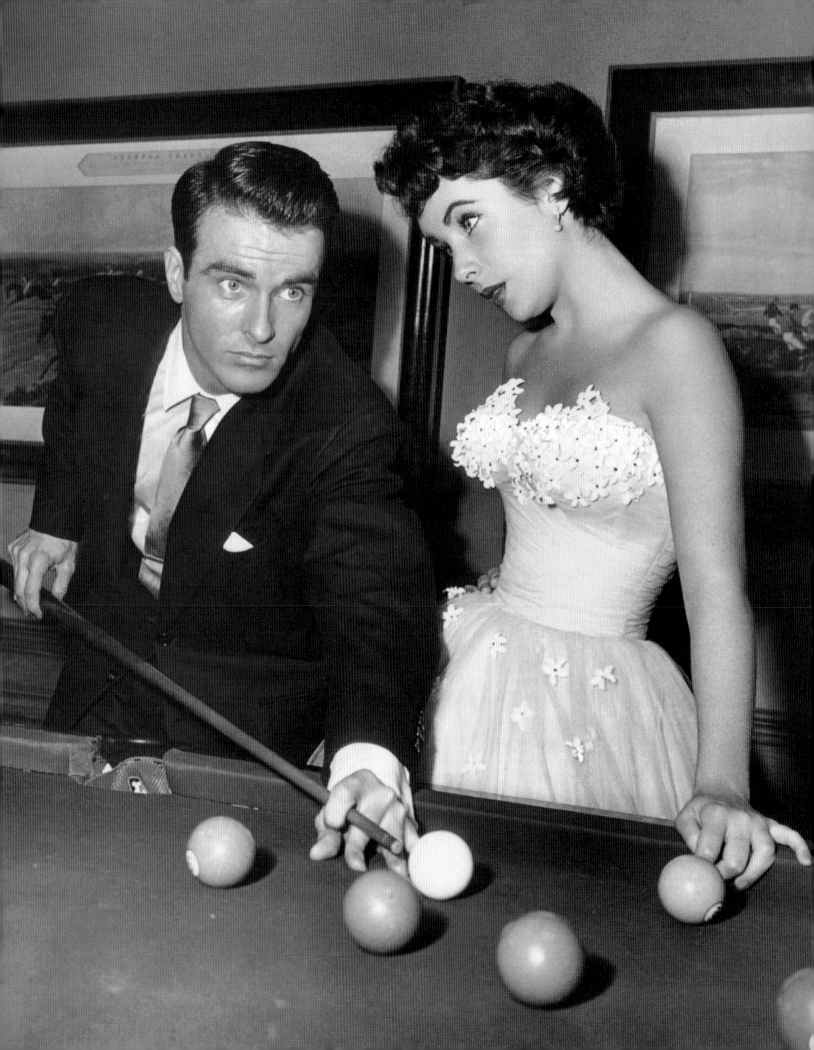

Barbara Stanwyck

THE LADY EVE, 1941, EDITH HEAD From Edith's first movie in the mid-twenties until THE LADY EVE, she did not receive recognition or big costuming jobs. But dressing Barbara Stanwyck changed all of that. Barbara was never a clotheshorse, although that was a necessity for a star of the silver screen. She was longer-waisted than most and her derriere was low-slung, so camouflage techniques were used by other designers. Edith created this flattering silhouette for Stanwyck, which was widely copied by the public, praised to the high heavens by Barbara, and repeated in all of her next movies.

Montgomery Clift, Elizabeth Taylor

A PLACE IN THE SUN, 1951, EDITH HEAD Elizabeth Taylor's dress from this film was copied extensively. Many fashion writers at the time commented, "Go to any party this summer and you'll see at least ten of them." Although the film was released in 1951, it had been in the can for almost two years after filming. Had it been released sooner, the Hays Office, which censored Hollywood films, would have balked, as Liz was underage when the film was shot.

Humphrey Bogart, Lauren Bacall

THE BIG SLEEP, 1946, LEAH RHODES Film critic Roger Ebert said, "Bacall's screen debut [TO HAVE AND HAVE NOT] was an enormous hit, and the on-screen chemistry between her and Bogart was sizzling. [You know how to whistle, don't you, Steve? You just put your lips together and blow]." By the time THE BIG SLEEP was released, Lauren was Mrs. Humphrey Bogart. This film originally was set for release in 1945, but parts of it were reshot and recostumed. The added scene with Lauren wearing this ensemble replaced a boring office sequence where Bacall wears a suit and an unflattering face veil, looking like "the Tattoo Lady." Both the new costume and dialogue were *hot*.

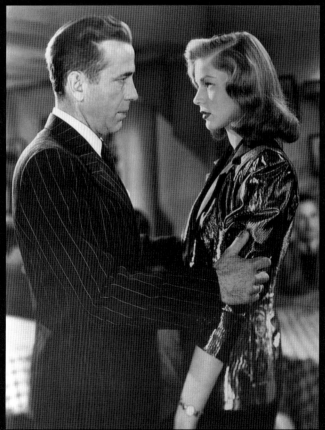

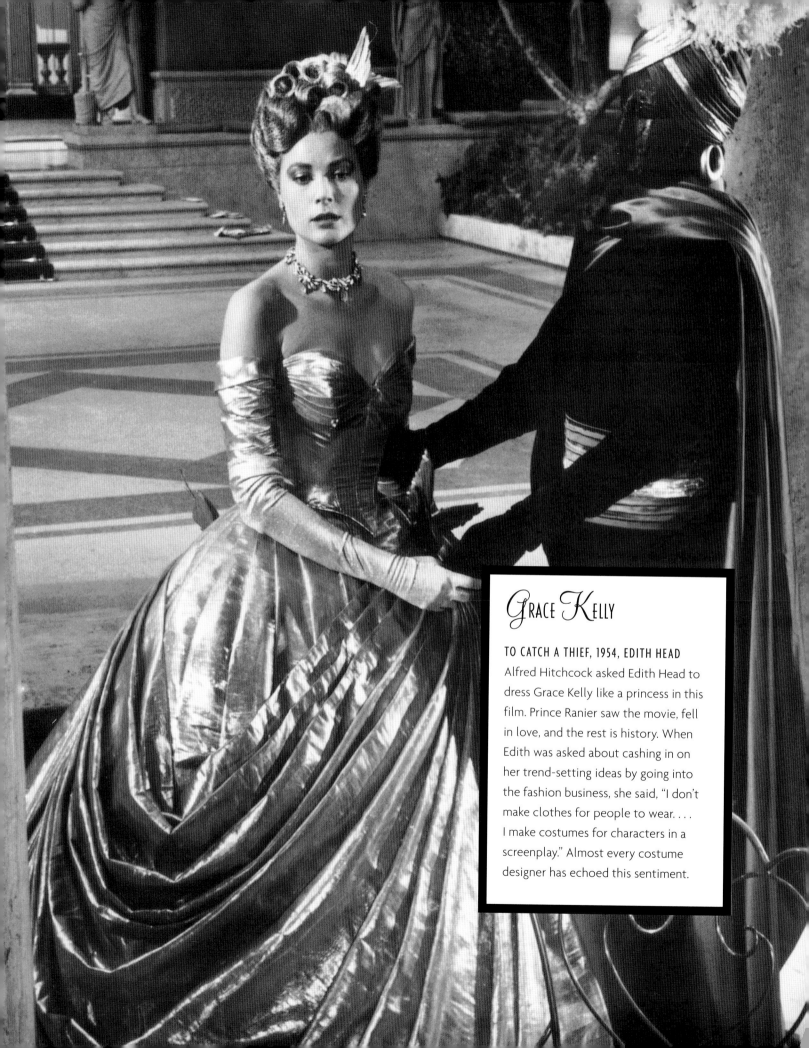

Grace Kelly

TO CATCH A THIEF, 1954, EDITH HEAD
Alfred Hitchcock asked Edith Head to dress Grace Kelly like a princess in this film. Prince Ranier saw the movie, fell in love, and the rest is history. When Edith was asked about cashing in on her trend-setting ideas by going into the fashion business, she said, "I don't make clothes for people to wear. . . . I make costumes for characters in a screenplay." Almost every costume designer has echoed this sentiment.

Grace Kelly, James Stewart

REAR WINDOW, 1954, EDITH HEAD Grace Kelly played this part so well—a stylish society girl, which was exactly her background. In this film, she carries her necessities and her nightie in a Mark Cross bag. A few years later, when she was pregnant with Princess Caroline, she covered her tummy with her Hermès bag whenever the paparazzi appeared. That purse was affectionately nicknamed the "Kelly Bag," and auction houses now sell them at prices far exceeding the original.

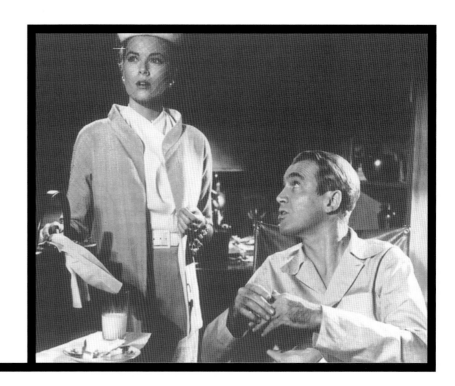

Grace Kelly, William Holden

THE COUNTRY GIRL, 1954, EDITH HEAD Up to this time, Grace had only appeared in movies as a rich socialite with a huge closet, but she was anxious to be accepted by the film industry as a dramatic actress. Kelly wanted the part of Bing Crosby's wife in THE COUNTRY GIRL. Confidante Edith Head whipped up a faded housedress for her to wear and advised her not to comb her hair or wear makeup to the script reading. It worked. Grace got the part and won the Oscar.

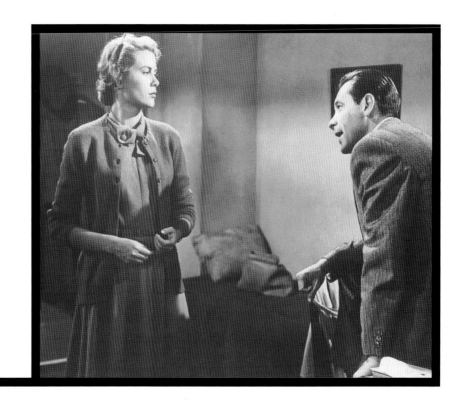

Jacqueline Bisset

BULLITT, 1968, THEODORA VAN RUNKLE Street fashion interpreted for a star reinforced the popularity of crocheted minis in the late sixties.

Faye Dunaway

BONNIE AND CLYDE, 1967, THEODORA VAN RUNKLE BONNIE AND CLYDE launched the midi hemline and the braless look of the early seventies. It took a lunch with producer Warren Beatty to persuade sketch artist Theadora Van Runkle to design for this film, her first, which won an Oscar nomination for costume. In 1989 Theadora received a spoken credit in TROOP BEVERLY HILLS. When Shelley Long is asked about her attire, she replies, "It's a Van Runkle. . . . Isn't it fabulous?"

Ali MacGraw

LOVE STORY, 1970, ALICE MANOUGIAN MARTIN AND PEARL SOMNER As Ali MacGraw said, "That hat was my hat . . . and it became THE LOVE STORY hat. It looked terrific on anybody who ever wore it. They wanted to look like me because that movie was so popular." THE GRADUATE (1967) was Hollywood's most profitable film until LOVE STORY.

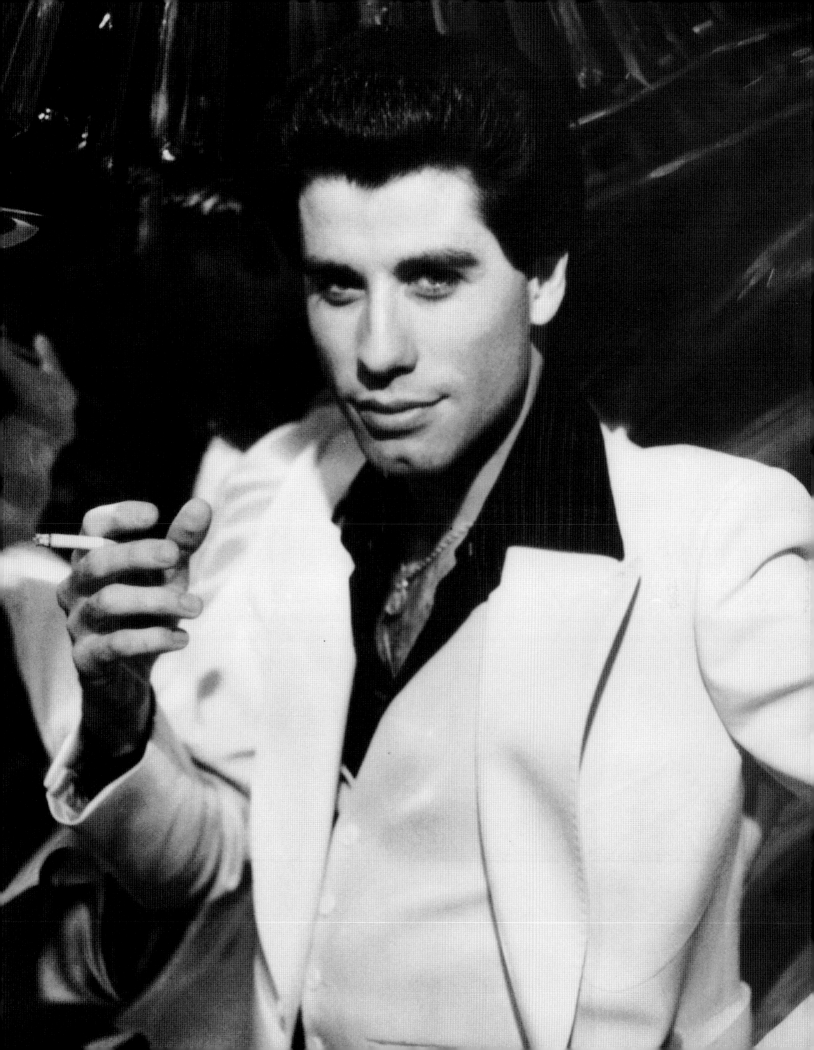

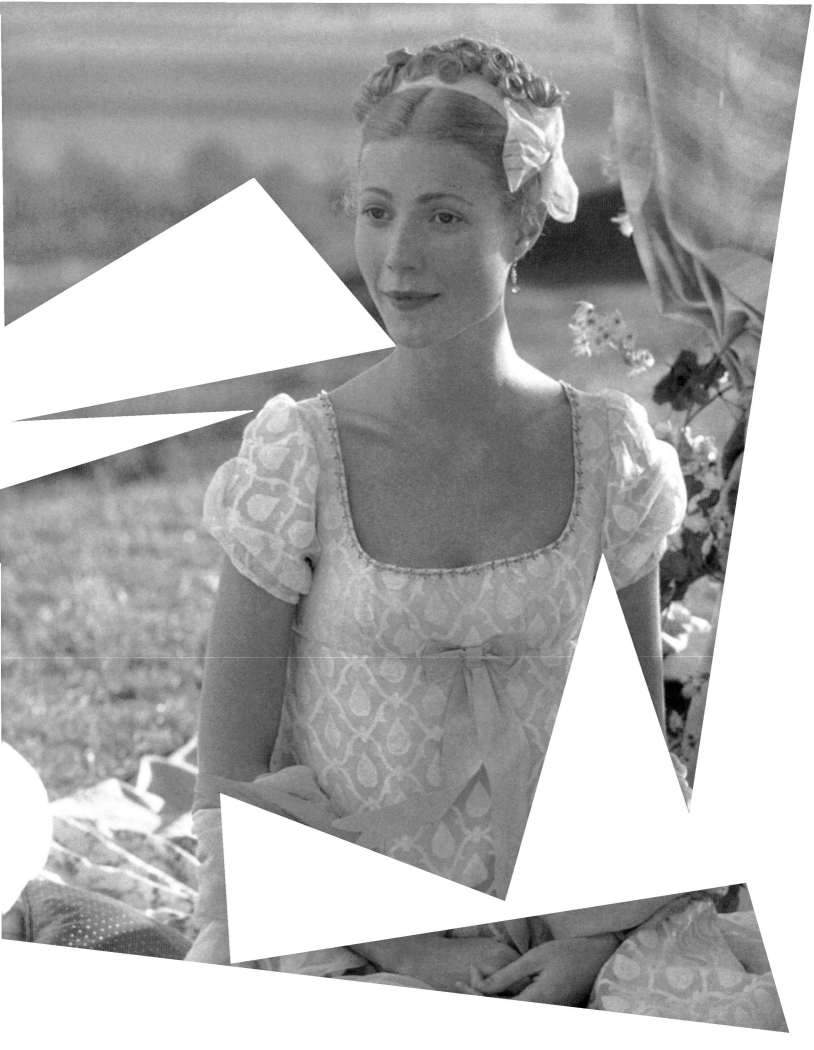

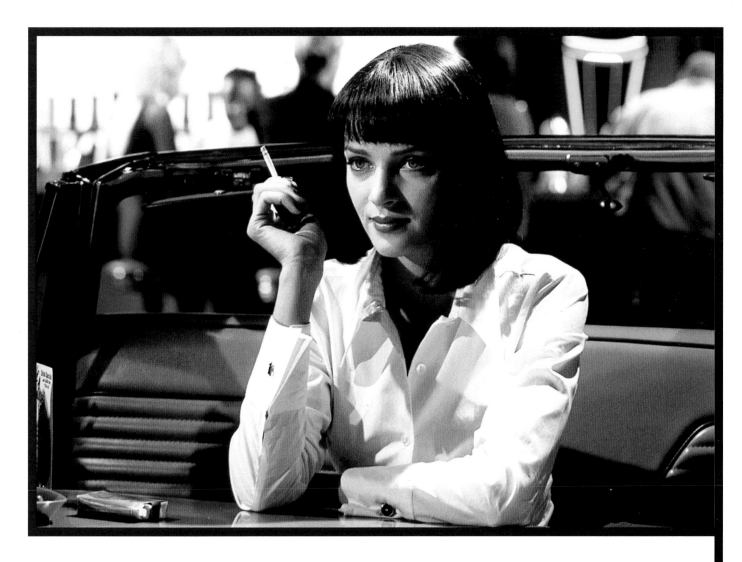

Gwyneth Paltrow

EMMA, 1996, RUTH MYERS The Empire style shown in EMMA, first popular in the early 1800s, made a comeback during the sixties as micromini dresses. This silhouette has never had long-term popularity, as the svelte woman prefers to show off her trim waist-line. The request for this EMMA-style dress became especially popular for bridal gowns in the late nineties.

Uma Thurman

PULP FICTION, 1994, BETSY HEIMANN Uma Thurman and John Travolta were stylish lowlifes in this film. The white shirt tail appeared not only on the screen, but in the Paris couture. Uma's entire look, including cigarette pants and blood red lips and nails, became "the look."

\mathcal{B}EGINNING

The Founding Fathers of the film industry were greatly influenced by the world of fashion and realized that if they were to attract large audiences and revenues, beautiful girls wearing beautiful clothes would be their draw.

In the early 1900s, Paris and fashion were synonymous, so bringing the French couturiers to America to design Hollywood costumes seemed to be the answer. The earliest costumes combined the stars' personal wardrobes, French couture, and a hodgepodge of everything else. To simplify this problem and to cut back on expenses, the "front office" started to hire socialites with beautiful wardrobes, such as Irene Castle, to be the "stars."

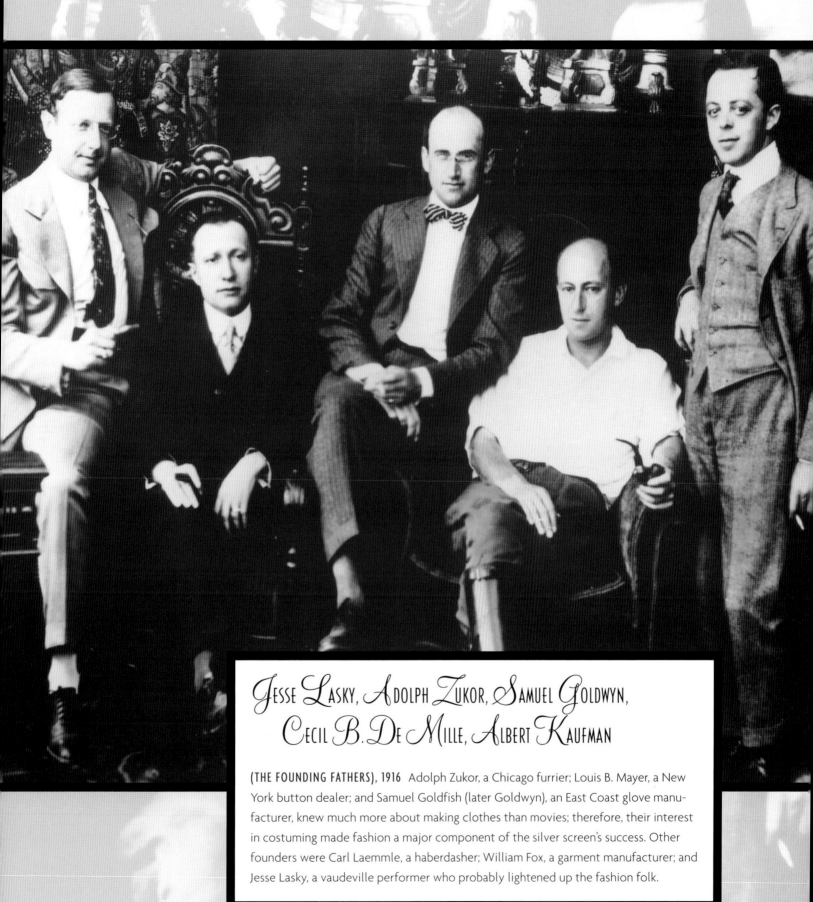

Jesse Lasky, Adolph Zukor, Samuel Goldwyn, Cecil B. De Mille, Albert Kaufman

(THE FOUNDING FATHERS), 1916 Adolph Zukor, a Chicago furrier; Louis B. Mayer, a New York button dealer; and Samuel Goldfish (later Goldwyn), an East Coast glove manufacturer, knew much more about making clothes than movies; therefore, their interest in costuming made fashion a major component of the silver screen's success. Other founders were Carl Laemmle, a haberdasher; William Fox, a garment manufacturer; and Jesse Lasky, a vaudeville performer who probably lightened up the fashion folk.

Cecil B. De Mille was one of the first studio heads to realize the importance of good costume and set design. In one of his films, THE SIGN OF THE CROSS (1932), he showed Claudette Colbert bathing in a marble tub filled with ass' milk. The public loved the idea, and due to demand, the fragrance industry started to manufacture bubble bath crystals. Also, because of C.B.'s films, bathrooms became much less utilitarian and much more glamorous. While De Mille understood the voyeuristic impact of a star disrobing on screen, he also realized the importance of gorgeous clothes.

By the early thirties, although Americans were standing in bread lines and, for the most part, were unemployed, movie costumes were being turned out by the thousands. The studios had workrooms and employed not only on-staff designers but also patternmakers, seamstresses, beaders, embroiderers, lacemakers, furriers, and even jewelers. Luxurious fabrics and trimmings were imported from Europe, making some of the work areas look as lavish as the inside of King Tut's tomb. Costume designer Adrian was churning out seventy-five designs per day, at a yearly salary of $75,000, the same salary as the President of the United States.

For any one film, preparation required hundreds of man-hours spent by talented craftspeople as well as by movie stars. Very often fittings went on through the night and couches were provided for the actresses' catnaps. There were many copies made of each dress to allow for accidental mishaps. Certain stars, like Mae West, wore such tight-fitting clothes that separate standing and sitting costumes were needed to guarantee a smooth, unwrinkled look. Between takes, a padded slant board was used so that stars could relax and not bother with undressing and re-dressing.

Test photographs were then taken of the costumes, hairdos, and makeup to insure perfection. Because the stars held up numbers across

their chests to identify the scenes, these photos looked similar to prison mug shots.

The advent of talkies resulted in new costuming problems: fabrics such as taffeta made too much noise; jewelry such as charm bracelets were a certain taboo; and footsteps could be heard (shoe soles were always taped and padded).

Color film changed costuming once again. The Technicolor consultants insisted that primary colors be used exclusively, but designer Walter Plunkett disagreed. For example, in GONE WITH THE WIND (1939), he dressed Scarlett O'Hara (Vivien Leigh) in bright colors for scenes in which she was happy and drab colors when the South was at war. Plunkett tried to remain true to historical detail, but often costumes did not photograph well on the screen, or they did not emphasize the best features of the star. Therefore, Norma Shearer's beautiful shoulders were seen repeatedly in MARIE ANTOINETTE (1938), even though shoulders were not normally exposed during the late eighteenth century.

During World War II, government regulations limited the use of fabric and trimmings and directly affected clothing manufacturers; but Hollywood designers were also hard hit. For example, Dorothy Lamour, who hated being stereotyped by the sarong, finally graduated to a suit in ROAD TO MOROCCO (1942); but because of the war, fabric was only available for one costume. Blouses, hats, and accessories were used to change her appearance from scene to scene. In 1944 Edith Head said that because of these limitations, cinema costuming became more realistic: secretaries were no longer shown wearing fur-trimmed ballgowns.

Today, couture is a respected art form at most fine arts museums, and costume exhibitions have often broken attendance records. Sadly, Hollywood did not have the foresight to preserve its costuming history, and the rare examples of individual pieces that remain are displayed and revered all over the world. Debbie Reynolds rescued some of Hollywood's costume history and for years has shared her collection with the public. Susan Sarandon recently remarked, "We are the keepers of the dreams." One wishes that Hollywood had also been the keepers of the costumes.

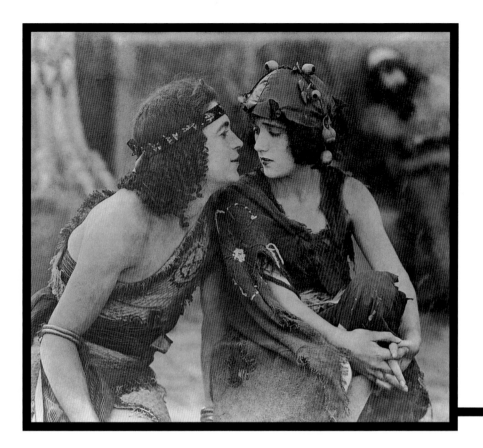

ELMER CLIFTON, CONSTANCE TALMADGE

INTOLERANCE, 1916, CLAIRE WEST The first film to use costumes for the leads and extras was D. W. Griffith's INTOLERANCE. Although the look was Babylonian, many of the costumes belonged to leading ladies Constance Talmadge and Lillian Gish (who complained that she did not get paid for allowing the dresses to be used). *Photoplay* reported that the INTOLERANCE costumes immediately influenced the fashion of the day.

GLORIA SWANSON

MALE AND FEMALE, 1919, CLAIRE WEST, PAUL IRIBE At the insistence of De Mille, producer Adolph Zukor brought one of couturier Paul Poiret's disciples, Paul Iribe, from Paris to design the set and Gloria Swanson's costumes. Iribe was Poiret's sketch artist and also Coco Chanel's lover. This was Gloria's third film for De Mille, and she was drawing a salary of $20,000 per week, an unheard of sum for that time. Among the crew for the film was a student dancer by the name of Martha Graham and eighteen-year-old Walter Disney, a sketch artist.

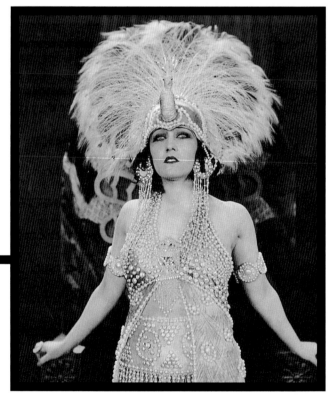

Sarah Bernhardt

C. 1905 Adolph Zukor imported his first feature film, QUEEN ELIZABETH (1912) starring stage actress Sarah Bernhardt, from Britain. When asked why, at the age of 67, she risked a new career in film, Bernhardt answered that it was her chance for immortality and the opportunity to wear the gorgeous gowns designed by French couturier Paul Poiret.

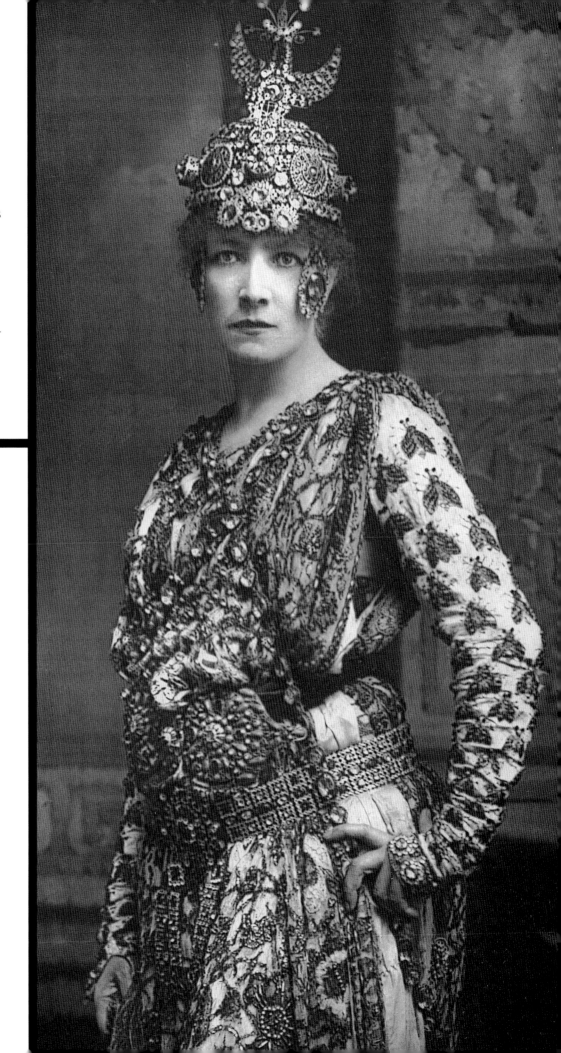

\mathscr{L}EATRICE \mathscr{J}OY

THE DRESSMAKER FROM PARIS, 1925, TRAVIS BANTON
When Douglas Fairbanks and America's sweetheart
Mary Pickford eloped in New York, Mary wore a
wedding gown designed by Travis Banton, a fashion
designer who was encouraged by Mary to work in the
movies. He found instant success, as he fulfilled
Adolph Zukor's wishes by filling every scene with
gorgeous furs. Zukor, a former furrier, wanted to give
the fur industry a much needed lift.

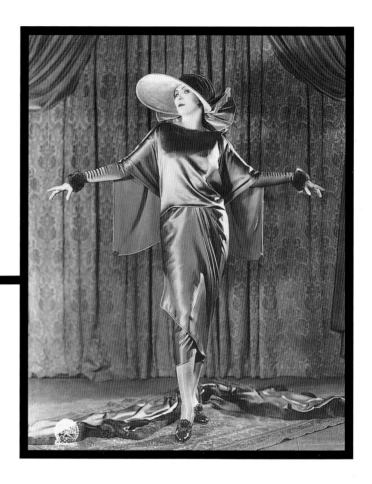

\mathscr{A}ILEEN \mathscr{P}RINGLE, \mathscr{C}ONRAD \mathscr{N}AGEL

THREE WEEKS, 1924, LUCILLE Madame Elinor Glyn wrote the screenplay
based on her popular and titillating novel THREE WEEKS and encouraged
her sister Lucille, the English couturier, to create the costumes. Although
the silent film was much more prudent than the novel, Aileen Pringle and
Conrad Nagel "pleasured" each other on a bed of roses, and on a tiger
skin, which prompted this popular ditty of the day:

Would you like to sin / With Elinor Glyn/ On a tiger skin?
Or would you prefer / To err with her / On some other fur?

Miss Pringle was gowned luxuriously with floating panels of fabric that
almost made Mr. Nagel drop her. She looked seductive, but her lips were
saying "If you drop me, you (blankety-blank blank) I will cut off your
(blank)." The Deaf and Dumb Society banned the film.

Lillian Gish, John Gilbert

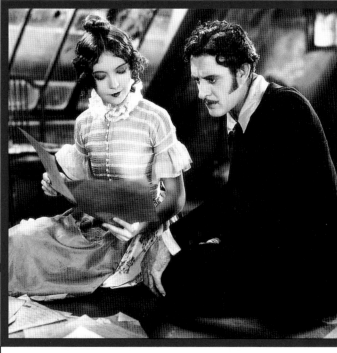

LA BOHÈME, 1926, ERTÉ On November 4, 1925, the *New York Times* reported that after seven months as an MGM designer, Erté was returning to Paris. Lillian Gish had offended him because she wanted simple costumes for her role as a poor girl, but she wanted them made of silk and other elegant fabrics. Miss Lillian, as she was later called, said that she personally redesigned all of the "dreadful" costumes, although Erté received the screen credit. The expense of hiring French designers to work in Hollywood prompted the Founding Fathers to seek socialites with fabulous wardrobes to be the movie stars and wear their own clothes on the screen.

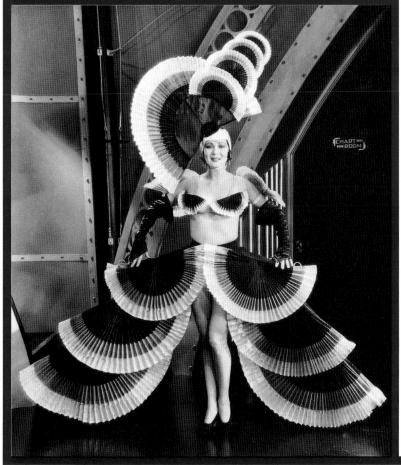

MADAM SATAN, 1930, PAUL IRIBE, ERTÉ, ADRIAN
Time apparently heals all wounds. Director De Mille persuaded Erté to return to Hollywood to design the set and influence the costume designer, Adrian, for MADAM SATAN, a wild costume romp on a zeppelin. This number was called "Madame Booby Trap."

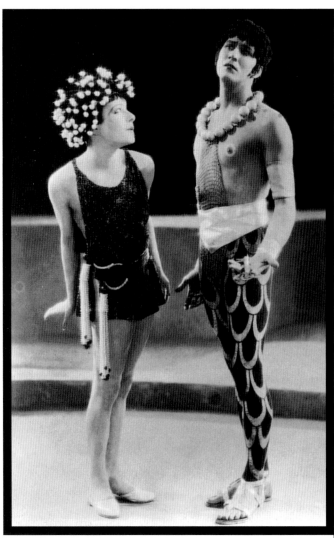

Alla Nazimova

SALOME, 1923, NATACHA RAMBOVA Nazimova, a Russian-born stage actress, produced and starred in SALOME. She chose Natacha Rambova, formerly Winifred Shaunessy of Salt Lake City, Utah, to create the sets and costumes. Natacha, a rich socialite who was flamboyant and wildly creative, set Aubrey Beardsley's art nouveau designs in motion by creating what is said to be the most extraordinary black-and-white costumes for the screen. Nazimova's hair in this scene was frizzed and then wrapped with "pigeon egg" pearls.

Rudolph Valentino and Natacha Rambova

1922 Valentino married designer Rambova before his divorce from his first wife was final, so he was arrested for bigamy. Natacha insisted on not only designing his costumes, but also supervising the writing, direction, and acting of her husband. Although Valentino's glances made his female fans swoon, in real life he was a pushover for a domineering woman. Together they spent over $100,000 on costumes for THE HOODED FALCON, a project that was scrapped.

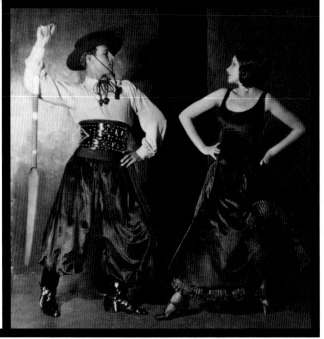

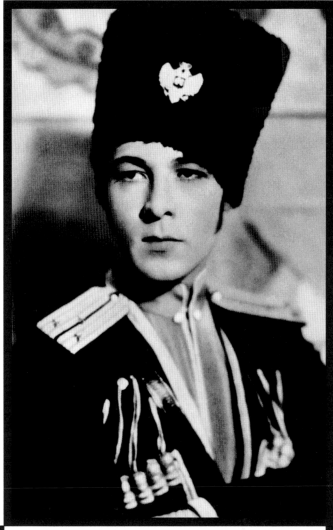

Rudolph Valentino

**MONSIEUR BEAUCAIRE, 1924, NATACHA RAMBOVA, GEORGES
BARBIER** Natacha was known for creating bizarre cos-
tumes, such as those she designed for Valentino in THE
YOUNG RAJAH (1922). With the assistance of another of
Poiret's artists, Georges Barbier, she produced the
wardrobe for MONSIEUR BEAUCAIRE, but instead of
swooning, Valentino's audiences were giggling—$90,000
worth of giggles. Natacha was eliminated from supervis-
ing Valentino's costumes and career and from their short-
lived marriage as well.

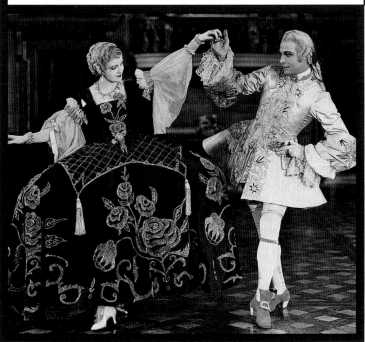

Rudolph Valentino

THE EAGLE, 1925, ADRIAN Box office receipts were
low during these years, due to America's infatuation
with the radio. Even this film, now looked upon as
Valentino's best movie, and his new look couldn't
displace the radio's popularity. This costume, sort of
Russian Robin Hood, made him a romantic figure
once again, restoring his popularity and insuring
Adrian's position as an important designer. The tall
astrakhan hat became a fashion trend.

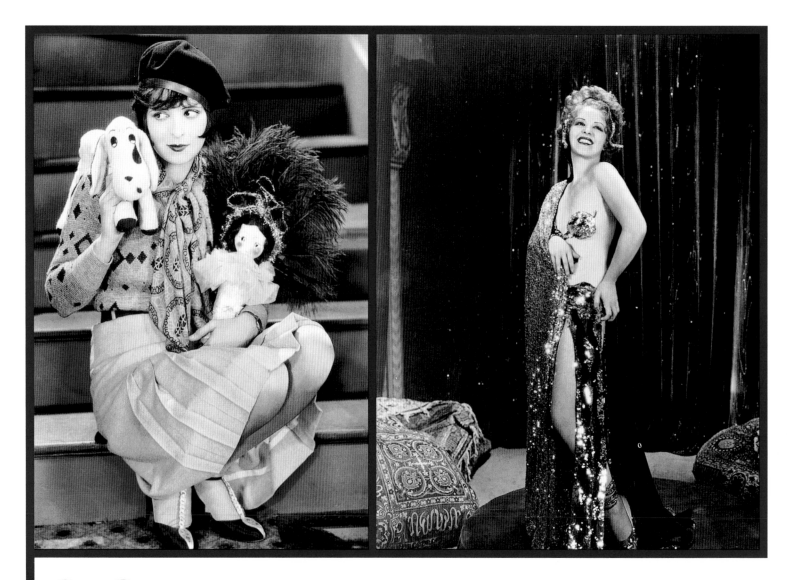

Clara Bow

IT, 1927, LUCILLE IT meant sex and Clara Bow and the Jazz Age, pouting red lips, flapper costumes, and dancing the Charleston wearing rolled stockings. IT was also a movie written by Elinor Glyn and costumed by her sister Lucille. Both women spent much time trying to explain the new phenomenon. When Bow was asked to explain exactly what "it" was, she replied in her authentic Brooklyn accent, "I ain't real sure."

HOOPLA, 1933, RITA KAUFMAN Clara Bow's career seemed doomed with the advent of talkies, but she tried for a comeback wearing this uncensored costume in HOOPLA. Between 1927 and 1930 a group of film industry leaders formed the Motion Picture Production code, a form of self-censorship primarily concerned with the depiction of sex on screen. Clara Bow once said that a prime consideration in the films chosen for her was how quickly she could be undressed. The comeback failed.

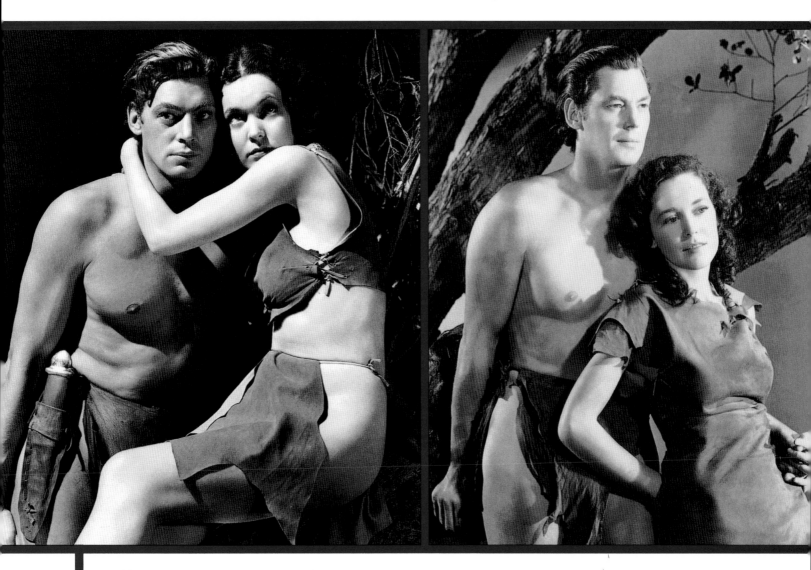

Johnny Weissmuller, Maureen O'Sullivan

TARZAN AND HIS MATE, 1934 Shortly after the release of this film, *Photoplay* published "The Miseries of Nudism." In the article, Mia Farrow's mom, Maureen O'Sullivan, tells of the inconveniences created by the brief costume she wore: a tiny halter and a loincloth. She often caught cold and couldn't stay warm during the long shoots. Fans thought her outfit immodest and unattractive.

TARZAN ESCAPES, 1936 Once the Hays Office declared war on indecent exposure, Maureen O'Sullivan was promptly covered up, although Tarzan (Johnny Weissmuller) remained "hangin' loose." In one of the Tarzan covered-up films, Jane says to Tarzan, "How do you like my dress?" Tarzan replies, "We go home now." Direct and to the point.

Lana Turner

THE POSTMAN ALWAYS RINGS TWICE, 1946, IRENE
When asked how she liked the remake of POSTMAN (1981) starring Jack Nicholson and Jessica Lange, Lana answered, "Mr. Garfield (John, her costar) and I didn't have to grope . . . we just acted." Designer Irene became MGM's head of costume in 1942, when Adrian left the studio. Her signature look was ladylike clothes, even for femmes fatales like Lana.

ROBERT DE NIRO, CATHY MORIARTY

RAGING BULL, 1980 Jake LaMotta, played by Robert De Niro, and his new bride, Vickie (Cathy Moriarty), were not the stars of this scene. Instead, Vickie's costume and turban, one of Hollywood's most famous "looks," stole the show.

PRODUCER ROSS HUNTER, LANA TURNER, AND JEAN LOUIS

IMITATION OF LIFE, 1959, JEAN LOUIS (OFF SET) One of the only producers who tried to bring back the glamour of Hollywood's Golden Age was Ross Hunter, who continued to use lavish costumes and rare jewels in his films. Lana persuaded him to include her beautiful Jean Louis gowns in her contract. When she died in 1995, they were still among her wardrobe. Before coming to Hollywood, Paris-born Jean Louis worked for Hattie Carnegie in New York, together with Norman Norell. Jean Louis's private clients included the Duchess of Windsor and Nancy Reagan.

UP CLOSE AND PERSONAL

In the twenties, the Hays Office, headed by Postmaster General Will H. Hays, was formed to improve Hollywood's image, and by the thirties, it tightly dictated how a small degree of violence and immorality and a large degree of sexual activity appeared on screen, including the choice of underwear.

D. W. Griffith, among other early filmmakers, used orgies and nudity in his films, causing the Legion of Decency, a Catholic film reform society, to threaten the boycotting of movie theaters—some 23,000 by 1930. Covering body parts with titillating underwear seemed to be the answer. During that time

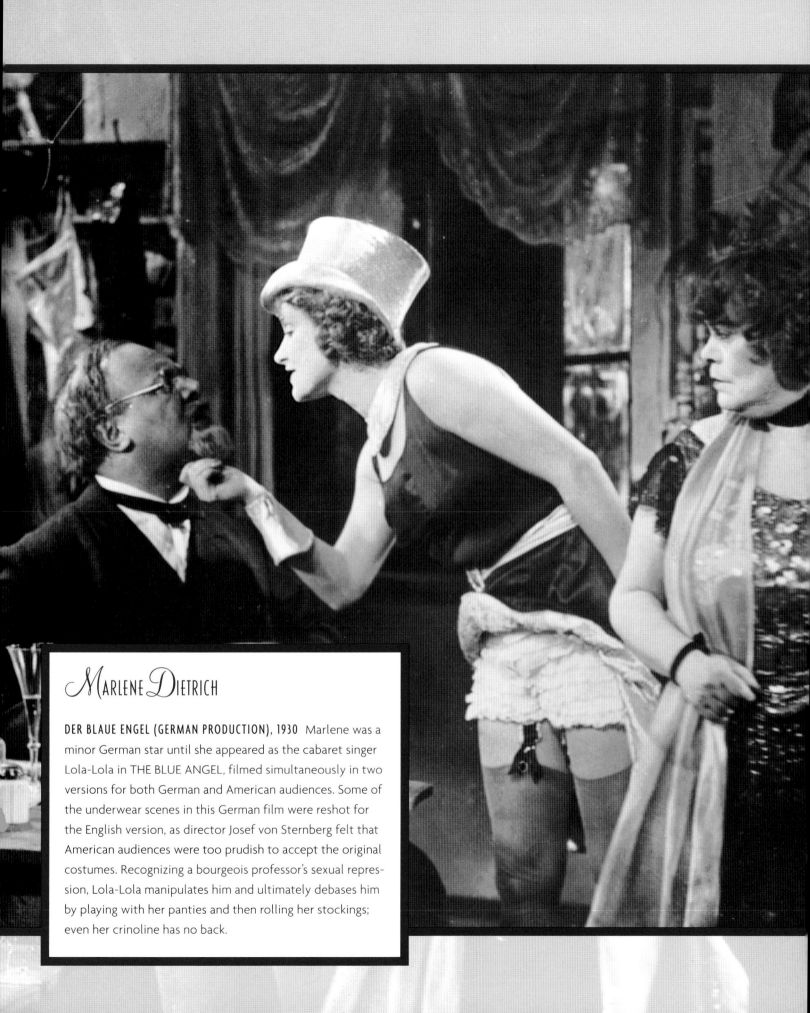

ℳarlene 𝒟ietrich

DER BLAUE ENGEL (GERMAN PRODUCTION), 1930 Marlene was a
minor German star until she appeared as the cabaret singer
Lola-Lola in THE BLUE ANGEL, filmed simultaneously in two
versions for both German and American audiences. Some of
the underwear scenes in this German film were reshot for
the English version, as director Josef von Sternberg felt that
American audiences were too prudish to accept the original
costumes. Recognizing a bourgeois professor's sexual repres-
sion, Lola-Lola manipulates him and ultimately debases him
by playing with her panties and then rolling her stockings;
even her crinoline has no back.

even cartoon characters were affected by censorship. Betty Boop was told to quit wearing her single black garter, but her fans went wild, so the Hays Office eventually relented.

The censors were in full control: no navels, garters, or bare thighs—and minimal cleavage. They preferred stars who were flat-chested and brassiered. Mae West's provocative clothing, posture, and language were the censors' first major target. Mae's costume designers were instructed to minimize her voluptuousness. She fought back. In an interview in *Playboy* in 1970, she said, "I'd be insulted if a picture I was in didn't get censored. Don't forget, dear, I invented censorship."

Because the movies were firmly scrutinized, the studios began using scantily clad actresses for publicity shots, which were sometimes backlit to give the illusion of nudity. The Hays Office then ruled that stars could be photographed in bathing suits, but not in revealing lingerie.

Although some regulations were relaxed by the early sixties, censorship rules were enforced until 1966, when the Hays Office was replaced by the Rating System. In a *Photoplay* interview, Joan Collins said, "When I was eighteen in Hollywood, the wardrobe lady had to measure my cleavage. Only one and one-half to two inches was permissible. If too much was showing, in went a disgusting flower."

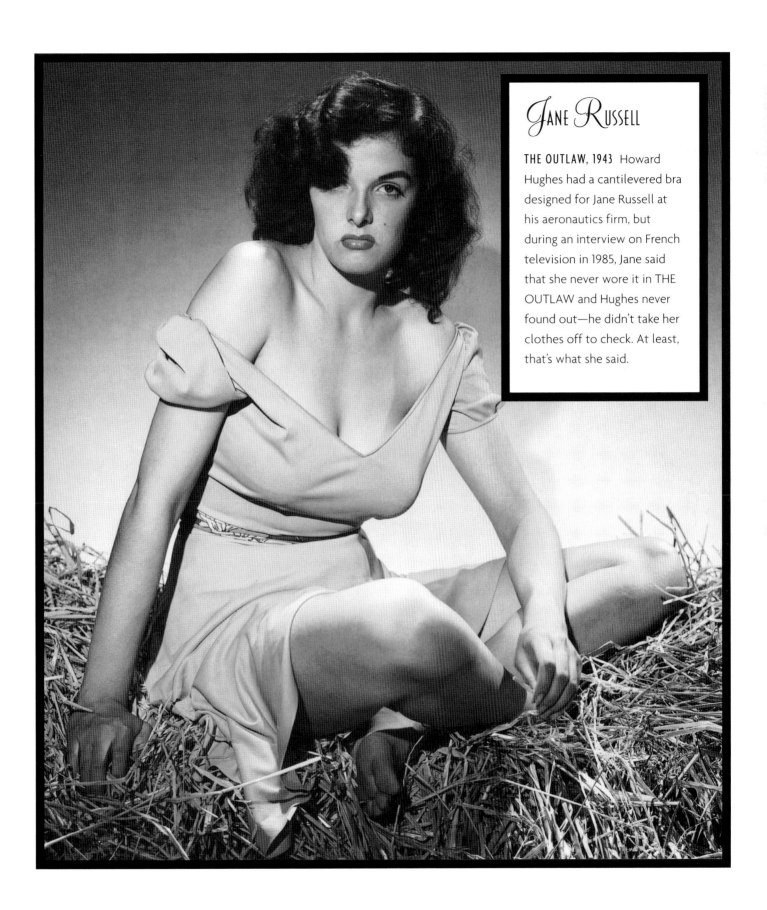

Jane Russell

THE OUTLAW, 1943 Howard Hughes had a cantilevered bra designed for Jane Russell at his aeronautics firm, but during an interview on French television in 1985, Jane said that she never wore it in THE OUTLAW and Hughes never found out—he didn't take her clothes off to check. At least, that's what she said.

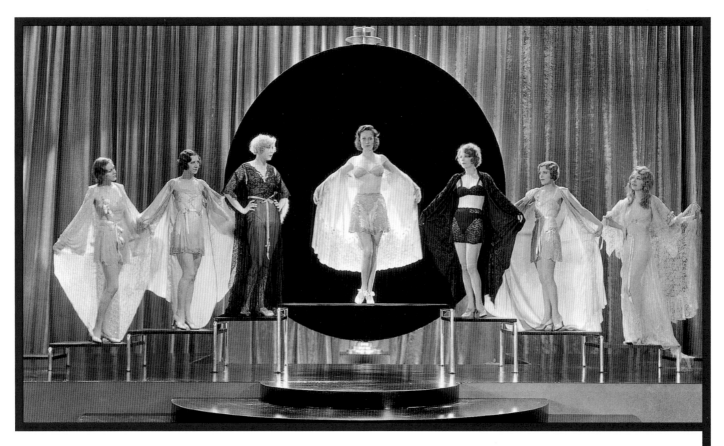

ℐoan ℭrawford

OUR BLUSHING BRIDES, 1930, ADRIAN In 1930, Joan Crawford (above center) was the top box office female star. Critics of silent film called her fresh and energetic, and by the early thirties, she was considered quite a clotheshorse. In this film she plays a shopgirl/model trying to get her man, Robert Montgomery. True to all of the early films of this period, dressing and undressing was the focus. *Photoplay* said of this film, "You must see Joan Crawford in those lace step-ins! Swell picture!"

DANCE FOOLS DANCE, 1931, ADRIAN Pre-Code again and using unisex undies—note the undershirt with ultradeep armholes—this film started a men's underwear trend. The *New York Times* said that Crawford's acting was still self-conscious, but her fans loved her performances as well as her clothes.

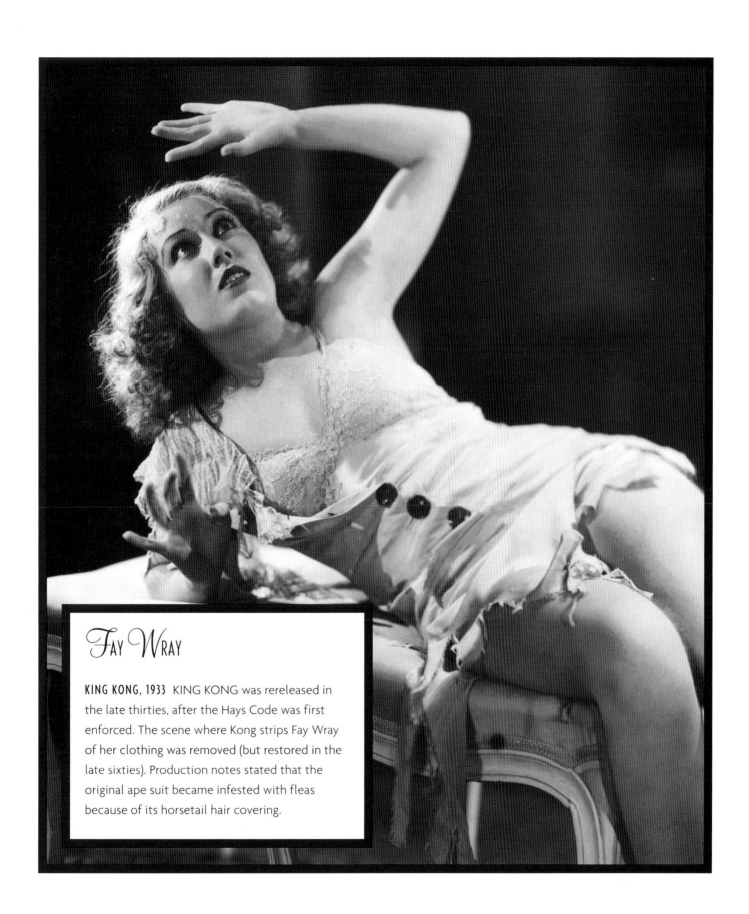

Fay Wray

KING KONG, 1933 KING KONG was rereleased in the late thirties, after the Hays Code was first enforced. The scene where Kong strips Fay Wray of her clothing was removed (but restored in the late sixties). Production notes stated that the original ape suit became infested with fleas because of its horsetail hair covering.

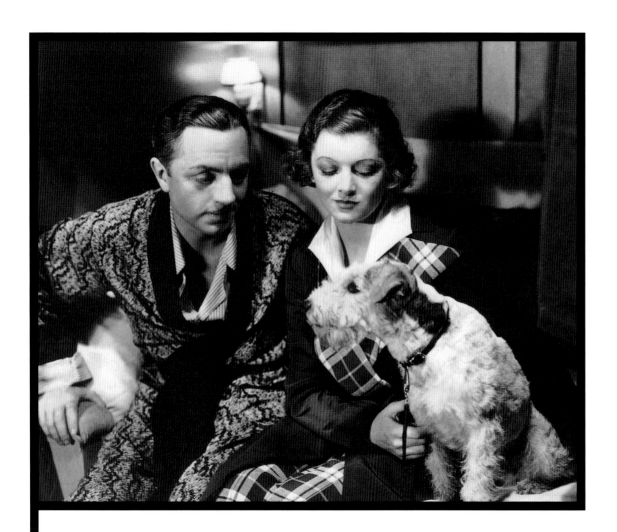

William Powell, Myrna Loy, Asta

THE THIN MAN, 1934, DOLLY TREE Fashions for lounging or for the boudoir, Hollywood style, usually meant satin, velvet, and feathers, but not in the case of Nick and Nora Charles. There wasn't a moment that they didn't look fashionable—even undressed. Thanks to beloved Asta, Nick and Nora's dog, "canine couture" began to be worn by the public: dog-printed fabrics and Scottie pins on the lapels of suits and coats became popular.

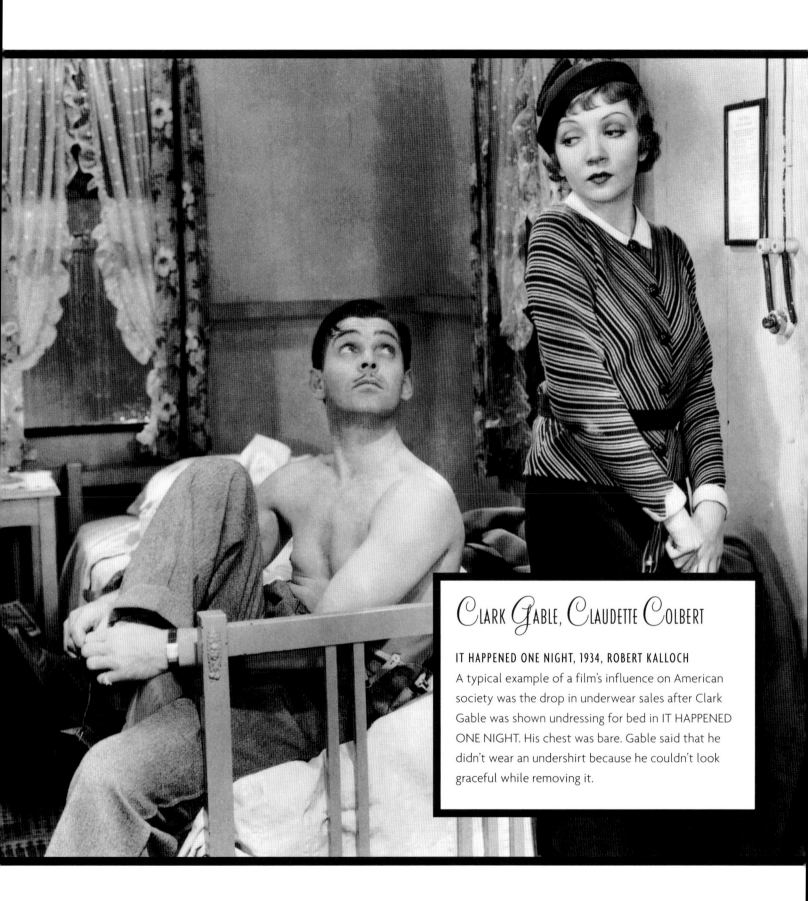

Clark Gable, Claudette Colbert

IT HAPPENED ONE NIGHT, 1934, ROBERT KALLOCH
A typical example of a film's influence on American society was the drop in underwear sales after Clark Gable was shown undressing for bed in IT HAPPENED ONE NIGHT. His chest was bare. Gable said that he didn't wear an undershirt because he couldn't look graceful while removing it.

Jeanette MacDonald, Maurice Chevalier

LOVE ME TONIGHT, 1932, TRAVIS BANTON

The greatest musical of the thirties starred naughty and sexy Jeanette MacDonald, pre-Code and before her more uptight performances with Nelson Eddy. These earlier films always featured lots of gorgeous lingerie, modeled by Jeanette and new starlet Myrna Loy, who was afraid of being typecast as a lingerie model. Even Charlie Ruggles ran around in his underwear.

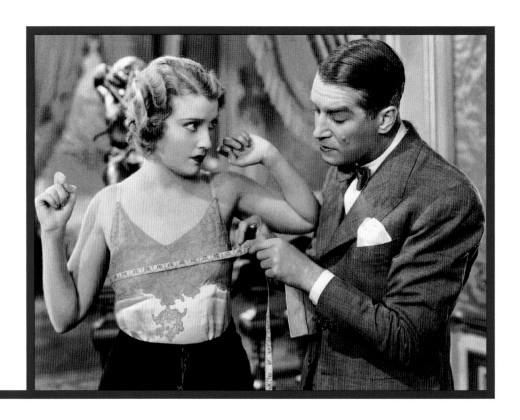

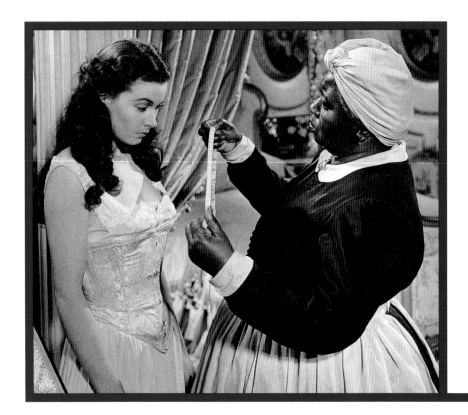

Vivien Leigh, Hattie McDaniel

GONE WITH THE WIND, 1939, WALTER PLUNKETT

When asked about the costuming of this film, Olivia De Haviland, who played Melanie, recalled that producer David O. Selznick was so particular about every aspect of the costumes that he once stopped production for weeks to wait for the handmade lace undergarments to arrive from Paris. Olivia told him that they should proceed, as the underwear didn't even show in the scenes. Mr. Selznick replied, "You couldn't possibly play the part of Melanie if you were wearing the wrong undies."

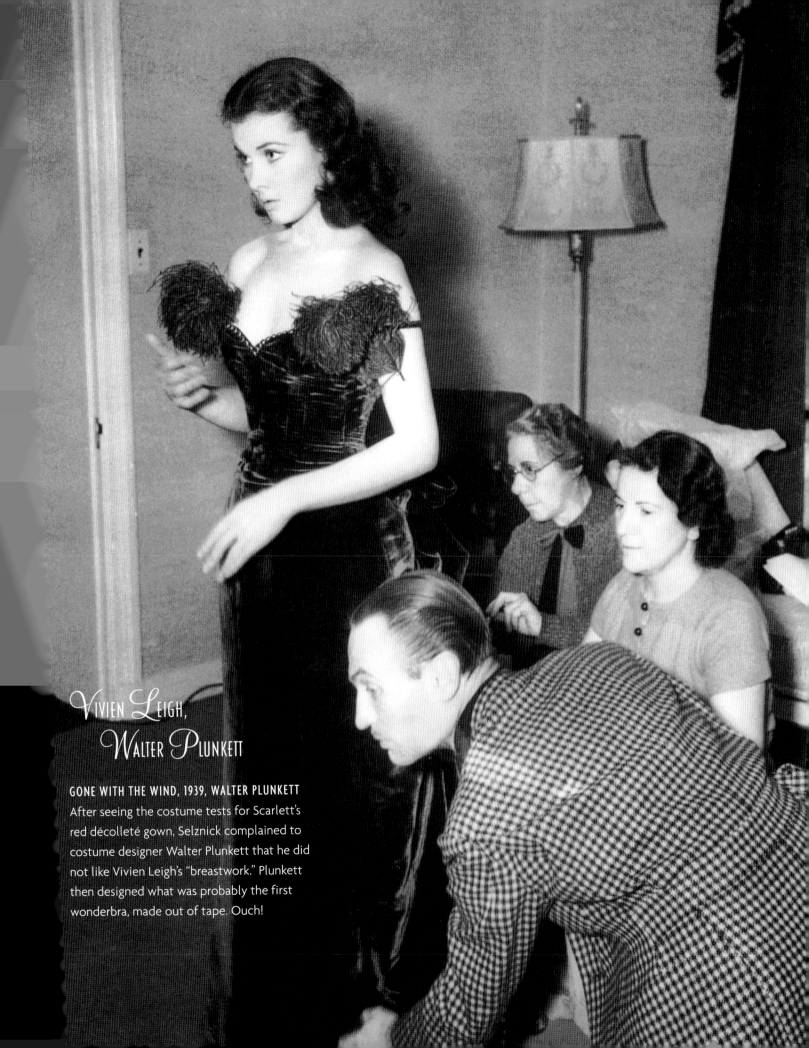

Vivien Leigh, Walter Plunkett

GONE WITH THE WIND, 1939, WALTER PLUNKETT
After seeing the costume tests for Scarlett's red décolleté gown, Selznick complained to costume designer Walter Plunkett that he did not like Vivien Leigh's "breastwork." Plunkett then designed what was probably the first wonderbra, made out of tape. Ouch!

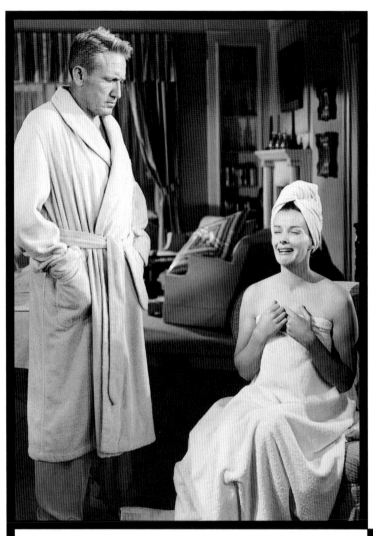

Doris Day

PILLOW TALK, 1959, JEAN LOUIS In the opening scene, Doris is all "baby blue": She wears a blue slip, eyeshadow, and even a blue tint in her French-twisted hair/wig. Later she slips into a matching duster for breakfast. In the fifties, "duster" meant a short robe, not the coat associated with the Model T.

Spencer Tracy, Katharine Hepburn

ADAM'S RIB, 1949, WALTER PLUNKETT In this film, as in all of their films, Tracy and Hepburn are very proper. This is probably their most undressed scene: they are lawyers relieving their stress by giving each other a massage.

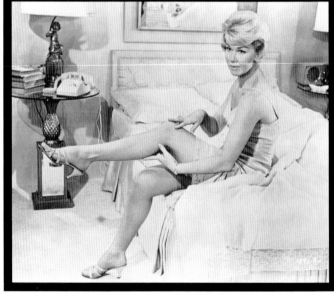

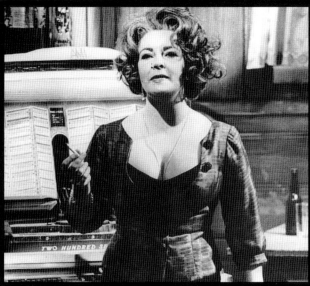

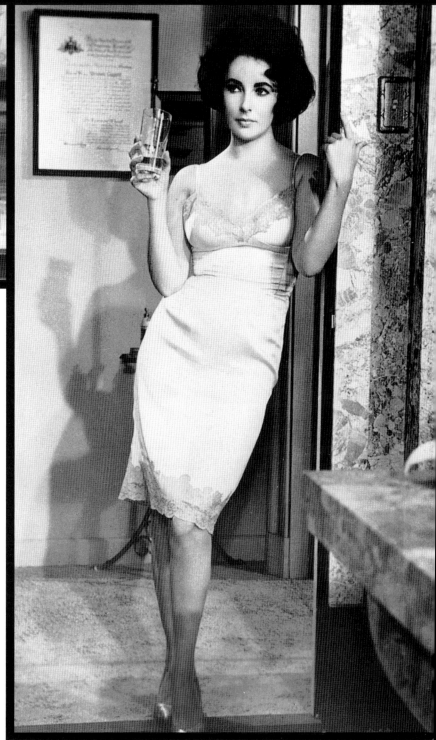

Elizabeth Taylor

(ABOVE) WHO'S AFRAID OF VIRGINIA WOOLF?, 1966, IRENE SHARAFF To make Liz appear matronly in this film, costume designer Irene Sharaff used a bouffant wig and poorly fitting costumes, although in the real world, Liz looked sensational. Now you see why Sharaff won the Oscar.

(RIGHT) BUTTERFIELD 8, 1960, HELEN ROSE Some of the most beautiful slips (remember that word?) were worn by Ms. Taylor in CAT ON A HOT TIN ROOF (1958) and BUTTERFIELD 8, her Oscar-winning role. This film was made during the "Liz steals Debbie's husband" scandal and then the "Liz almost dies" period. Eddie Fisher also appears in this film, but although Liz is gorgeous, dressed or not, the sparks were not flying! Both Liz and Grace Kelly wore wedding gowns designed by Helen Rose. Grace's is now at the Philadelphia Museum of Art.

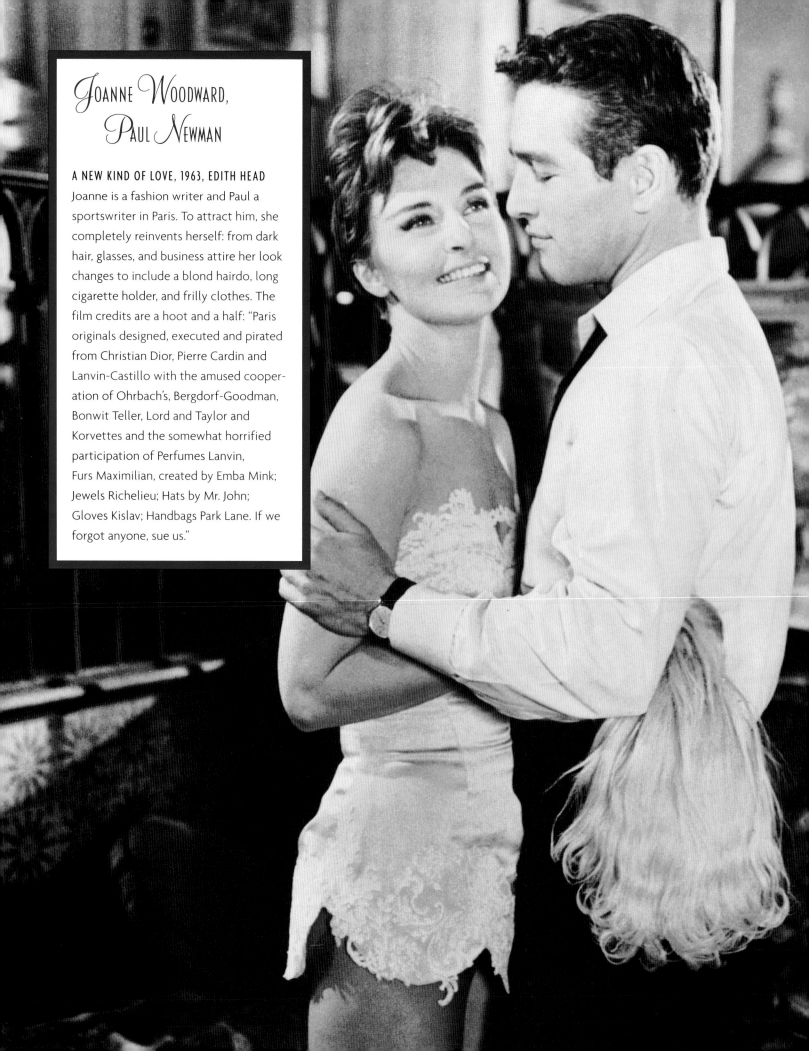

Joanne Woodward, Paul Newman

A NEW KIND OF LOVE, 1963, EDITH HEAD

Joanne is a fashion writer and Paul a sportswriter in Paris. To attract him, she completely reinvents herself: from dark hair, glasses, and business attire her look changes to include a blond hairdo, long cigarette holder, and frilly clothes. The film credits are a hoot and a half: "Paris originals designed, executed and pirated from Christian Dior, Pierre Cardin and Lanvin-Castillo with the amused cooperation of Ohrbach's, Bergdorf-Goodman, Bonwit Teller, Lord and Taylor and Korvettes and the somewhat horrified participation of Perfumes Lanvin, Furs Maximilian, created by Emba Mink; Jewels Richelieu; Hats by Mr. John; Gloves Kislav; Handbags Park Lane. If we forgot anyone, sue us."

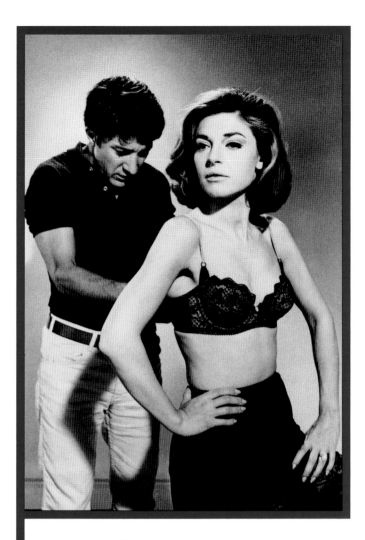

Marilyn Monroe

Marilyn Monroe's penchant for tight clothes, low neck-lines, and no underwear frustrated her designers and film censors. Anything and everything worn by her has become a classic American look. Warner's, a lingerie manufacturer, created the Marilyn Monroe underwear line in 1997 . . . as sweet as sugar candy.

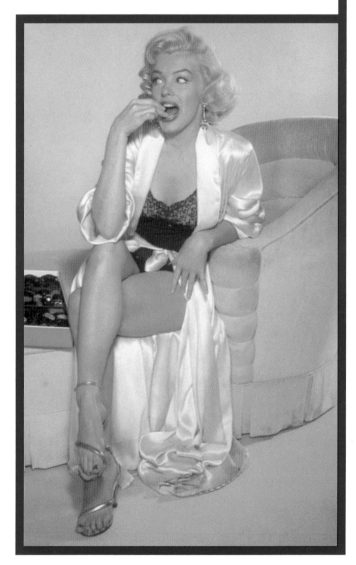

Dustin Hoffman, Anne Bancroft

THE GRADUATE, 1967, PATRICIA ZIPPRODT A naïve college grad, played by Dustin Hoffman, is seduced by his mother's friend, Anne Bancroft, who goes from respectable matron to a tease. Hoffman and Bancroft are almost the same age—but here she plays a woman old enough to be his mother. Although pantyhose were then the rage, costume designer Zipprodt made Bancroft's character assignation-ready: she wears silk stockings and garters. Anne appears in underwear again in 1995's HOME FOR THE HOLIDAYS—now *that's* acting!

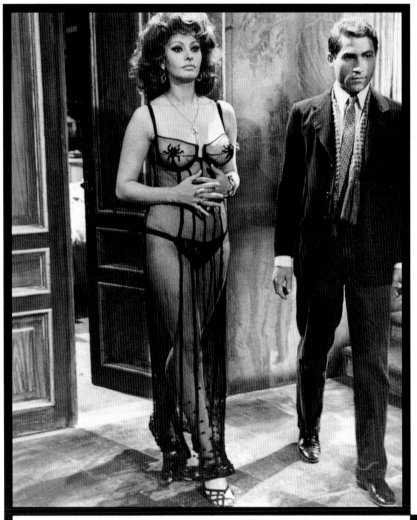

Goldie Hawn

BUTTERFLIES ARE FREE, 1972, MOSS MABRY
Thanks to Goldie, "Rowen and Martin's Laugh-In" became known as the television show with the giggling girl in the bikini. This underwear shot brings back those memories, and so does seeing Goldie, the "wonder body" even today—twenty-five years later. Her love interest in this film was not so privileged . . . he was supposed to be blind.

Sophia Loren

MARRIAGE ITALIAN STYLE, 1964, PIERO TOSI In 1964, Sophia said, "I can't bear being seen nearly naked. I'm not exactly a tiny woman. When Sophia Loren is naked, there is a lot of nakedness." Sophia showed her fabulous bod once again in READY-TO-WEAR (1994).

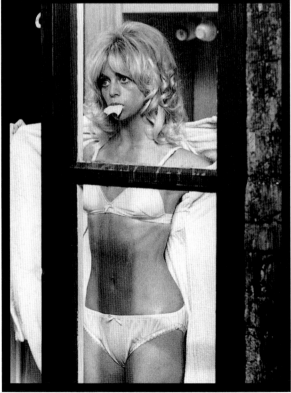

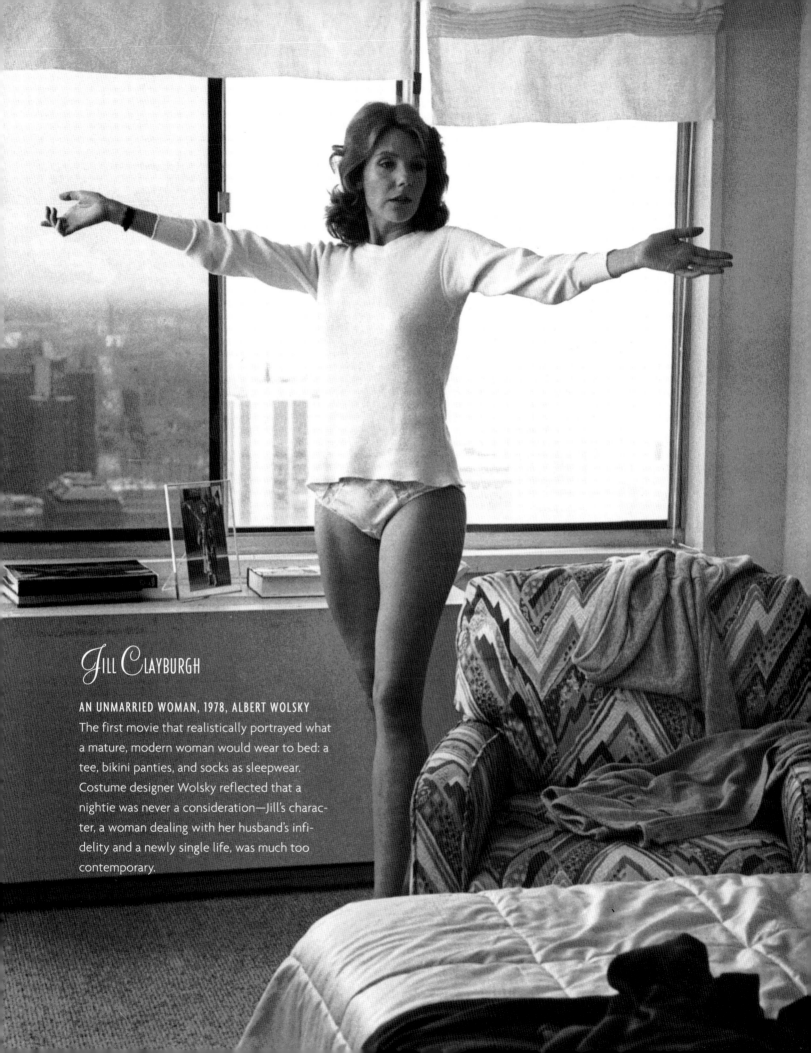

Jill Clayburgh

AN UNMARRIED WOMAN, 1978, ALBERT WOLSKY

The first movie that realistically portrayed what a mature, modern woman would wear to bed: a tee, bikini panties, and socks as sleepwear. Costume designer Wolsky reflected that a nightie was never a consideration—Jill's character, a woman dealing with her husband's infidelity and a newly single life, was much too contemporary.

Sarah Jessica Parker, Johnny Depp

ED WOOD, 1994, COLLEEN ATWOOD Costume designer Atwood, who also gave Johnny Depp his EDWARD SCISSSORHANDS (1990) look, dresses him as both a man and a woman in ED WOOD; in this movie he wears his favorite angora sweater. Bullet bras like the one pictured on Sarah Jessica were used under period gowns in fifties films. Joan Collins wore one in THE VIRGIN QUEEN (1955), a story of Elizabethan England, a time when women were corseted and not bulleted.

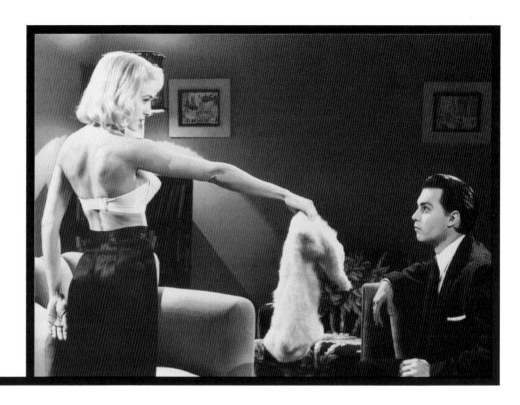

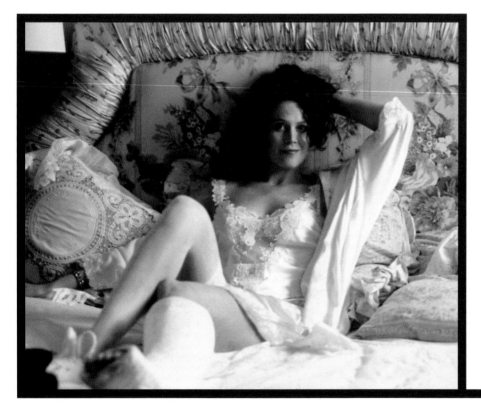

Sigourney Weaver

WORKING GIRL, 1988, ANN ROTH Sigourney Weaver tries to renew the excitement in her romance with Harrison Ford, although her leg is in a cast. Romance in this scene means underwear in the bedroom, courtesan style, with a return to corsets, teddies, and femininity. Cast or no cast, the lingerie didn't help. Designer Roth bought Sigourney's undies in Monte Carlo after waiting in line with "ladies of the night" who were getting ready for a busy evening.

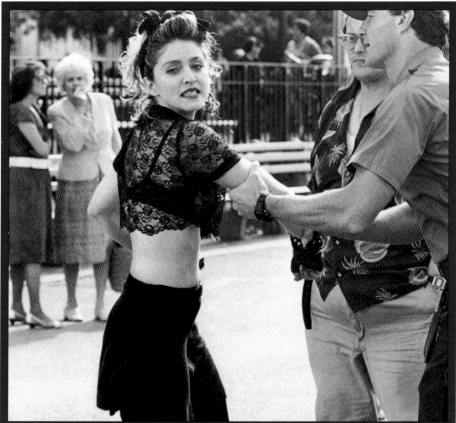

Madonna

DESPERATELY SEEKING SUSAN, 1985, SANTO LOQUASTO Desperately seeking the return of this Madonna: she's charming, sweet, energetic, and kooky, and wears the type of costumes synonymous with her original persona. She is the originator of the underwear-as-outerwear trend that lives on. Madonna said that as a young girl in a parochial school, she often hung upside down on the monkey bars to show off the wild underwear beneath her uniform. Costume designer Loquasto admittedly exploited Madonna's personal look: "There wasn't much room for change. I was enamored with her."

Christine Taylor

THE WEDDING SINGER, 1998, MONA MAY Designer May dressed the characters in this film in eighties attire in anticipation of a fashion comeback, which includes a world filled with Madonna wannabe's. Star Adam Sandler was the exception—he personified Sinatra's "Rat Pack" look of the fifties.

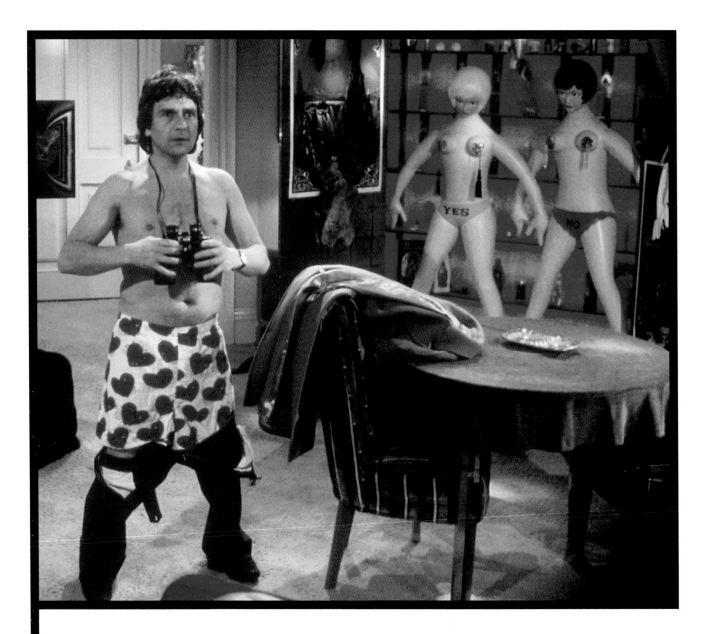

DUDLEY MOORE

FOUL PLAY, 1978 Director Colin Higgins spent hours dealing with the underwear that Dudley Moore's character, an orchestra conductor and closet pervert, would wear. The winner was a pair of boxers that Colin himself stenciled with hearts. Higgins wrote HAROLD AND MAUDE (1972) as a film school term paper and in the eighties was properly thanked by the studio, which had paid next to nothing for the script: Colin asked for and got a Mercedes limo—the price of a cult movie.

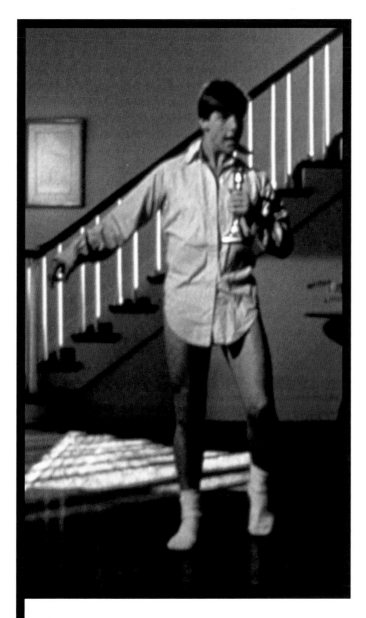

Annette Bening

THE AMERICAN PRESIDENT, 1995, GLORIA GRESHAM Changing into a man's shirt, sans underwear, is a more realistic nineties take on the seduction scene. Designer Gresham followed Aaron Sorkin's script: "SYDNEY comes back into the room . . . she's wearing one of Shepherd's dress shirts and nothing else. She walks toward him."

Tom Cruise

RISKY BUSINESS, 1983, ROBERT DE MORA Tom's character lives out his rock 'n roll fantasy by playing a guitar and dancing wildly to Bob Seger. Cruise is dressed only in his Jockey's and a white button-down, tails-out shirt. Tom insisted that the shirt cover his strategic parts, to the consternation of costume designer Bob de Mora. This scene and Tom became stars.

WORKING *G*
BOTH KINDS

Typewriters" were single women who worked in offices in the late 1800s, wearing skirts and blouses with removable collars and cuffs for easy maintenance. Although this was one of the first "good girl" jobs, working anywhere became taboo for a woman when she married. Early films depicted the working woman realistically, and in 1940, costume designer Renie showed Ginger Rogers in KITTY FOYLE wearing "typewriter" attire, including the small bow tie, which reappeared as a crucial working accessory of the eighties.

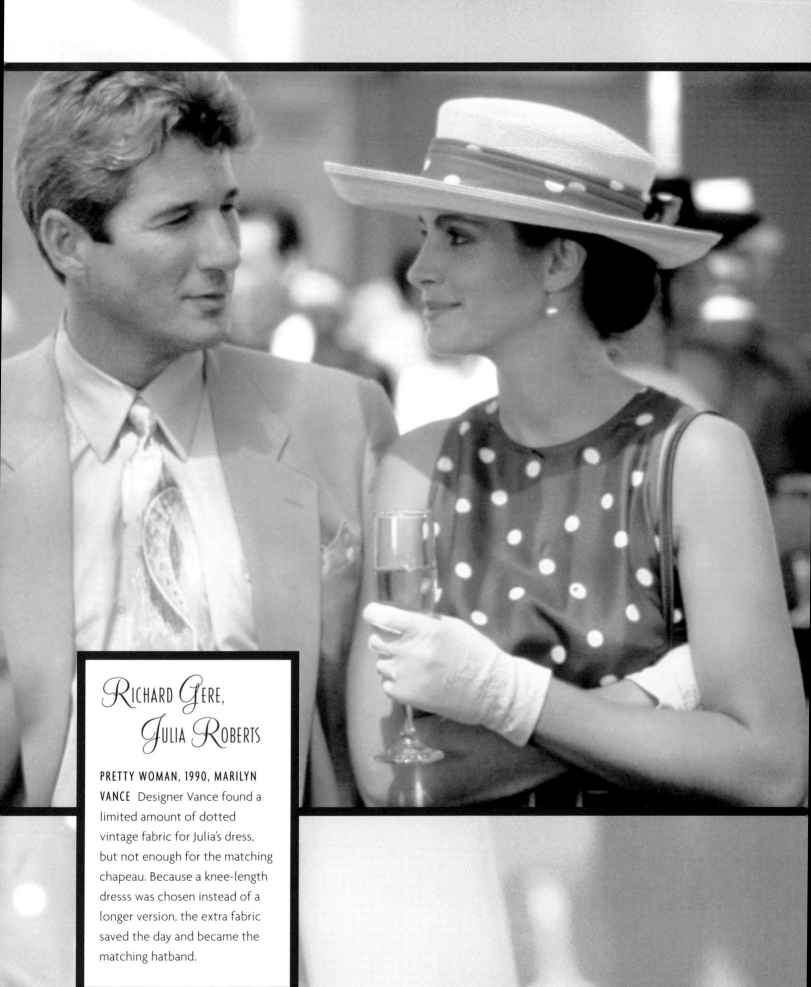

Richard Gere, Julia Roberts

PRETTY WOMAN, 1990, MARILYN VANCE Designer Vance found a limited amount of dotted vintage fabric for Julia's dress, but not enough for the matching chapeau. Because a knee-length dresss was chosen instead of a longer version, the extra fabric saved the day and became the matching hatband.

In the early films, as in real life, when a woman aspired to a position of authority, she was advised to dress like a man. What better way to do so than by wearing a structured dark or pinstriped suit with the ultimate accessory: shoulder pads. Adrian dressed Joan Crawford in these suits in the thirties and forties and then sold them to stores across the country. Because of their popularity, he later remarked, "Who would ever believe that my entire career rested on Crawford's shoulders?" Another of Adrian's popular designs was the smock maternity top he created for his wife, actress Janet Gaynor, in 1941.

In the fifties, traditional jobs for women included receptionist, clerk, typist, teacher, stenographer, nurse, secretary, and salesgirl. Today's list is endless, and movies such as THE AMERICAN PRESIDENT (1995) and AIR FORCE ONE (1997) show women in such diverse positions as environmental lobbyist and vice president of the United States.

Identification of "bad girls" by their clothing is now nearly impossible. The silver screen's tramps and trollops are dead, but their costumes are alive and well and worn by the general public: hot pants, minis, over-the-knee boots, and sheer clothing as daywear. In PRETTY WOMAN (1990), a Hollywood fairytale, Julia Roberts demonstrates upward mobility and economic gain by changing her attire: her character, hooker Vivian, goes from looking vulgar to demurely elegant and captures the heart of Edward, played by Richard Gere, her Cerruti-clad co-star.

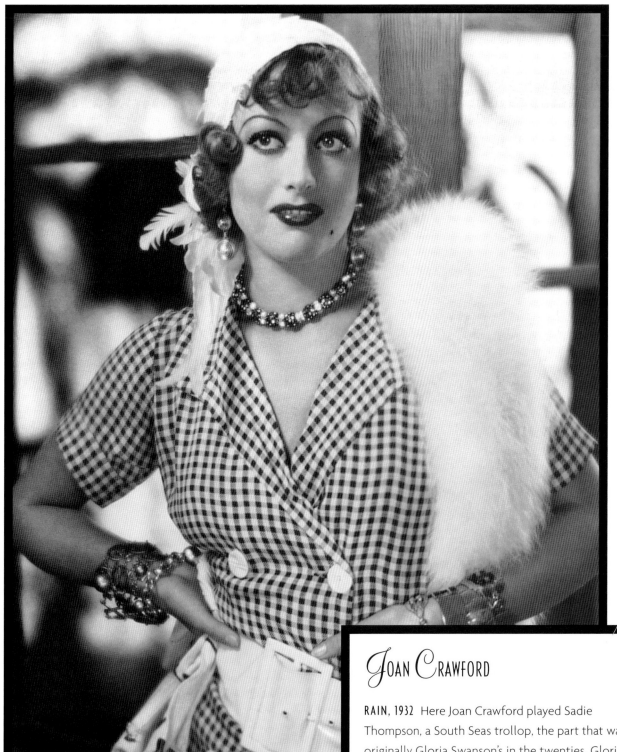

Joan Crawford

RAIN, 1932 Here Joan Crawford played Sadie
Thompson, a South Seas trollop, the part that was
originally Gloria Swanson's in the twenties. Gloria
complained ironically that Joan was overdressed
and looked "cheap." SADIE THOMPSON, the 1928
film on which RAIN was based, almost passed into
oblivion, unreleased, until Gloria and her friend
Joseph P. Kennedy applied pressure on the Hays
Office to allow its distribution.

Jon Voight, Sylvia Miles

MIDNIGHT COWBOY, 1969, ANN ROTH Sylvia Miles, playing a rich blond floozy, reminds hustler Jon Voight that she's "one hell of a gorgeous chick." Her short linen shift, "spring-a-lator" shoes, and printed bra were tossed aside for a few moments of sex. Afterward, she quickly throws on a black push-up bra, panties, and a minidress covered in black sequins and takes $20 from the cowboy for a taxi. Class act! This film is the only X-rated film to be awarded an Oscar for best picture.

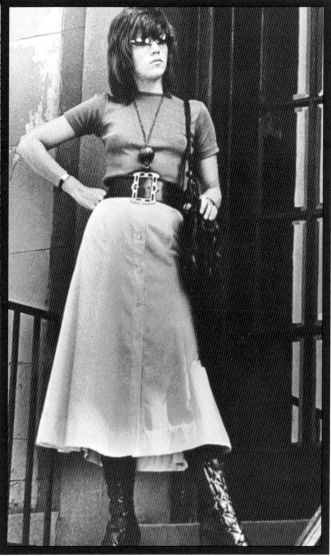

Jane Fonda

KLUTE, 1971, ANN ROTH Bree Daniels, played by Jane Fonda, looks like the classiest prostitute working. From mini to maxi, she's outstanding. It must have been those pre-video workouts.

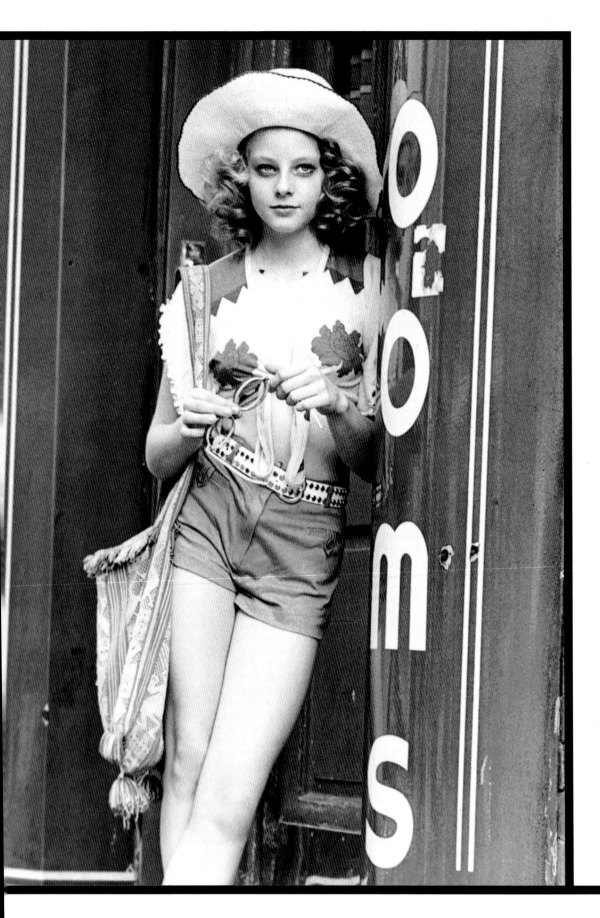

Jodie Foster

TAXI DRIVER, 1976, RUTH MORLEY Jodie Foster, then thirteen years old, played a twelve-year-old runaway prostitute wearing the fashion of the day, hot pants—the term coined by *Women's Wear Daily* in the early seventies. Jodie won the Oscar for best supporting actress, a long way from "Mayberry R.F.D.," her first acting job on television when she was six!

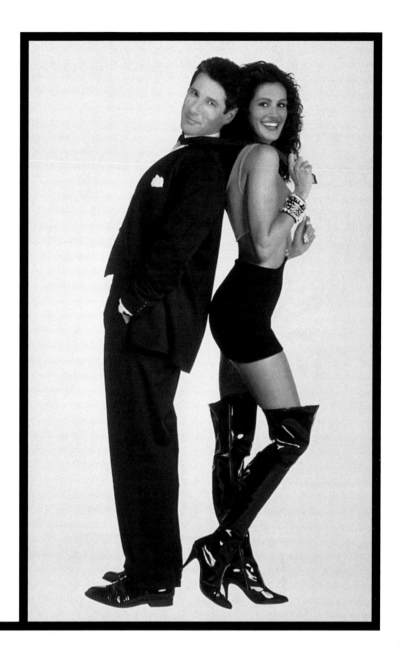

Richard Gere, Julia Roberts

PRETTY WOMAN, 1990, MARILYN VANCE, CERRUTI 1881 FOR RICHARD GERE Hollywood Boulevard hooker finds millionaire who sends her on a fantasy Rodeo Drive shopping spree until she catches him. This scenario must be contagious!

Dolly Parton AND THE GIRLS

BEST LITTLE WHOREHOUSE IN TEXAS, 1982, THEADORA VAN RUNKLE Miss Mona's (Dolly Parton) staff at the Chicken Ranch looks a lot like society ladies dressed for a benefit. According to costume designer Van Runkle, the fireworks on Dolly's beaded gown represented "exploding semen."

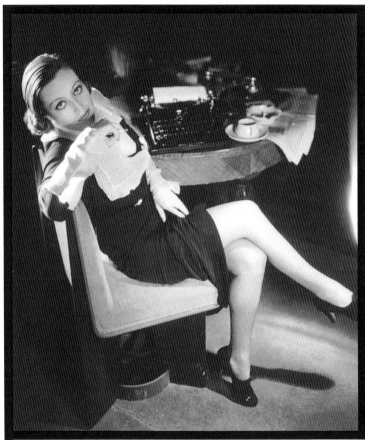

Greta Garbo

NINOTCHKA, 1939, ADRIAN "GARBO LAUGHS," as the headlines screamed, and maybe it's because she plays a Russian agent who wears sensible modern clothes for the first time instead of complicated ballgowns and corsets, as in past films. Also, one of her costars, Ina Claire, was married in the real world to Garbo's ex-lover, John Gilbert. In NINOTCHKA, they get to really fight over their man, and, of course, still look fashionable.

Joan Crawford

GRAND HOTEL, 1932, ADRIAN In her role as a cheap stenographer, Crawford was dressed by Adrian in dark colors and no jewelry, for drama. She insisted that her bra and girdle be eliminated to play up her character's sensuousness. Even her textured stockings look modern.

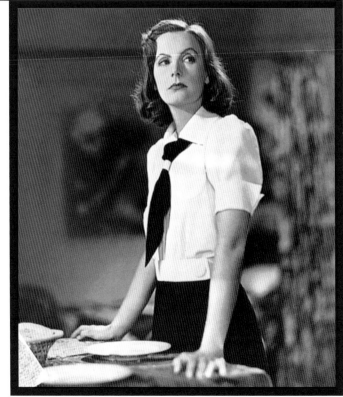

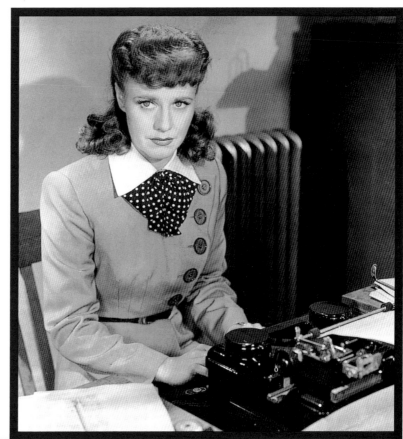

𝒦atharine 𝓗epburn

WOMAN OF THE YEAR, 1942, ADRIAN
Can you believe the year? Over a half
century ago !

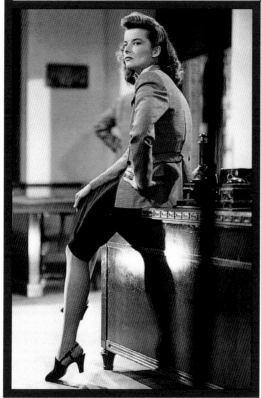

𝒢inger 𝓡ogers

KITTY FOYLE, 1940, RENIE This was an Academy Award
performance for a serious Ginger Rogers, wearing what
was to become standard working-girl attire. Costume
designer Renie said that her inspiration was Adrian's
look for Joan Crawford in GRAND HOTEL.

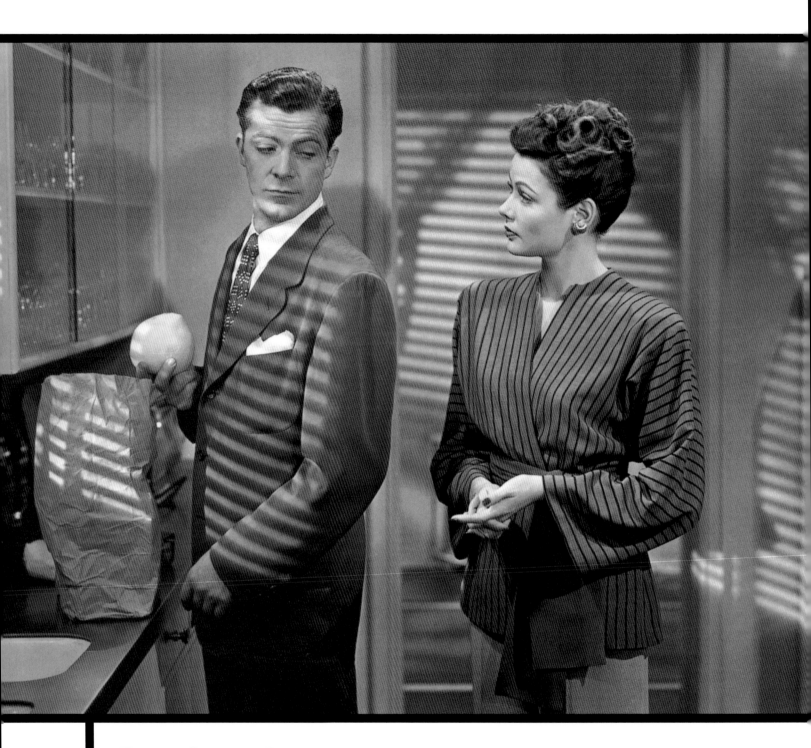

Dana Andrews, Gene Tierney

LAURA, 1944, BONNIE CASHIN LAURA was a film of obsession: dark, moody, and stylish. Dana Andrews, playing a detective, becomes obsessed with deceased Laura (Gene Tierney), a graphic designer. He stares at her portrait in a shadowy room while the Laura theme provides musical poignancy to the moment. A hot and bothered Andrews strips off his jacket and goes into Laura's bedroom, where he caresses her clothing and smells her perfume.

Loretta Young

THE FARMER'S DAUGHTER, 1947, EDITH HEAD
When Loretta Young won the Oscar for her performance as the Swedish maid who goes to Congress, she was dressed in an over-the-top green taffeta gown by Adrian, saying, "Up until now, presentations of the Academy Award had been a purely spectator sport for me. . . . However, tonight I dressed for the stage . . . just in case." In the film, her blond, braided hair reads "foreign," but her shoulder-padded costumes are timely and smart. Could the hair have inspired Princess Leia's cinnamon buns from STAR WARS (1977)?

Cary Grant, Rosalind Russell

HIS GIRL FRIDAY, 1940, ROBERT KALLOCH Rosalind Russell, playing a hard-nosed reporter with rapid-fire lines, wears a hat in every scene and, when on deadline, turns back the brim, à la Hollywood's newspapermen. She even chases an ex-con while clutching her hat and gloves in her hand. On the other side of the coin, Cary Grant's girlfriend wears sheer blouses, ruffles, and poufed baby doll boleros. Grant's double-breasted suits, with buttonhole carnation, and Ralph Bellamy's rubber galoshes round out this terrific fashion romp.

\mathcal{F}AYE \mathcal{D}UNAWAY

THE THOMAS CROWN AFFAIR, 1968, THEADORA VAN RUNKLE
Faye Dunaway plays a crackerjack insurance investigator, but her ultramod clothes and micromini hemlines were not in keeping with the female lead's character. Faye wanted her screen wardrobe to reflect her personal closet and argued this point over the objections of designer Van Runkle. Theadora foresaw the television industry's future interest in Hollywood films and feared that Faye's short hemlines would appear silly to future viewers. She was right.

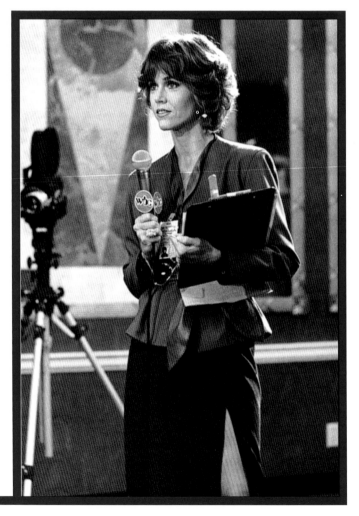

\mathcal{J}ANE \mathcal{F}ONDA

THE ELECTRIC HORSEMAN, 1979, BERNIE POLLACK Jane plays a television reporter chasing Robert Redford for a story. Her maxi-length skirt and textured stockings are typical of late-seventies dressing. At one point, Redford says, ". . . and now I'm carrying a crazy woman around, wearing shoes from Bloomingbirds." Notice the similarity between a television reporter's attire and Jane's prostitute outfit in KLUTE.

Jane Fonda, Lily Tomlin, Dolly Parton

NINE TO FIVE, 1980, ANN ROTH Remember when office attire meant a dress, heels, and stockings? And casual day probably meant flats.

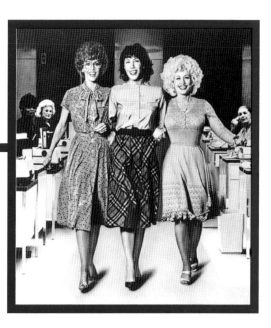

Goldie Hawn, Kurt Russell, Christine Lahti

SWING SHIFT, 1984, JOE I. TOMPKINS Because of wartime limitations on clothing and underwear (silk and rayon were used for the war effort), a woman's femininity could be expressed only by her makeup. Red lips sinking ships!

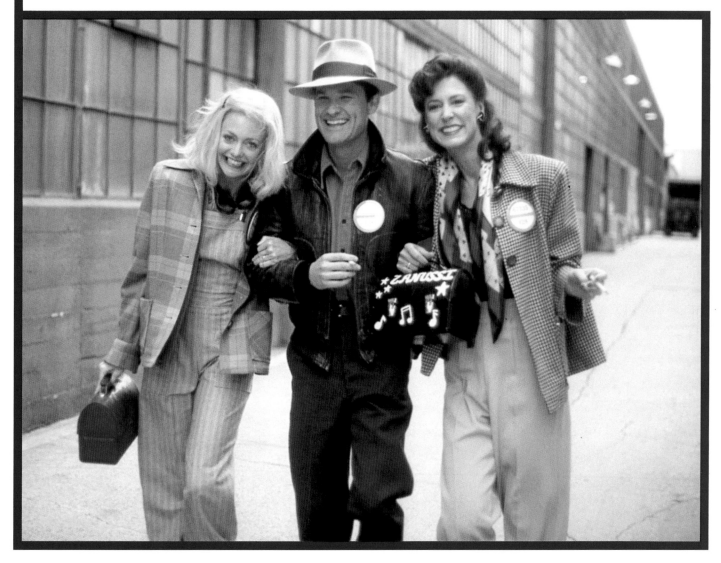

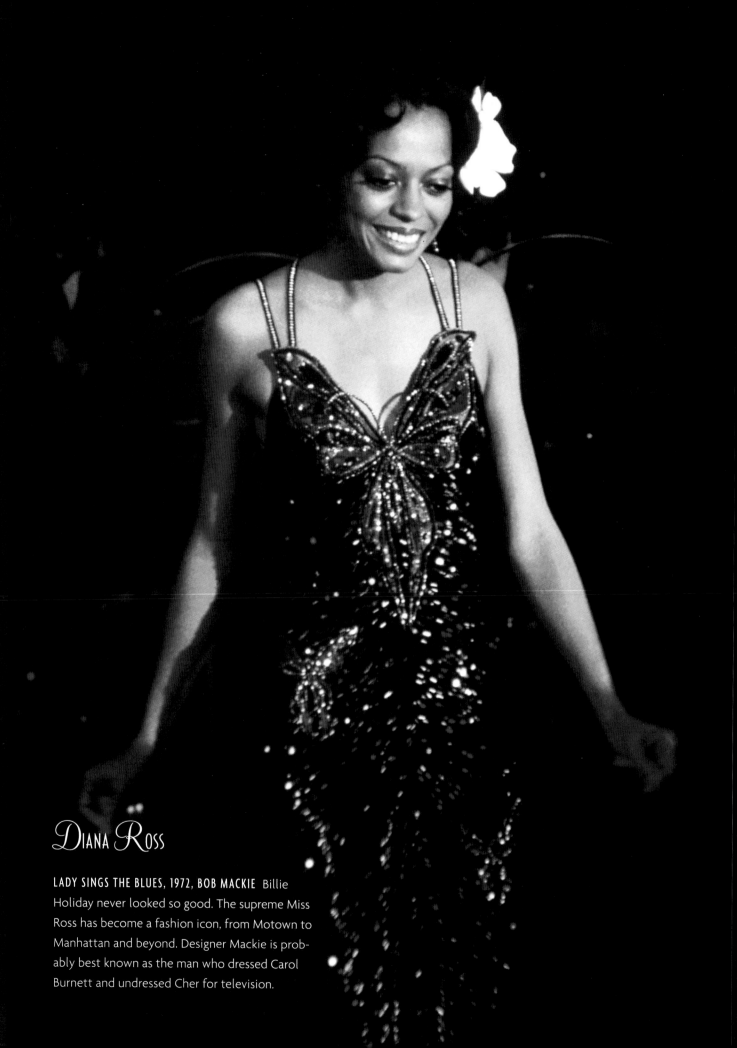

Diana Ross

LADY SINGS THE BLUES, 1972, BOB MACKIE Billie
Holiday never looked so good. The supreme Miss
Ross has become a fashion icon, from Motown to
Manhattan and beyond. Designer Mackie is prob-
ably best known as the man who dressed Carol
Burnett and undressed Cher for television.

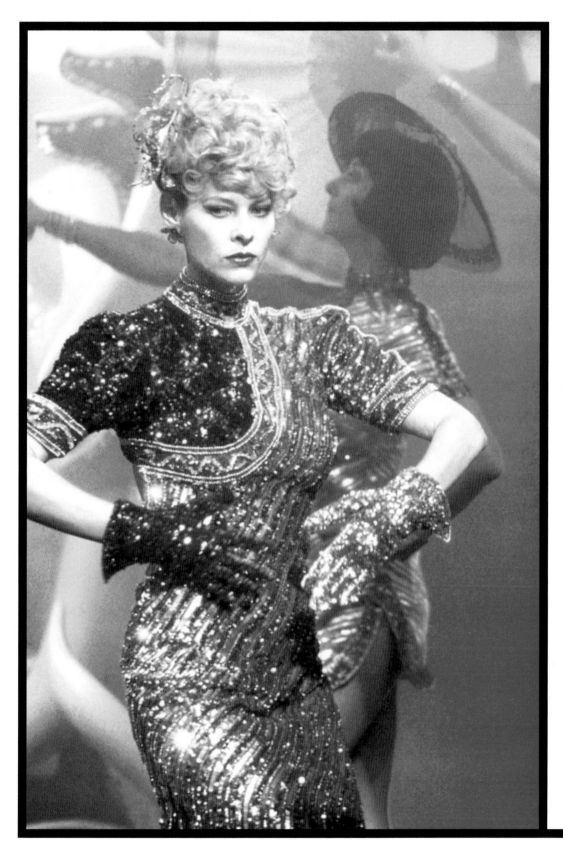

Kate Capshaw

INDIANA JONES AND THE TEMPLE OF DOOM, 1984, ANTHONY POWELL Kate Capshaw, playing a night-club singer, travels through muck and mire carrying her gown on her back, slinging it over an elephant's trunk and diving out of a plane with it: she risks her life to save her beaded dress.

Melanie Griffith

WORKING GIRL, 1988, ANN ROTH
Melanie Griffith reinvents her character, Tess, in her boss' closet, loses her fussy makeup and hairdo, becomes a success, then gets on her sneakers and catches Harrison Ford. Tess's tresses for success.

Diane Keaton

BABY BOOM, 1987, SUSAN BECKER, NINO CERRUTI FOR DIANE KEATON Taking baby to work must have been contagious for Diane Keaton, who personified the high-powered corporate woman in this film. Since she's a new mom, she can do the same in her personal life, sans the striped suit and blouse. Diane's still Annie Hall.

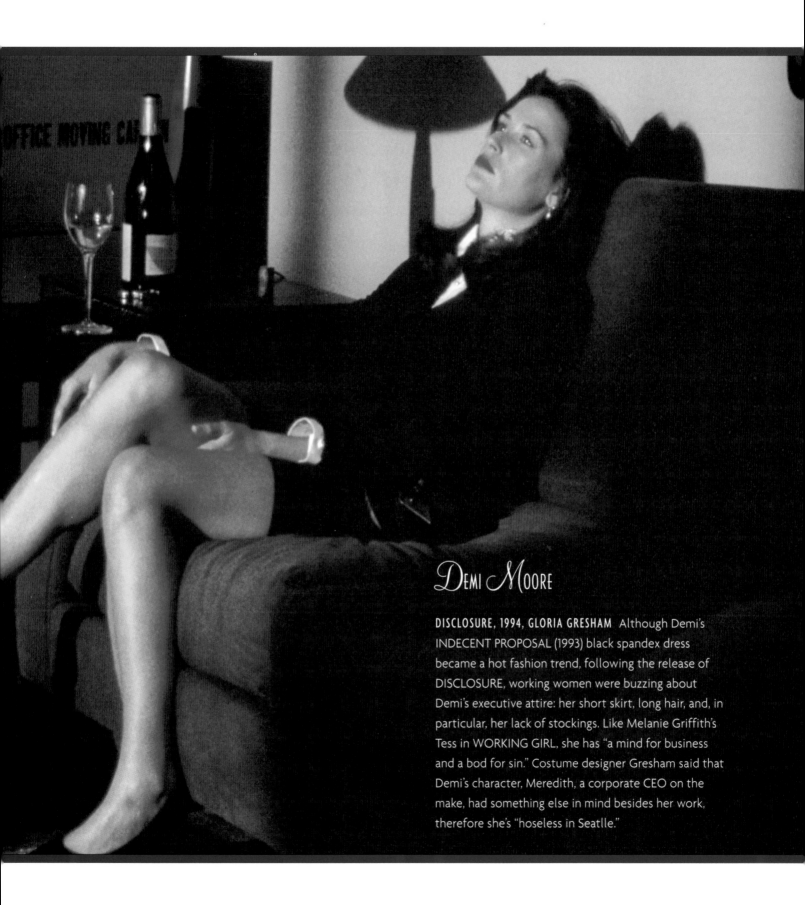

Demi Moore

DISCLOSURE, 1994, GLORIA GRESHAM Although Demi's INDECENT PROPOSAL (1993) black spandex dress became a hot fashion trend, following the release of DISCLOSURE, working women were buzzing about Demi's executive attire: her short skirt, long hair, and, in particular, her lack of stockings. Like Melanie Griffith's Tess in WORKING GIRL, she has "a mind for business and a bod for sin." Costume designer Gresham said that Demi's character, Meredith, a corporate CEO on the make, had something else in mind besides her work, therefore she's "hoseless in Seatlle."

Michael Douglas, Annette Bening

THE AMERICAN PRESIDENT, 1995, GLORIA GRESHAM Love in bloom in the White House . . . so what else is new? Designer Gresham said that the only First Lady who wore strapless gowns was Jackie Kennedy, and Gresham decided to create the same look for Annette because of her great shoulders and neck. Gloria loved the idea of midnight blue as the dress color, but how to keep it from looking black on camera was a problem. "I used very shiny, bright marine-blue fabric and then placed navy silk chiffon over it," she said. "The result was just what I wanted—dark blue with life."

Diane Keaton, Goldie Hawn, Bette Midler

THE FIRST WIVES CLUB, 1996 THONI V. ALDREDGE THE FIRST WIVES CLUB grossed $19 million its first weekend at the box office, the largest September opening in history. The woman's power suit in this film is definitely white. Obviously, success in the Big Apple is never having to worry about cleaning bills.

Frances McDormand

FARGO, 1996, MARY ZOPHRES The costuming of FARGO was an exercise in complete restraint, according to designer Zophres. The Coen brothers wanted Frances's coat to be made of cheap nylon, and to squeak and not move very well. It was found in a vintage shop, but the sheriff's maternity uniform was custom. (Frances wasn't really pregnant.)

Lisa Kudrow, Mira Sorvino

ROMY AND MICHELE'S HIGH SCHOOL REUNION, 1997, MONA MAY Mona's biggest challenge in a film geared to teens was to foresee "cool and hip" fashions a year in advance, when the costumes were being designed. Mira and Lisa's clothes were custom, not off-the-rack. In the film, Romy and Michele's trendy reunion attire opened the door to their future: a successful career in fashion.

PEACOCK

The motion picture industry gave young men an entrée into a world they never knew existed. By watching Fred Astaire in his white tie and tails, Bogie in his trench coat, and Cary Grant in his dapper double-breasted suits, anyone, from any walk of life, could gain confidence and the know-how associated with fashionable dressing.

Men's wardrobes on the screen, for the most part, were the personal property of the stars. For example, Cary Grant and Spencer Tracy provided their tailors with fabric swatches of their choice and then selected the style of their suits. Many copies were made of each, for the stars and their stand-ins,

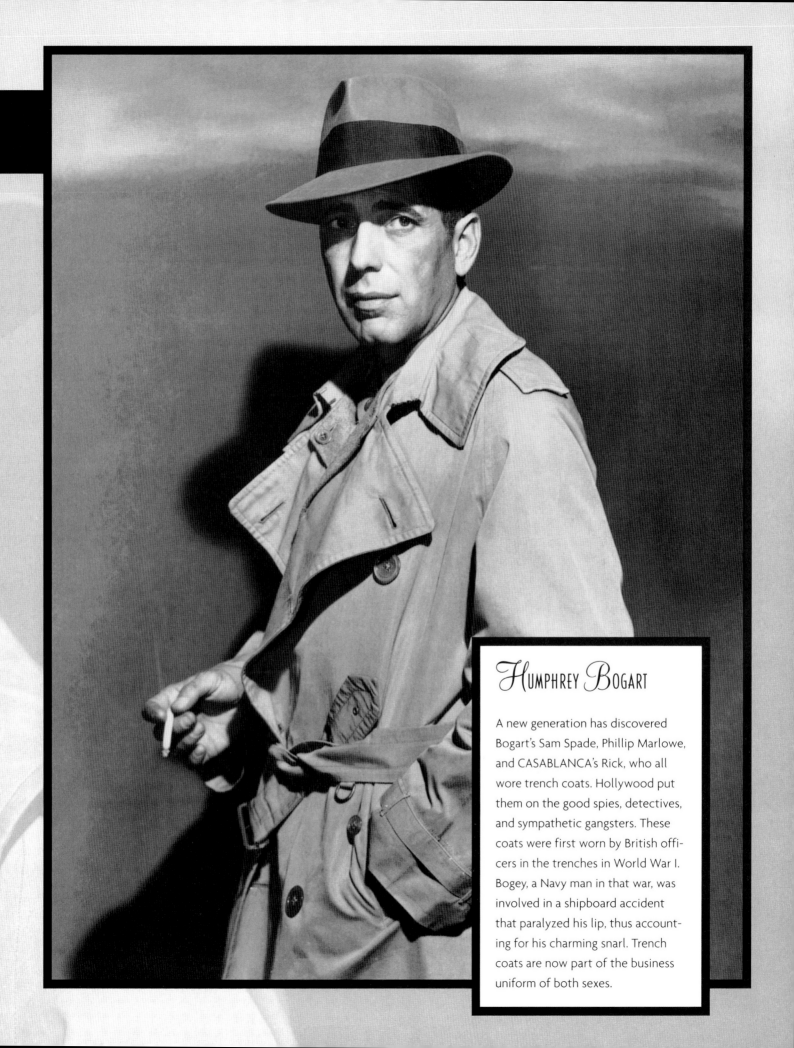

Humphrey Bogart

A new generation has discovered Bogart's Sam Spade, Phillip Marlowe, and CASABLANCA's Rick, who all wore trench coats. Hollywood put them on the good spies, detectives, and sympathetic gangsters. These coats were first worn by British officers in the trenches in World War I. Bogey, a Navy man in that war, was involved in a shipboard accident that paralyzed his lip, thus accounting for his charming snarl. Trench coats are now part of the business uniform of both sexes.

for which the studio gave no compensation. It is easier to categorize men's clothes than women's, and the styles adopted by most men, like those in the movies, can be stereotyped. To name a few:

"DAPPER DANS":
Cary Grant, William Powell, and Michael Douglas

"ROUGH AND READYS":
John Wayne, Clark Gable, Mel Gibson, and Bruce Willis

"REBELLIOUS YOUTHS":
James Dean, Brad Pitt, and Spike Lee

"THE NERDS":
Woody Allen and Robert Carradine

Jeff Buhai, co-creator of REVENGE OF THE NERDS (1984, 1987, and 1992) spoke out in defense of the nerd's floodpants and mismatched look: "The nerd is someone who is too smart to care about clothes." It sounds like Jeff is paraphrasing Edith Wharton in *The Age of Innocence:* "Is fashion a serious consideration? Yes, among people who have nothing serious to consider."

Fred Astaire often wore his own clothes in his films, and his elegance and style are still a barometer of men's formal attire. Hamish Bowles, *Vogue* magazine's European editor-at-large, enjoys dressing up in looks ranging from dandy to classic elegance. He says his inspiration is Louis Jordan in GIGI, Jeremy Brett in MY FAIR LADY, and Fred Astaire in anything. Black-tie dressing reappeared in the eighties thanks to the Reagans and the Carringtons of TV's "Dynasty" fame.

The classic look was the most pervasive until the fifties, when the bad boys—Brando's "wild ones" and Dean's "rebels"—took over, followed in the sixties by the "easy riders." It wasn't until AMERICAN GIGOLO (1980) that well-tailored menswear appeared. Hamish Bowles commented:

I think that AMERICAN GIGOLO was a staggeringly influential example of fashion. Giorgio Armani's costuming for Richard Gere established his name internationally and made it acceptable for heterosexual men to begin thinking about grooming and their clothing in seasonal fashion terms.

When a freakish fashion fad sweeps the country, it is often blamed on Hollywood, but never on the men. For example, a silly feathered hat for women does not compare to Harrison Ford's INDIANA JONES hat, although Indiana did risk his life to save it. The low-backed, tush-revealing Scaasi that Barbra Streisand wore at the Oscars in 1968 was far more over-the-top than Woody Allen's Nikes with his tux, but then, Woody's look became a trend and Barbra's didn't. And did the public talk about Gable's lack of an undershirt half as much as Harlow's lack of a brassiere?

NO. NO. NO. The subsequent popularity of these fashion statements proves that menswear seen on the screen has a more subtle influence on the public than an ad in the newspaper or magazine. Menswear moves at a snail's-pace compared to women's clothing. But, in the last centuries, it was reversed . . . the men were the peacocks.

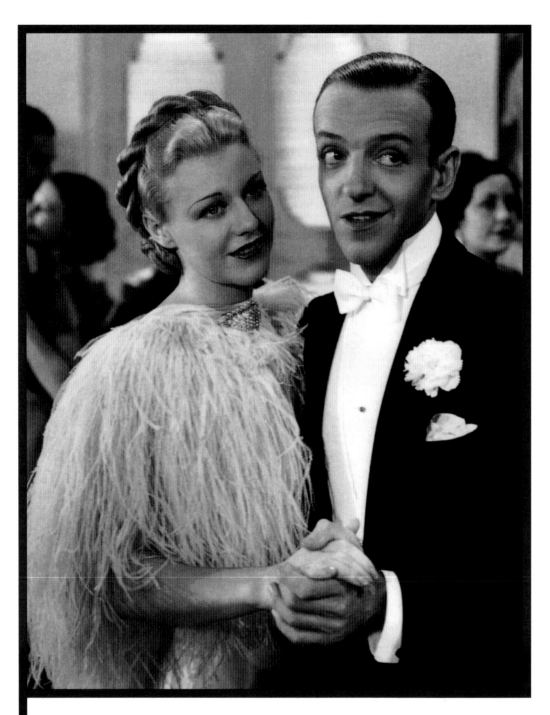

Ginger Rogers, Fred Astaire

TOP HAT, 1935, BERNARD NEWMAN The public loved Fred and Ginger, but Ginger's costumes were annoying to Astaire: her beaded sleeves almost knocked him out with their weight and her love of feathers exacerbated his allergies. Although ostrich feathers have long been fashionable since Eve spotted her first ostrich, they are high-maintenance. After each take, Fred's tuxedo had to be de-feathered. He once commented, "People think I was born in a top hat and tails."

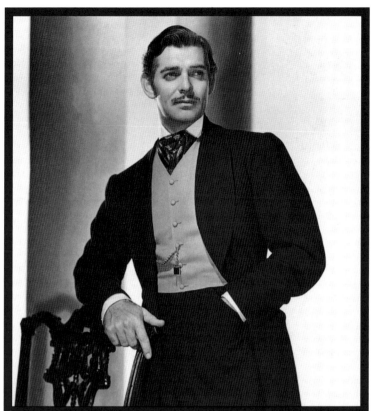

Leonardo DiCaprio

TITANIC, 1997, DEBORAH L. SCOTT *Titanic* was sinking, but Leonardo would have looked perfect no matter what, according to his fans, who multiplied as fast as box office receipts for the "film of the century." Designer Scott explained that it was difficult to reproduce the opulence of the period because of a limited costume budget. A few saving graces, she said, were finding authentic vintage pieces and working with talented tailors and beaders. TITANIC sailed away with eleven Oscars, including one for costume design, tying the record set by BEN HUR in 1959.

Clark Gable

GONE WITH THE WIND, 1939, WALTER PLUNKETT Clark Gable complained that he had more costume changes in GONE WITH THE WIND than any other actor in any film. There were 5,500 costumes in total and 36 for Gable alone. Another complaint Gable aimed at producer Selznick was his refusal to hire Gable's personal tailor for the fittings. Selznick relented after seeing the first costume tests. The fit and style of Gable's personal wardrobe was so much more attractive than the film costumes that Selznick instructed Walter Plunkett to design Rhett Butler's wardrobe more in the style of the thirties than that of the Civil War era. The fit of Gable's costumes was so tight that he could not sit down in them.

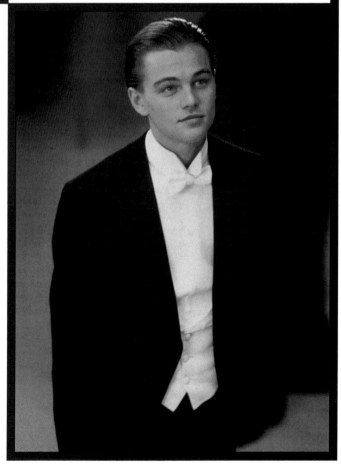

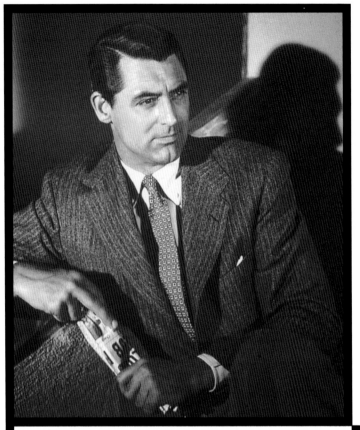

\mathcal{G}ARY \mathcal{C}OOPER

The star of so many favorite films, including A
FAREWELL TO ARMS, HIGH NOON, and LOVE
IN THE AFTERNOON, Cooper was tall, hand-
some, well-dressed, and a man of few
words . . . no wonder women loved him! In this
famous photo, Cooper's trousers are sup-
ported by suspenders, a fashion statement of
the day. Belts became a popular alternative in
the forties, so kids thought that only Grandpa
wore suspenders. They returned via Wall
Street in the eighties, but now with a new,
British name: braces.

\mathcal{C}ARY \mathcal{G}RANT

Simon Doonan, executive vice president of
creative services for Barneys New York, com-
mented, "At Barneys and elsewhere within
the clothing industry, Cary Grant and Fred
Astaire are still yardsticks for tailored ele-
gance, used by every window dresser when
coordinating men's merchandise for display."
Cary Grant wore striped and checkered suits,
accessorized with colored shirts and pat-
terned ties, a look that originated with
English "gents," the music-hall comedy
figures of the mid-nineteenth century.

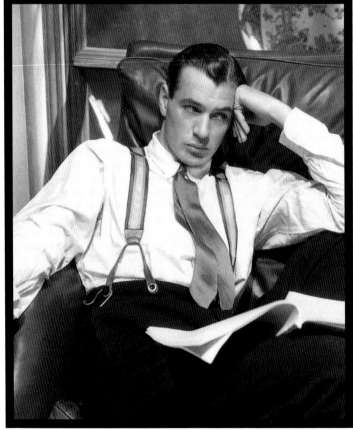

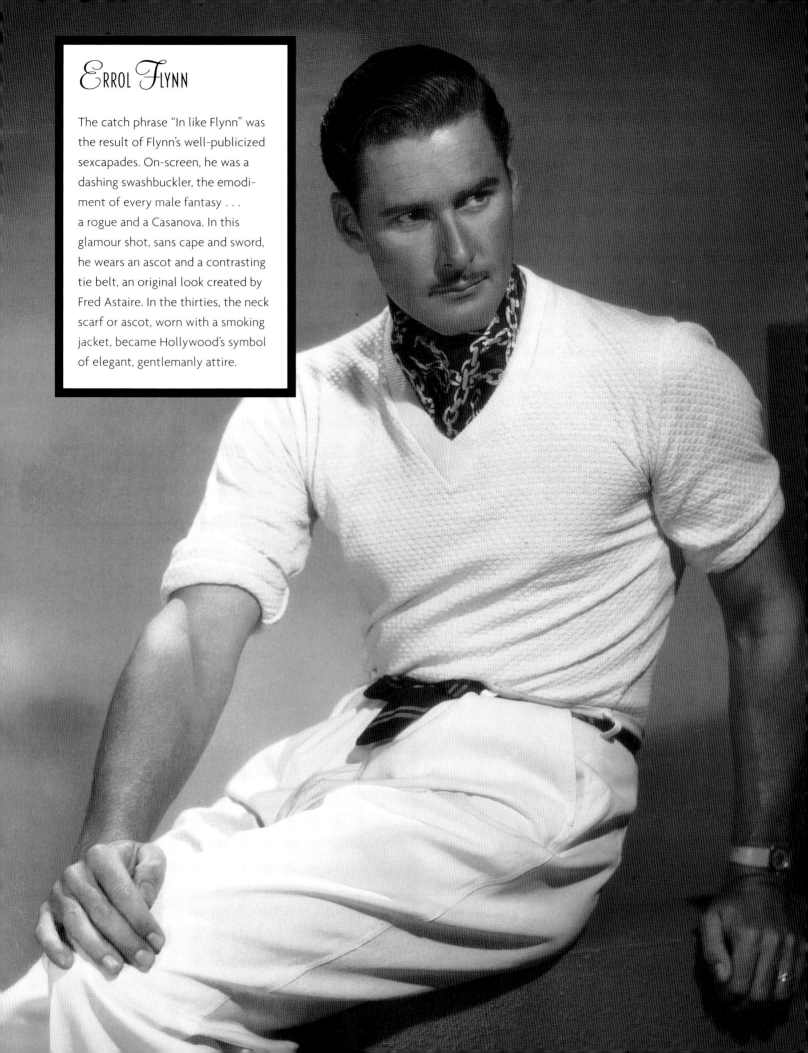

Errol Flynn

The catch phrase "In like Flynn" was the result of Flynn's well-publicized sexcapades. On-screen, he was a dashing swashbuckler, the emodiment of every male fantasy . . . a rogue and a Casanova. In this glamour shot, sans cape and sword, he wears an ascot and a contrasting tie belt, an original look created by Fred Astaire. In the thirties, the neck scarf or ascot, worn with a smoking jacket, became Hollywood's symbol of elegant, gentlemanly attire.

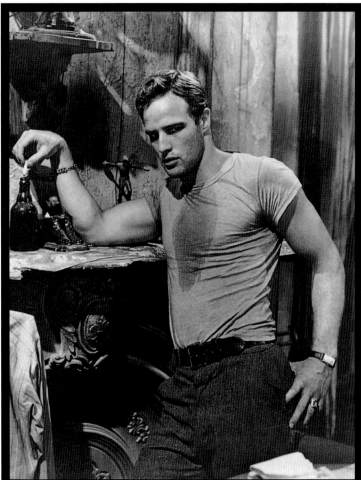

Marlon Brando

A STREETCAR NAMED DESIRE, 1951, LUCINDA BALLARD In 1966, Brando was quoted as saying, "I could've made more money if I'd sold torn T-shirts with my name on them . . . they would have sold a million." He once told James Dean to stop imitating his "slob" look of jeans and a tee—which became the unisex uniform of the late twentieth century.

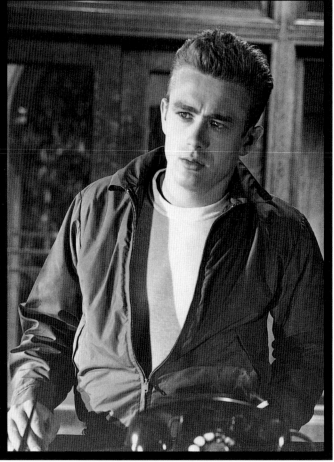

James Dean

REBEL WITHOUT A CAUSE, 1955, MOSS MABRY James Dean's large cult following is largely due to his performance in this film, and to his sad, premature death and the deaths of his co-stars. Richard Martin, costume curator of The Metropolitan Museum of Art, explained, "There is no doubt that the male rebels, James Dean and Marlon Brando, were highly influential for clothing that people could easily imitate." Dean's pose and clothes are the standards for today's Hollywood hunks.

Steve McQueen, Jacqueline Bisset

BULLITT, 1968, THEADORA VAN RUNKLE Steve wore turtlenecks and narrow-cut tweed jackets that became an instant hit because he had more sex appeal than anyone. Steve reinforced the popularity of the trenchcoat and brought it to a more casually dressed generation than Bogart's.

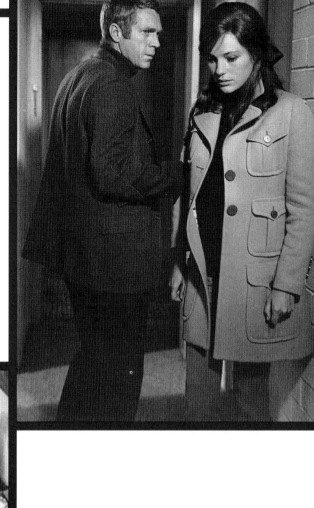

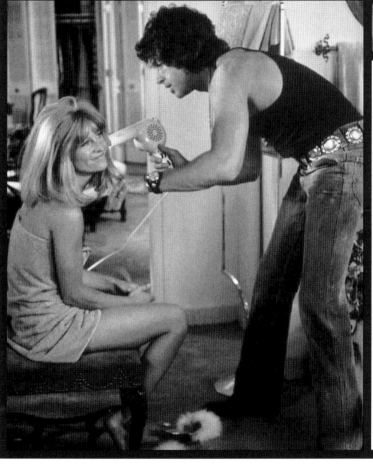

Julie Christie, Warren Beatty

SHAMPOO, 1975, ANTHEA SYLBERT George, played by Warren Beatty, was patterned after real-life hairdresser Gene Shacove, who did more than hair—but Warren looked better doing it. The financial success of this film and its overall popularity were not simply due to its focus on the beautiful people of Beverly Hills. After all, every city had its Georges . . . and, at that time, a salon where every head was done exactly the same. It succeeded because Warren had the style of the sixties: hiphuggers, tank tees, and ruffled shirts . . . and Julie Christie and Goldie Hawn and Lee Grant and Carrie Fisher.

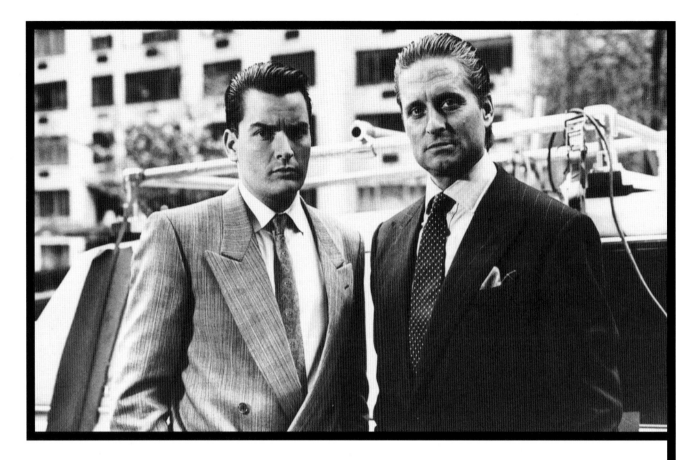

Charlie Sheen, Michael Douglas

WALL STREET, 1987, ELLEN MIROJNICK When receiving an Oscar for his role in this film, Michael Douglas said that Mirojnick, who worked with Nino Cerruti, had succeeded in showing that "clothes do make the man." The power suit, with its suspenders and dress shirt, was a look that not only continued to characterize Douglas's roles but also influenced a new standard of dress for men.

Woody Allen

SLEEPER, 1973, JOEL SCHUMACHER Costume designer Schumacher, who gave up designing for directing (BATMAN FOREVER, 1995), robotized Woody for the year 2173 and created the party scene as a sixties spoof. But in this film, ironically set in a world devoid of sex, the star is the "orgasmatron."

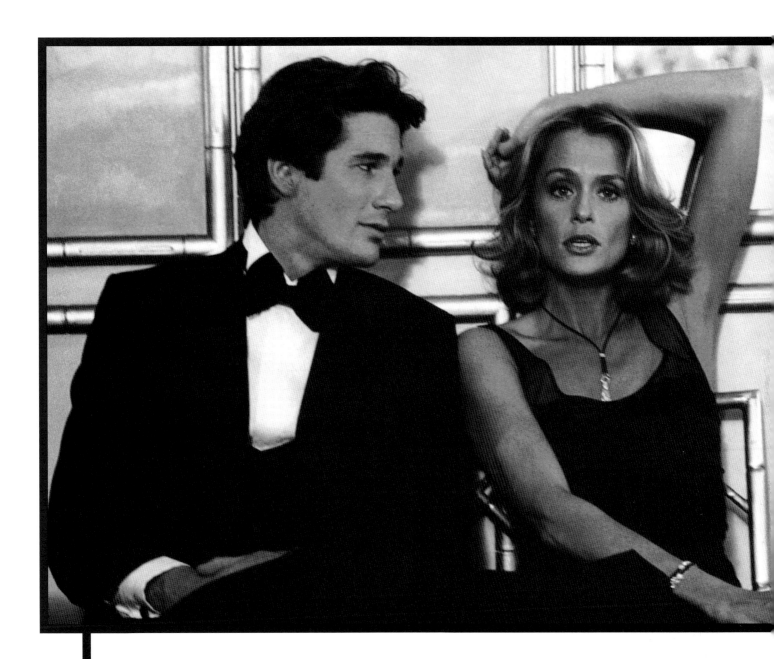

Richard Gere, Lauren Hutton

AMERICAN GIGOLO, 1980, ALICE RUSH, AND GIORGIO ARMANI FOR RICHARD GERE
Richard Gere was dressed by Armani and his dresser drawers were color-
coordinated, almost alphabetically, by none other than Gabriella Forte, now
the President and CEO of Calvin Klein. Gere's best fashion accessory was his
co-star, supermodel Lauren Hutton. Richard Martin, costume curator of The
Metropolitan Museum of Art, said, "The real moment of liberation for late-
twentieth-century menswear is the film AMERICAN GIGOLO."

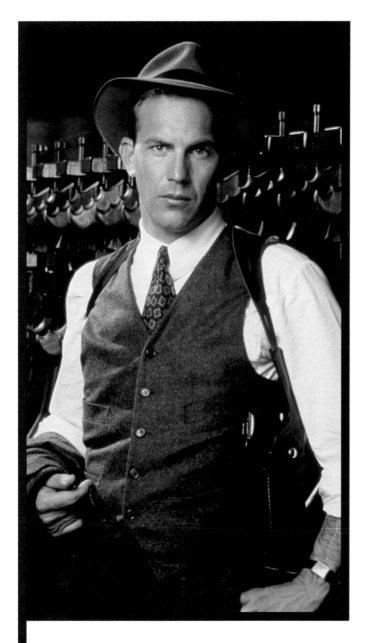

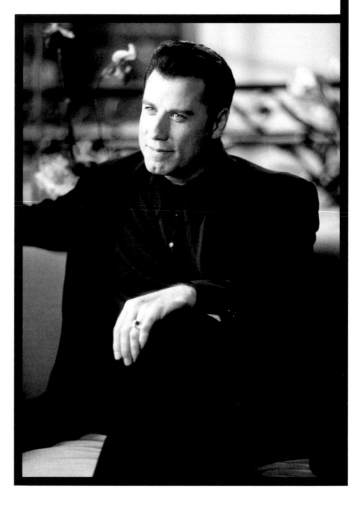

John Travolta

GET SHORTY, 1995, BETSY HEIMANN Elmore "Dutch" Leonard, who wrote *Get Shorty*, described Chili Palmer's dark suit and shirt in the novel, which costume designer Betsy Heimann followed to a "T." She said that if audiences like the character and the star, they want to wear that look. Dutch particularly loved Bette Midler's uncredited appearance in a black-and-yellow bumble bee suit, which stole the show.

Kevin Costner

THE UNTOUCHABLES, 1987, MARILYN VANCE For the shootout scene, a last-minute addition, costume designer Vance bought new suede and leather garments and, using original thirties patterns, reworked them so they looked appropriate for the time. The following year, Vance's look was seen in the Armani line.

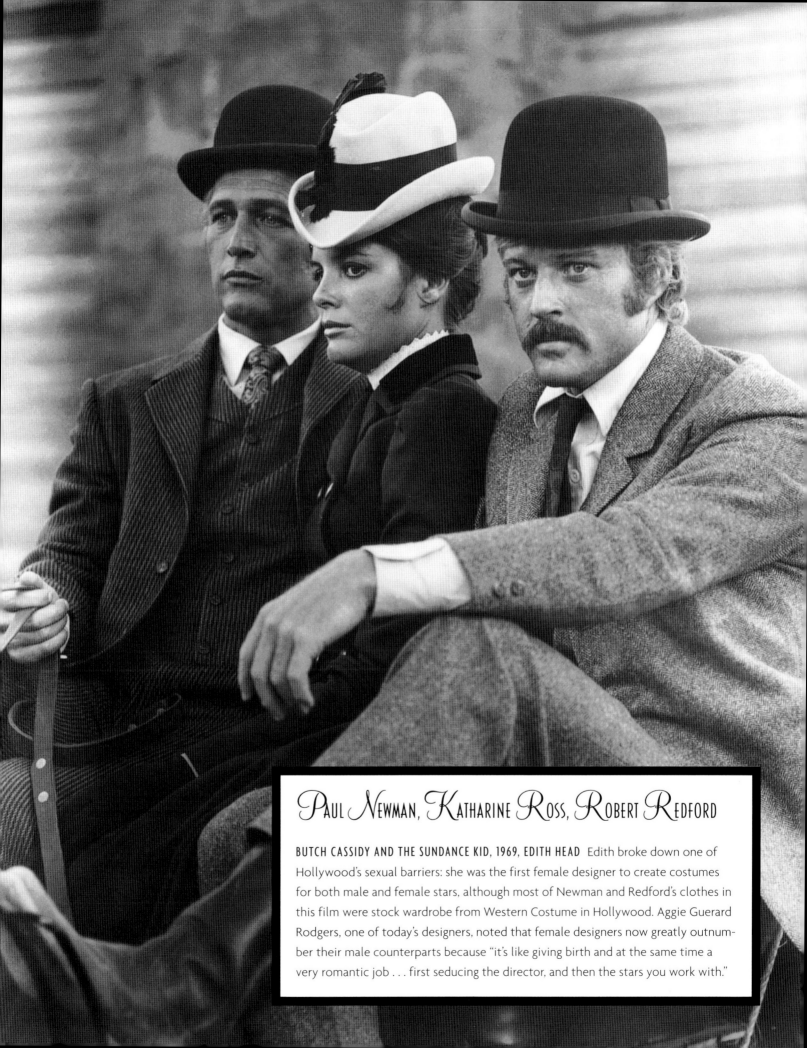

Paul Newman, Katharine Ross, Robert Redford

BUTCH CASSIDY AND THE SUNDANCE KID, 1969, EDITH HEAD Edith broke down one of Hollywood's sexual barriers: she was the first female designer to create costumes for both male and female stars, although most of Newman and Redford's clothes in this film were stock wardrobe from Western Costume in Hollywood. Aggie Guerard Rodgers, one of today's designers, noted that female designers now greatly outnumber their male counterparts because "it's like giving birth and at the same time a very romantic job . . . first seducing the director, and then the stars you work with."

Eddie Murphy, Martin Brest (Director)

BEVERLY HILLS COP, 1984, TOM BRONSON This is the trendsetting sweatshirt that put the school, Detroit's Mumford High, on the map and on everyone's back.

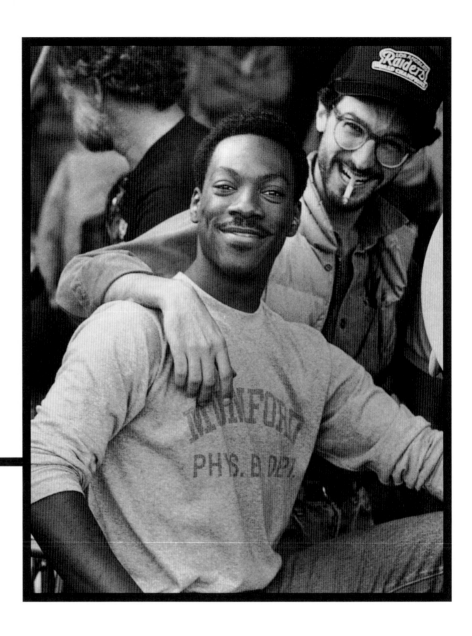

Dennis Hopper, Peter Fonda

EASY RIDER, 1969 "Mod" visits the Hell's Angels. In 1969, California motorcyclists were wearing leather jackets, the military look, and lots of facial hair, inspired first by the Beatles. Hopper's look in the film is right out of Sgt. Pepper's Lonely Hearts Club Band. Fonda and Hopper depicted their rebellion against corporate America and the return to a more idyllic lifestyle, the romanticized Hollywood version of the Old West.

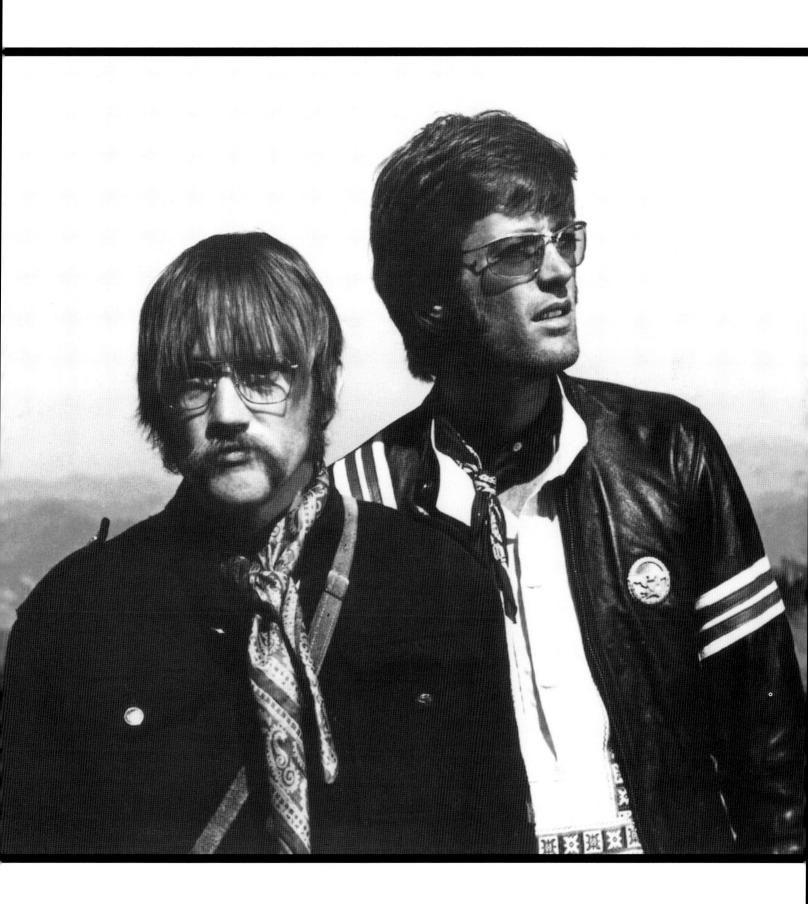

Tom Hanks, Elizabeth Perkins

BIG, 1988, JUDIANNA MAKOVSKY Charming and sweet describe both BIG and its star, Tom Hanks, who plays a twelve-year-old boy waking up one morning to find that he has a thirty-year-old body. When invited to his office party, he does what any little boy would do: he gets a white tux trimmed with lots of sparkly stuff. Everyone else, of course, is wearing dark suits and black dresses. But Tom is not embarrassed . . . he is just so naïve and so innocent and so adorable . . .

Warren Beatty

DICK TRACY, 1990, MILENA CANONERO Milena brought the comic strip characters to life, only larger and better and with more color. It was producer Beatty's idea to film true to the original strip, using only primary colors. Milena's inspiration for the Dick Tracy character was the work of German expressionists and their way of looking at strong colors. The fedora is a Stetson, while Burberry made all ten of Warren's trench coats in "yowee" yellow.

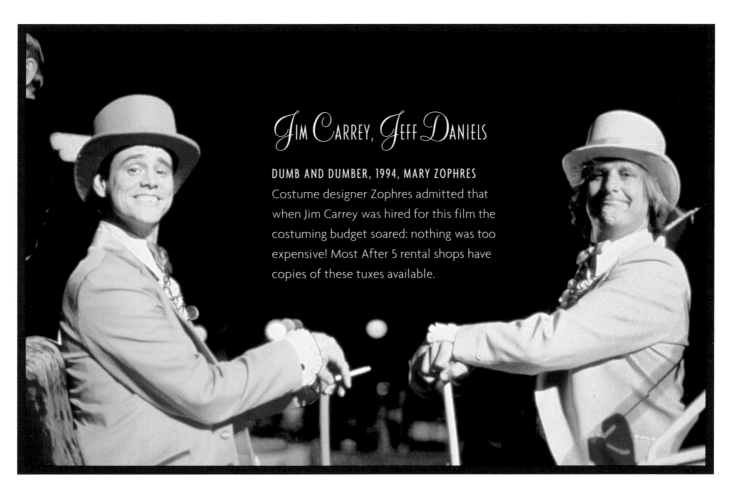

Jim Carrey, Jeff Daniels

DUMB AND DUMBER, 1994, MARY ZOPHRES
Costume designer Zophres admitted that when Jim Carrey was hired for this film the costuming budget soared: nothing was too expensive! Most After 5 rental shops have copies of these tuxes available.

Mike Myers and friends

AUSTIN POWERS, INTERNATIONAL MAN OF MYSTERY, 1997, DEENA APPEL Designer Appel's inspiration was Jane Fonda's BARBARELLA (1968) for costar Elizabeth Hurley, who wears the Appel/Paco Rabanne psychedelic look. Paco Rabanne is the French couturier who, in the riotous sixties, started making minis out of plastic discs. Instead of needle and thread, he used pliers to fasten them. Mike Myers, as Austin Powers, was dressed creatively in lace cuffs and velvet suits, but what's under his shirt steals the show.

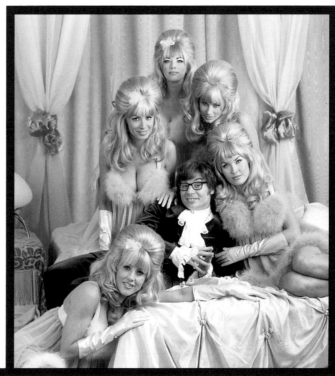

H IN DRAG

When I put together Josephine in SOME LIKE IT HOT, I thought of Grace Kelly, my mother, and a little of Eve Arden.

— *Tony Curtis*, 1996

When the movies show a man dressed as a woman, it gets a big laugh, but when a woman dresses like a man, everyone loves her, and her style can become a fashion trend. Marlene Dietrich's tuxedo dressing in the thirties was, no doubt, an inspiration for Yves Saint Laurent's "Le Smoking" tuxedos for women, which debuted in 1966.

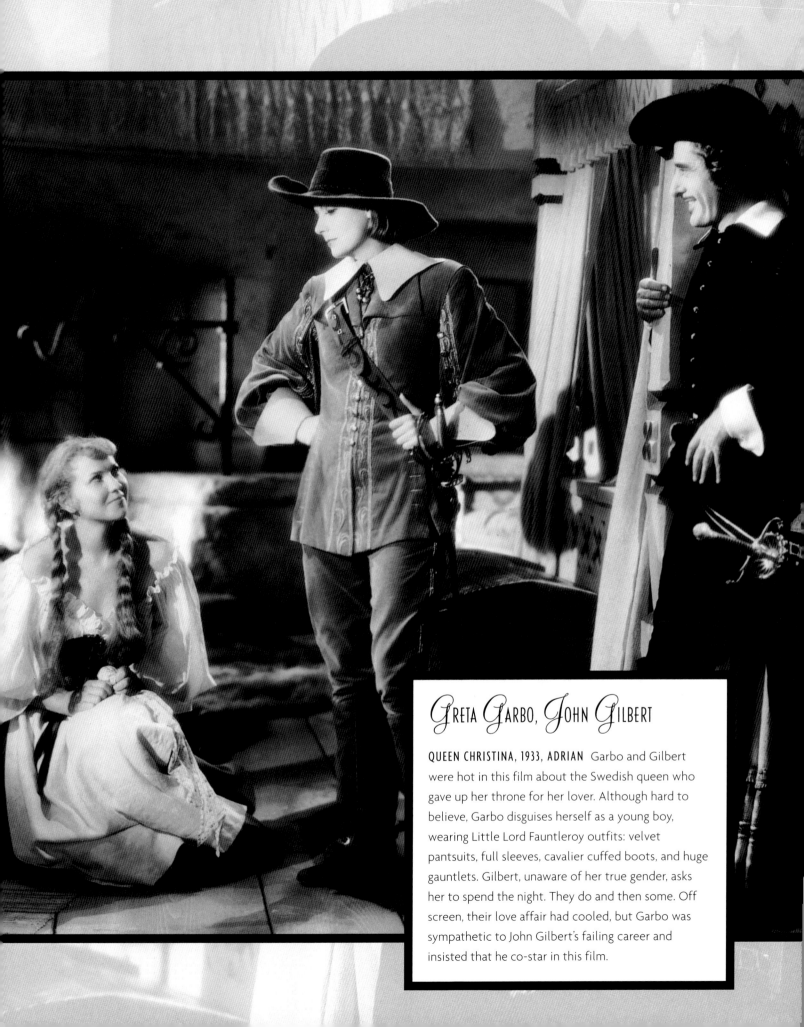

Greta Garbo, John Gilbert

QUEEN CHRISTINA, 1933, ADRIAN Garbo and Gilbert were hot in this film about the Swedish queen who gave up her throne for her lover. Although hard to believe, Garbo disguises herself as a young boy, wearing Little Lord Fauntleroy outfits: velvet pantsuits, full sleeves, cavalier cuffed boots, and huge gauntlets. Gilbert, unaware of her true gender, asks her to spend the night. They do and then some. Off screen, their love affair had cooled, but Garbo was sympathetic to John Gilbert's failing career and insisted that he co-star in this film.

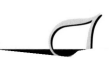

Conversely, as Valerie Steele, chief curator of the museum at the Fashion Institute of Technology in New York, has said, "Cross-dressing in the movies can be used to signify sexual perversion and, by extension, mental instability. Thus, in Brian De Palma's film DRESSED TO KILL (1980), the murderer turns out to be a cross-dressing psychiatrist."

Andy Warhol was always fascinated with drag both on a personal and professional level. His "factory" in the sixties included transvestites Candy Darling, Holly Woodlawn, and Jackie Curtis, who starred in his film WOMEN IN REVOLT. In the seventies, Warhol made composites of movie stars, trying to create the ideal woman using Garbo's lips and Sophia Loren's eyes. Divine, one of Warhol's entourage, said, "People don't even know the meaning of the word transvestite. I don't live in drag. Now, Candy Darling was a transvestite, and a beautiful one. But I don't sit around in negligees and I don't wear little Adolpho suits to lunch. Of course, if I had a couple of Bob Mackie outfits, things might be different."

Cary Grant often wore women's clothes, such as a marabou-trimmed negligee in BRINGING UP BABY (1938). In THE MISSOURI BREAKS (1976) Marlon Brando speaks with an Irish accent and wears a dress; but Bing Crosby's refusal to cross-dress in WHITE CHRISTMAS (1954) almost resulted in cancellation of the film. In the early films, most of the cross-dressers were women, but today they are predominantly men: lovable characters like Dorothy Michaels (Dustin Hoffman) in TOOTSIE, and MRS. DOUBTFIRE, played by Robin Williams. As a result of the popularity of these characters and films, cross-dressing is no longer considered a perversion. It is now acceptable to mainstream audiences. Has the moviegoing public become so attuned to cross-dressing that "Mr. Macho" next door can now wear his bra and panties while watering his garden, without his neighbors going into shock or calling the police?!

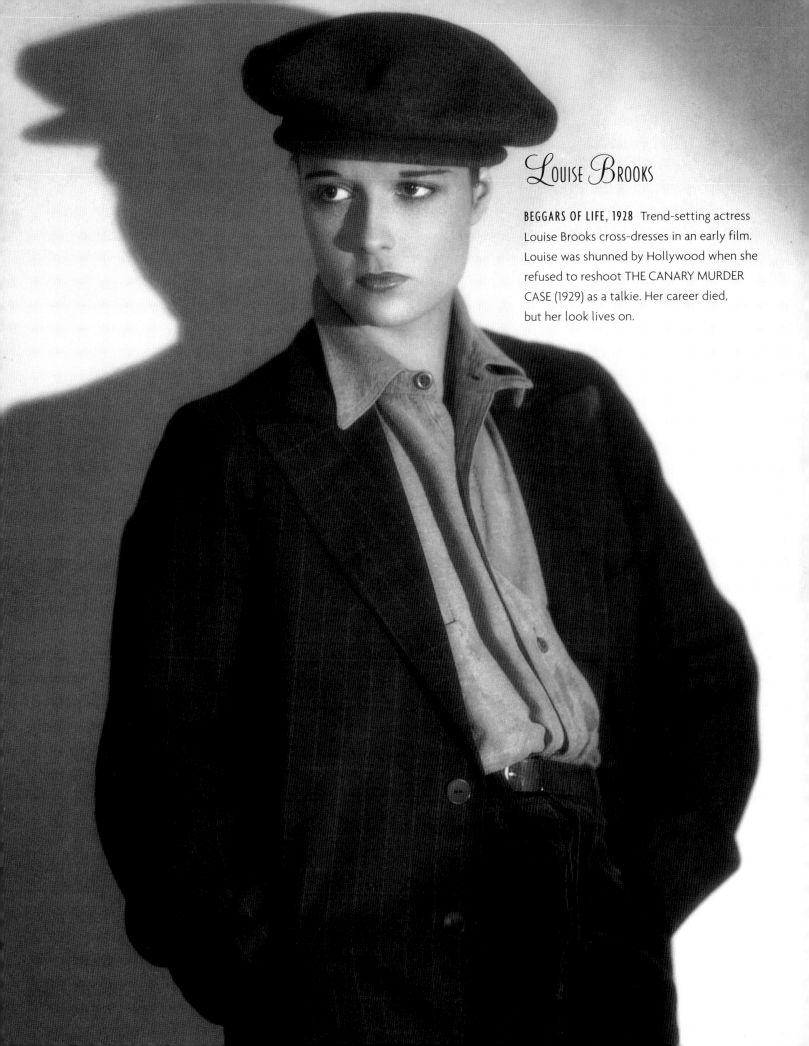

Louise Brooks

BEGGARS OF LIFE, 1928 Trend-setting actress Louise Brooks cross-dresses in an early film. Louise was shunned by Hollywood when she refused to reshoot THE CANARY MURDER CASE (1929) as a talkie. Her career died, but her look lives on.

Antonio Moreno, Marion Davies

BEVERLY OF GRAUSTARK, 1926 Antonio Moreno eventually discovers Marion Davies's true sex in this silent film bankrolled by Davies's real-life lover, newspaper magnate William Randolph Hearst. Marion's talent as an actress was long a figment of his imagination. Orson Welles's CITIZEN KANE (1941) was a take-off on the life of Hearst and his relationship with Davies.

Mary Pickford

KIKI, 1931 Another big fad of the twenties was curled hair, à la Mary Pickford, but in 1928, she cut off the curls. She was one of the few stars to make the successful transition to talkies. In KIKI she succumbed to the current craze for singing and dancing in masculine attire. She originally wanted to study fashion design in case her film career failed.

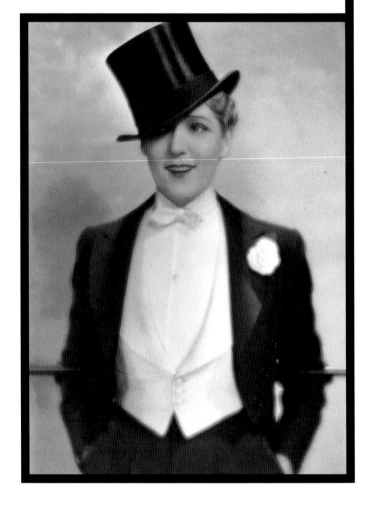

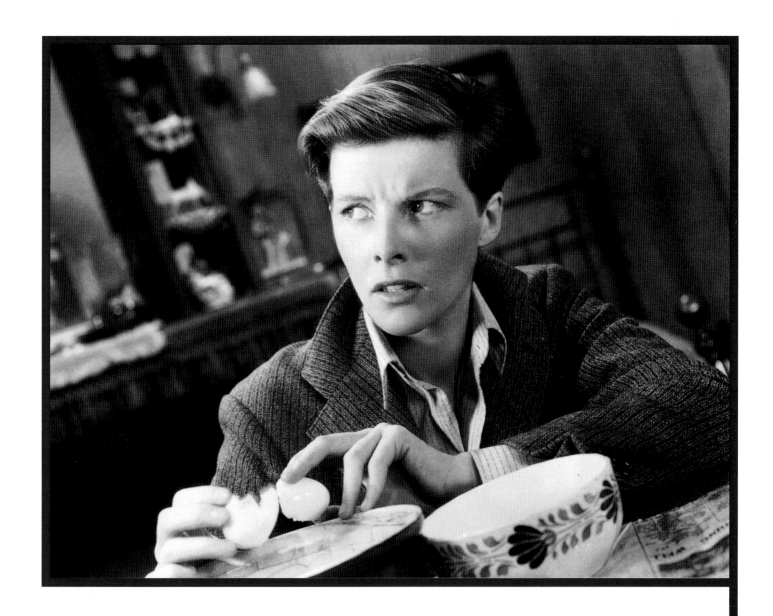

Katharine Hepburn

SYLVIA SCARLETT, 1935, MURIEL KING Although Hepburn is more convincing than some as a boy, the audience at the preview hated this film: Hepburn and her father take the high road with Cary Grant in a touring show. Director George Cukor and Hepburn offered producer Pandro Berman a deal: they would do another movie for him at no salary. He declined to ever work with them again. Although this film was considered an embarrassment, it became a cult classic on college campuses in the sixties.

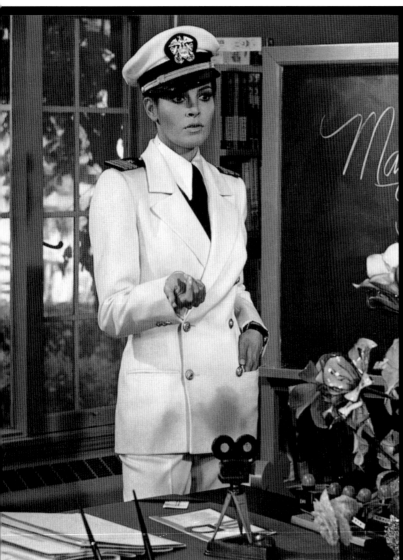

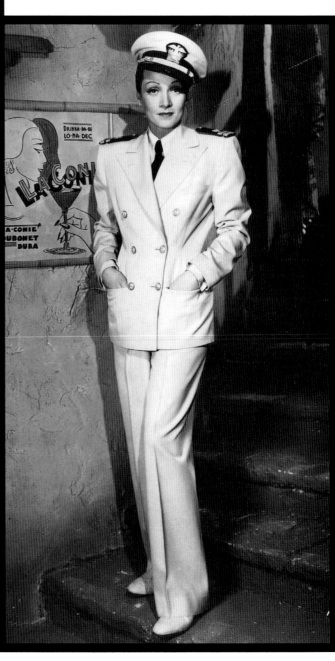

MYRA BRECKINRIDGE, 1970, THEADORA VAN RUNKLE
This was Theadora's homage to Marlene, whom she had met in a fabric store in Los Angeles while working on this film.

Marlene Dietrich

SEVEN SINNERS, 1940, IRENE FOR MARLENE DIETRICH Here's Dietrich, as a flamboyant singer, wearing the kind of Marlene clothes that recall her character in earlier movies: a floozy with class. In naval drag, she's the best, chanting, "You can bet the man's in the navy." Off screen, Dietrich much preferred dressing in pants, arguing that dresses had no longevity.

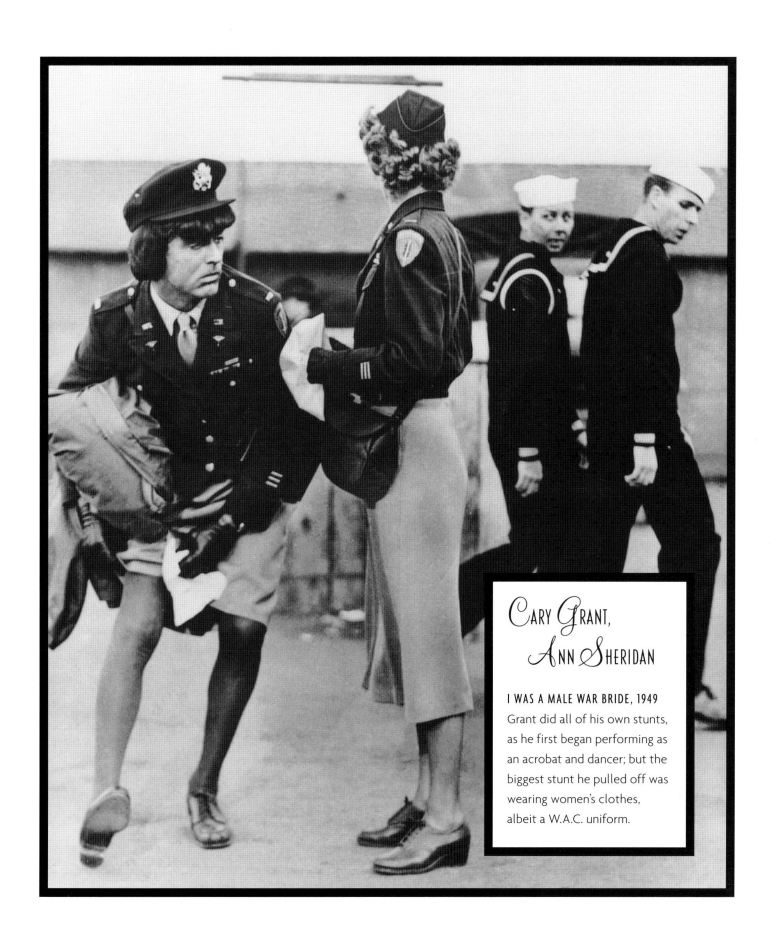

CARY GRANT, ANN SHERIDAN

I WAS A MALE WAR BRIDE, 1949
Grant did all of his own stunts, as he first began performing as an acrobat and dancer; but the biggest stunt he pulled off was wearing women's clothes, albeit a W.A.C. uniform.

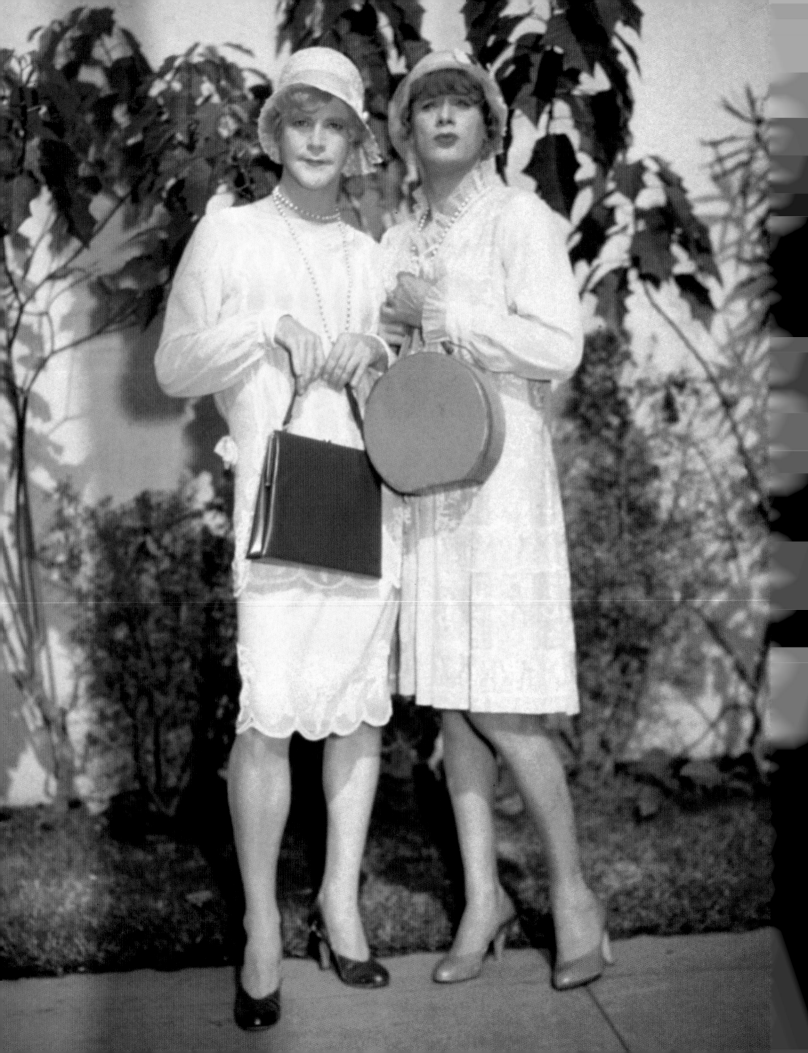

ℛobert ℘reston, ℐulie ℐndrews

VICTOR/VICTORIA, 1982, PATRICIA NORRIS First the original Mary Poppins, Julie Andrews, exposes her breasts in S.O.B. (1981); then she cross-dresses but still retains her enormous popularity. Julie comes back to play the role in VICTOR / VICTORIA on Broadway fifteen years later, her perfect body kept under wraps once more.

ℬarbra ℛreisand

YENTL, 1983, JUDY MOORCROFT Barbra disguises herself as a boy to get an education at the turn of the century. Lots of great music in this film . . . but Streisand as a boy? *Oy vey . . .*

ℐack ℒemmon, ℐony ℭurtis

SOME LIKE IT HOT, 1959, ORRY-KELLY Tony and Jack looked incredible in their flapper dresses, but buxom co-star Marilyn Monroe (she was pregnant at the time) did not look like an authentic flapper in her costumes. Her hair and makeup reflected the fifties while the "girls," Jack and Tony, with their cupid-bow lips and marcelled hair, were just perfect for the twenties. Makeup artist Dorothy Pearl explained that because color film exposes every pore, it was more difficult to cover Dustin Hoffman's stubble in TOOTSIE (1982) than it would have been to cover Tony and Jack's in SOME LIKE IT HOT, a black-and-white film that was supposed to have been shot in color. However, unlike the film, the stills were shot in color.

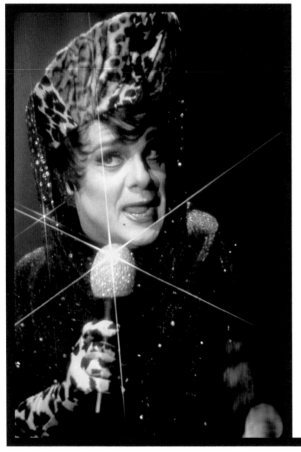

Terence Stamp

THE ADVENTURES OF PRISCILLA, QUEEN OF THE DESERT, 1994, LIZZY GAR-
DINER, TOM CHAPPEL Two drag queens and a transsexual wear the
outrageous costumes designed by Lizzy Gardiner, now famous for
the outrageous American Express Card dress she wore to the Oscars
in 1995.

Nathan Lane

THE BIRDCAGE, 1996, ANN ROTH, ROBERT DE MORA "This costume is a com-
bination of Hedy Lamarr's ALGIERS look and Swanson's Norma
Desmond thrown in a blender—and out came this drag queen," said Bob
de Mora. In another scene, where co-star Christine Baranski reminisces
about "that night" with Robin Williams, director Mike Nichols first
requested that designer Roth dress Baranski in Pucci pants. But when
Nichols had a change of heart and wanted to see legs, no skirt could be
found. Christine saved the day by wearing her own.

Jaye Davidson

THE CRYING GAME (BRITISH PRODUCTION), 1992, SANDY POWELL
This movie is living proof that drag dressing camouflages every little thing. Powell was an Oscar nominee for best costume design for WINGS OF THE DOVE (1997), in which she re-created the silks and velvets of designer Mariano Fortuny's Venice of the early 1900s.

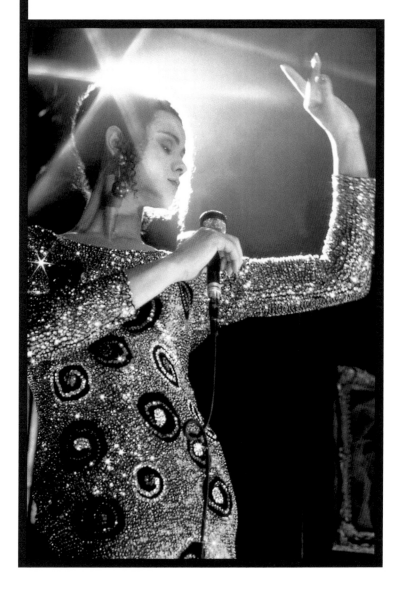

Robin Williams

MRS. DOUBTFIRE, 1993, MARIT ALLEN Robin Williams convincingly played a British housekeeper, and his makeup won an Oscar, a relatively new category for the Academy Awards. Robin's wardrobe was not as stylish as Dustin's in TOOTSIE, which caused cross-dressers to be cross.

CONNECTION

While haute couture designer Elsa Schiaparelli was creating the Duchess of Windsor's "Lobster Dress" in Paris in 1937, Adrian was putting blinking eyes on Roz Russell's chest and shooting stars on the shoulders and headdresses of Lana Turner and Hedy Lamarr in Hollywood. But, whose designs were seen the most? Whose designs were talked about the most? And whose designs were copied the most? Adrian's, *not* Schiaparelli's.

Was the one designer more talented than the other? That's like comparing Garbo and Dietrich. Adrian and Schiaparelli both were designing clothes, but that is where the similarity ended.

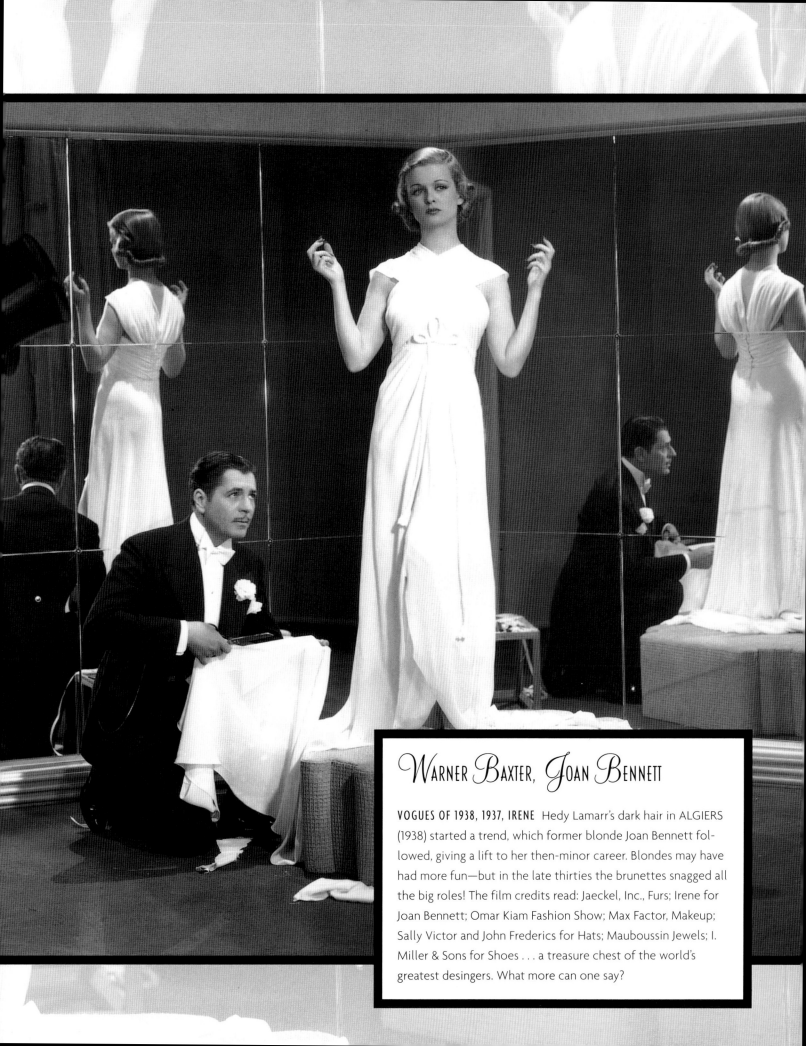

Warner Baxter, Joan Bennett

VOGUES OF 1938, 1937, IRENE Hedy Lamarr's dark hair in ALGIERS (1938) started a trend, which former blonde Joan Bennett followed, giving a lift to her then-minor career. Blondes may have had more fun—but in the late thirties the brunettes snagged all the big roles! The film credits read: Jaeckel, Inc., Furs; Irene for Joan Bennett; Omar Kiam Fashion Show; Max Factor, Makeup; Sally Victor and John Frederics for Hats; Mauboussin Jewels; I. Miller & Sons for Shoes . . . a treasure chest of the world's greatest desingers. What more can one say?

Adrian studied under French couturier Paul Poiret; his early designs brought Poiret's orientalism to the screen and to the attention of the American public. The legendary Ballets Russes first came to Paris in 1909, changing not only Poiret's designs but the entire look of fashion, decorating, and home furnishings. Poiret later bragged, "I freed the bosom and gave liberty to the body." In 1912 he threw away the corset, invented the modern brassiere, and dressed his clientele in harem trousers and lampshade dresses. The sources of Adrian's creative inspiration, both Poiret and the Ballets Russes, contributed to the early look of the movies that continued well into the thirties, evidenced by Greta Garbo's MATA HARI in 1932.

Hollywood costume designers were creating a look for a character in a screenplay and, at the same time, enhancing the star's best features. The French couturiers, on the other hand, were designing a collection for private individuals whose needs were taken into consideration, choosing the colors and fabrics, and presenting these pieces to their wealthy patrons for selection. Mrs. Harvey Firestone, Jr., one of America's "best dressed," wore the couture of Jean Patou in the thirties, Balenciaga and Christian Dior in the forties, and Yves Saint Laurent following Dior's death. She insisted that the designers change their color palette to match her baby blue eyes, even though powder blue was rarely included in their collections, and Mrs. Firestone's diminutive size forced them to adapt their designs to her figure.

Although related, the two fields, costume design and couture, were not the same and did not involve the same customer. Edith Head, Hollywood's most prolific designer, said, "Actually, I think the one great reason I have never gone into fashion is that I think it's a ridiculous idea to design a dress that will look just as good on a

size 6 as on a 16." And that is precisely what the fashion designer does, though the 6-to-16 range has now shrunk to a 4-to-12 range, to the dismay of larger women.

Women read about French fashion in *Vogue* and *Harper's Bazaar,* but the couture attracted only a few hundred American women per year, whereas in 1937, the average weekly attendance at movie theaters was approaching ninety million. The moviegoing public saw one or two films per week during the depression, when admission was twenty-three cents, more than the price of a dozen eggs. The movie industry, together with the media, made Adrian's name a household word. At that time, New York fashion publicist Eleanor Lambert opened her public relations firm, and one of her first clients was Adrian, further adding to his name recognition.

According to fashion historian Caroline Rennolds Milbank, "In any decade, the cost of a couture dress is comparable to the price of a new car." Just imagine how few couture dresses sold to Americans, or to anyone, during the depression as compared to the thousands of copies of Joan Crawford's LETTY LYNTON gown sold at Macy's in 1932 for less than twenty dollars.

There was a great change after World War II, once the American ready-to-wear designers became known. Here was the real competition for Hollywood's designers . . . or so they thought. Claire McCardell, the "Mother of American Sportswear," and Norman Norell became more popular after the war when patriotism was paramount. Stars like Dietrich, whose accent was thought mysterious before the war, were considered somewhat "dangerous" after the war and were no longer in demand. The publicity machine, led by Eleanor Lambert, made more Americans aware of American designs. Stores like Neiman Marcus and Lord & Taylor started to

promote designers' names as well as their dresses. For the first time, Hollywood's costume designers felt threatened by the "new kids on the block," the New York designers. But it wasn't until Halston's appearance in the sixties that a New York designer reached the superstar status of Adrian, who, at the height of his career, built a literal throne room in his studio and lived a royal lifestyle perhaps comparable to that of today's successful couturiers and designers.

Attempts at designing for film by the French and New York designers were mostly unsuccessful. Walter Plunkett said that Chanel and Erté failed in Hollywood because they "just couldn't figure it out." The problem was that they were not trying to design for film. Chanel was promoting her own look: black and minimalist. During the thirties, that was not what the public wanted to see on the screen, especially not on Gloria Swanson, the Queen of Glamour.

Gradually the screen's fashion shows also lost their draw. During the golden years of Hollywood in the thirties, films realistically depicted women going to luncheons, card parties, and fashion shows. Real women saw real fashion shows in the movies. With the advent of television, the public could see couture and ready-to-wear shows in the privacy of their family rooms, and videos of designer shows were shown in many stores. Fashion shows today are frequently charity benefits and have become like Hollywood and Broadway extravaganzas, with special lighting effects, music, and unusual venues such as New York's Radio City Music Hall, the Bagatelle Gardens in Paris, and even boxing rinks of local gymnasiums.

Unlike Adrian, Lilly Daché didn't have Garbo to promote her hats; Schiaparelli didn't have Crawford to promote her couture suits; and Madame Vionnet didn't have Harlow to model her bias-cut gowns. Likewise, the New York designers did not have the Hollywood machine to advance their name recognition. Hollywood's costume designers should receive public recognition by means other than wearing American Express "Gold Card" dresses to the Oscars. Perhaps Mel Gibson and Julia Roberts could wear sweats with the names Albert Wolsky and Theadora Van Runkle instead of Calvin Klein and DKNY emblazoned across their chests.

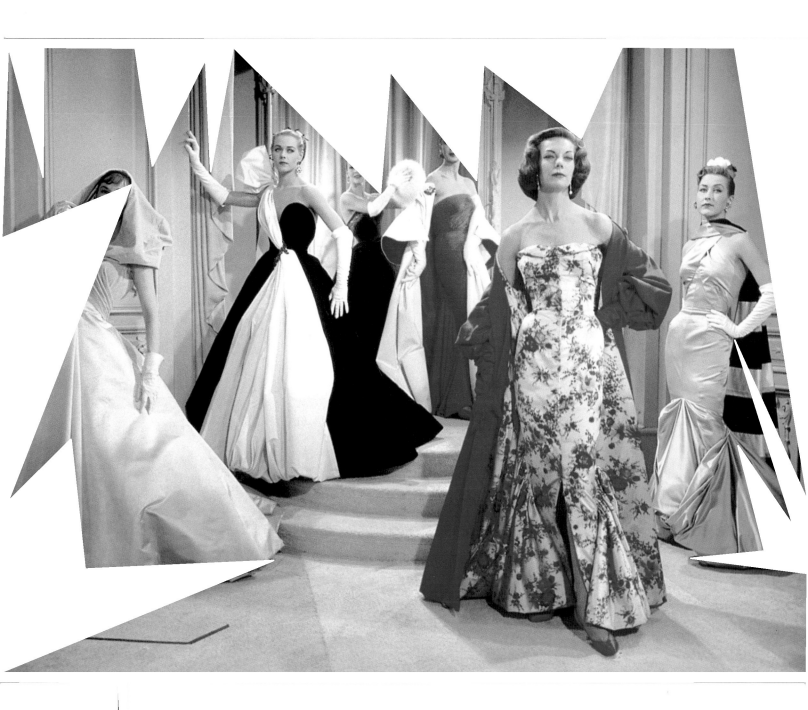

DESIGNING WOMAN, 1957, HELEN ROSE This is costume designer Rose's homage to the couture and to Charles James, an English-born designer who spent the fifties in New York, designing sculptured ballgowns for socialites. They called the gowns their "Charlies" and would often buy an extra seat on a plane so their gowns could travel in the lap of luxury with nary a wrinkle.

ARTISTS AND MODELS ABROAD, 1938, EDITH HEAD

Edith Head and this film brought the names of the French couturiers, such as Charles Frederick Worth, the Father of the Couture, to middle America. The fashion sequence featured gowns by eight couturiers, brought from Paris for the film. The stars are, believe it or not, Jack Benny and Judy Canova.

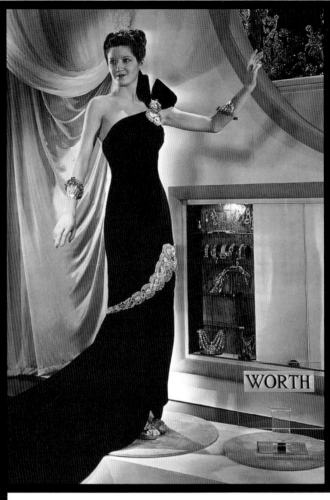

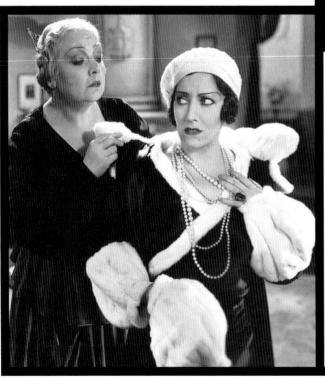

Gloria Swanson

TONIGHT OR NEVER, 1931, CHANEL Chanel began her costuming career with this film starring Gloria Swanson. Coco wanted to bring her classic understated look to the screen, but Gloria disagreed and sent Coco packing. When the film was released, Gloria had glitzed up the costumes. Early designer Howard Greer explained, "New York and Paris disdainfully looked down their noses at the dresses we designed in Hollywood. Well, maybe they were vulgar, but they did have imagination. If they were gaudy, they but reflected the absence of subtlety which characterized all early motion pictures."

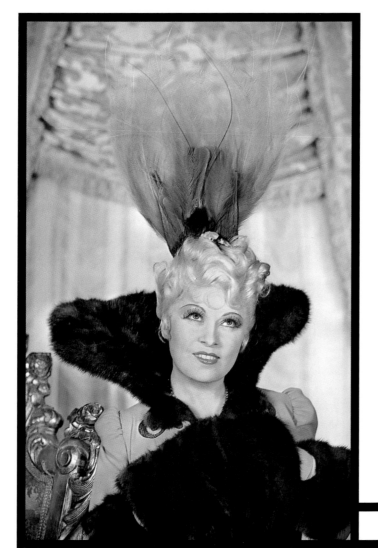

Mae West

EVERY DAY'S A HOLIDAY, 1937, ELSA SCHIAPARELLI FOR MAE WEST By the late thirties, West was a very big and very demanding star. She insisted that her costumes be made in Paris by the surrealist designer Elsa Schiaparelli, but Madame Schiaparelli would not come to Hollywood for the fittings, and Mae would not budge. A dress form of Mae's body was sent to Madame's atelier and, as the story goes, when Elsa saw it she exclaimed, "shocking"—and that became the name of her famous fragrance. The bottle was designed to look like Mae West's dress form. (When the costumes arrived in Hollywood, they did not fit.) Mae rescued the career of costume designer Walter Plunkett, whom producers refused to hire after GONE WITH THE WIND (1939), thinking his services would be too pricey. Mae requested his expertise for her next film. When Plunkett appeared at their first meeting, Mae greeted him in the nude and said, "Walter, I'd like you to see what you're working with."

Joan Fontaine, Norma Shearer

THE WOMEN, 1939, ADRIAN The all-female cast of THE WOMEN included Joan Crawford, Norma Shearer, Rosalind Russell, Joan Fontaine, Paulette Goddard, and Hedda Hopper. Their dialogue centers on their two favorite subjects: men and fashion, and not necessarily in that order. These suits are Adrian's homage to Elsa Schiaparelli. Sean Young's suit in BLADE RUNNER (1982) was designer Michael Kaplan's homage to Adrian. What goes around . . .

Irene Dunne, Fred Astaire, Ginger Rogers

ROBERTA, 1935, BERNARD NEWMAN Roberta was a French couturier in this film, which was directly related to the fashion industry. By the start of filming, Ginger Rogers's hemlines on her faux-countess costumes were a foot shorter than originally designed. Their upward attitude reflected the economy's gain as it emerged from the Great Depression.

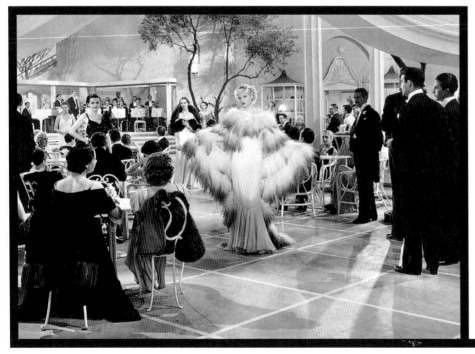

Lucille Ball

ROBERTA, 1935, BERNARD NEWMAN Costume designer Newman's inspiration for the spectacular fashion show sequence, "The French Couture," was never more obvious. The gowns alone in this movie cost $250,000. Lucille Ball appeared as a model, almost unrecognizable: blonde and speechless.

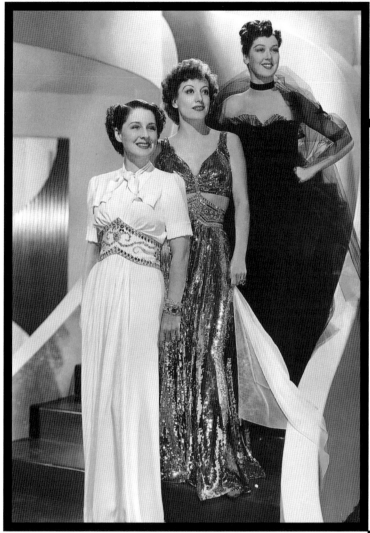

Norma Shearer, Joan Crawford, Rosalind Russell

THE WOMEN, 1939, ADRIAN Because Joan Crawford's facial features were so strong, people believed her to be a much larger woman. One of her best roles was the manicurist/husband stealer in THE WOMEN. Adrian dressed her in thirties floozy attire: a glitzy bare midriff dress. The nice wife, Norma Shearer, wore white crepe with a raised waistline, which slimmed her broadening hipline, as it had been ten years since Adrian's costuming of THE DIVORCÉE, and gravity had taken its toll. Roz Russell, the bitchy gossip, wears silly hats, Hollywood's way of "dressing for a laugh."

THE WOMEN, 1939, ADRIAN The best fashion sequence in any film is the Adrian fashion show. This film is black and white, but the show sequence was filmed in breathtaking color. It includes daytime big-shouldered suits, dramatic evening attire (mostly with trompe l'oeil effects), tennis clothes not meant for playing tennis, and swimsuits too glamorous for swimming. There were even monkeys dressed in Adrian Originals, the name of his business. The fantasy of the motion picture and the talent of Adrian were never more evident.

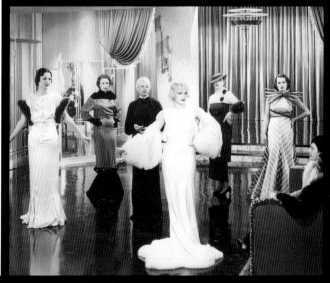

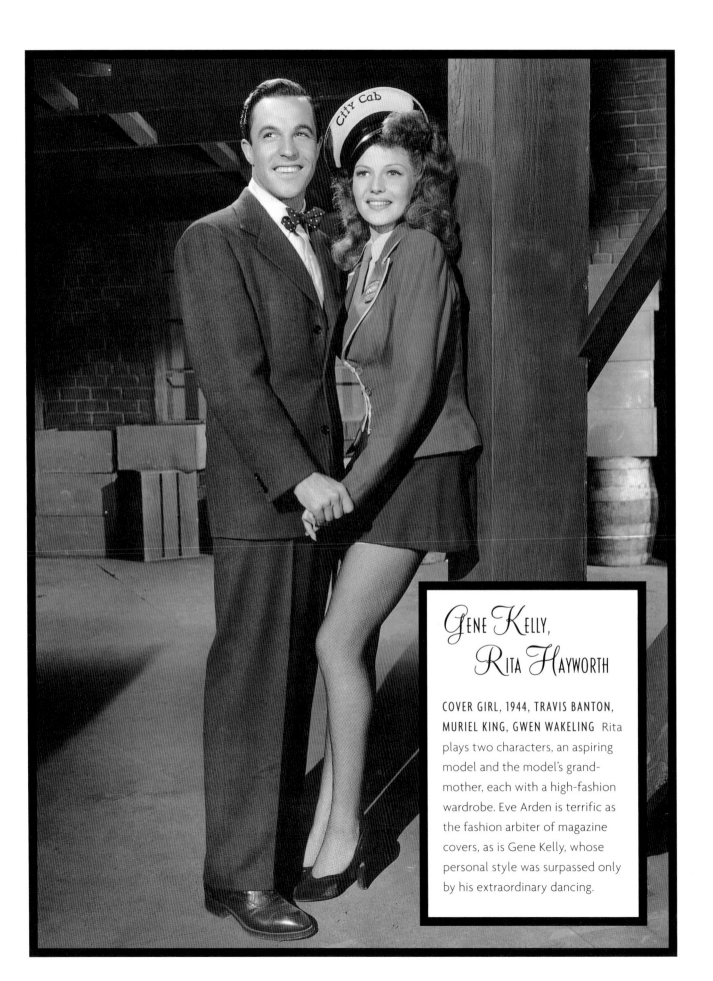

Gene Kelly, Rita Hayworth

COVER GIRL, 1944, TRAVIS BANTON, MURIEL KING, GWEN WAKELING Rita plays two characters, an aspiring model and the model's grandmother, each with a high-fashion wardrobe. Eve Arden is terrific as the fashion arbiter of magazine covers, as is Gene Kelly, whose personal style was surpassed only by his extraordinary dancing.

Zsa Zsa Gabor

MOULIN ROUGE, 1952, ELSA SCHIAPARELLI FOR ZSA ZSA GABOR
This is the famous dress immortalized by Toulouse Lautrec for Moulin Rouge chanteuse Jane Avril and re-created by Schiaparelli for Zsa Zsa. Gabor kept the costume and, some years later, added a green polyester panel to enlarge the dress so she could wear it to a party. When purchased at auction in the nineties, not one stitch of Schiaparelli's was touched. The wide panel remains for sentimental reasons.

Jane Wyman, Marlene Dietrich

STAGE FRIGHT, 1950, CHRISTIAN DIOR Very often, well-known stars demanded their choice of a designer, which meant importing couturiers from Paris. In this film, Marlene abandoned her Svengali-like designer, Travis Banton, for New Look designer Dior. The result was a new, overdressed look for Dietrich, who is also over-jeweled by Cartier. . . . Can one ever wear too much Cartier?

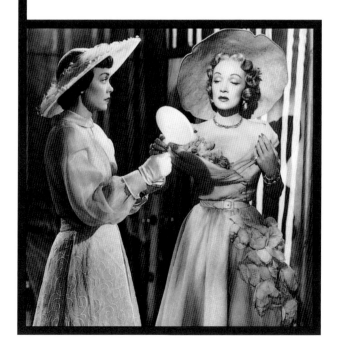

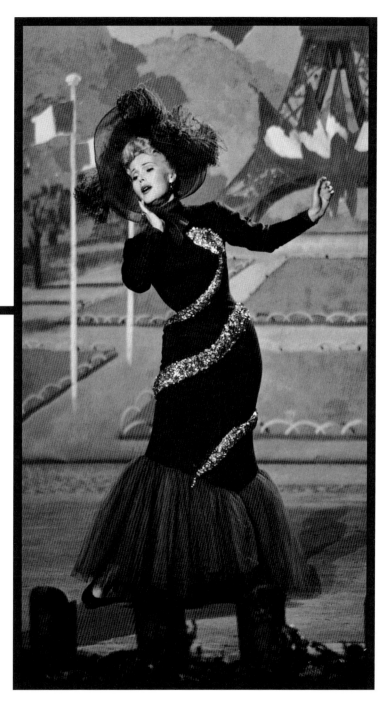

Patricia Neal, George Peppard

BREAKFAST AT TIFFANY'S, 1961, EDITH HEAD, HUBERT DE GIVENCHY FOR AUDREY HEPBURN, PAULINE TRIGÈRE FOR PATRICIA NEAL Trigère's ladylike ensemble best suited the character played by Patricia Neal, a successful interior designer who was keeping her lover, George Peppard. Neal was only a few years older than Audrey Hepburn, but Trigère's serious ensembles were in juxtaposition to Holly Golightly's *joie de vivre* wardrobe by Givenchy. Neal's "Evil Queen" attire in this film was inspired by the costumes in SNOW WHITE (1937).

Doris Day, Cary Grant

THAT TOUCH OF MINK, 1962, ROSEMARY ODELL, NORMAN NORELL A rich playboy business executive played by Cary Grant chases Doris Day right into Bergdorf's for a fabulous Norman Norell fashion show, and offers to buy her an entire wardrobe. That guy had style! Norell was one of America's greatest designers, and his sequinned "Mermaid" dresses were shown in *Life* magazine's September 1960 issue.

Audrey Hepburn, Fred Astaire

FUNNY FACE, 1957, EDITH HEAD, HUBERT DE GIVENCHY
Fred Astaire plays a Richard Avedon–type photographer
(Mr. Avedon was the consultant on this film) who turns book-
worm Audrey into a supermodel in Paris. Her beatnik garb
was designed by Edith Head, who transformed Hepburn into
a star in ROMAN HOLIDAY (1953). Edith's trend-setting
designs included capri pants, ballerina slippers, and the
forever popular SABRINA neckline, which may or may not be
attributed to Mr. Givenchy. Her Paris attire, designed by
Givenchy, includes a red chiffon gown, almost identical to
the one she wore to the Oscars in 1992, thirty-five years later.

Audrey Hepburn

SABRINA, 1954, EDITH HEAD, HUBERT DE GIVENCHY This film
was the first collaboration between Hepburn and
Givenchy, who was to become Audrey's lifetime couturier
and confidante. In this film, Audrey suggested that Sabrina
return from Paris with "real Paris clothes." The Hollywood
producers disagreed, but Edith Head sided with Audrey.
When the actress arrived at Givenchy's Paris salon, he was
surprised because he had expected the "other" Miss
Hepburn. In 1990, Audrey recalled their first meeing: "I had
never seen a haute couture dress, much less worn one."

Claudia Cardinale

THE PINK PANTHER, 1964, YVES SAINT LAURENT Inspector Clouseau, Yves Saint Laurent, and the Pink Panther—the strangest of trios. This film not only sounds terrific, but its look is evidence of the master couturier at work. It's not BELLE DE JOUR (1967), but what is? Claudia Cardinale and Capucine, the PANTHER stars, give Catherine Deneuve's BELLE some fierce competition. The couture is amazingly au courant: when BELLE was rereleased in 1996, Yves Saint Laurent picked up a new generation of fans.

Cyd Charisse

TWO WEEKS IN ANOTHER TOWN, 1962, PIERRE BALMAIN FOR CYD CHARISSE Irwin Shaw's film-within-a-film has an all-star cast that includes beautiful Cyd Charisse, dressed by the French couturier Pierre Balmain. In 1945 he designed a silhouette that was adapted by Dior and became known as the New Look of 1947. Hollywood continued to show knee-length skirts, anticipating a short run for longer hemlines. When producers realized that the New Look was here to stay, most films were scrapped or reshot, covering the pretty legs synonymous with Hollywood.

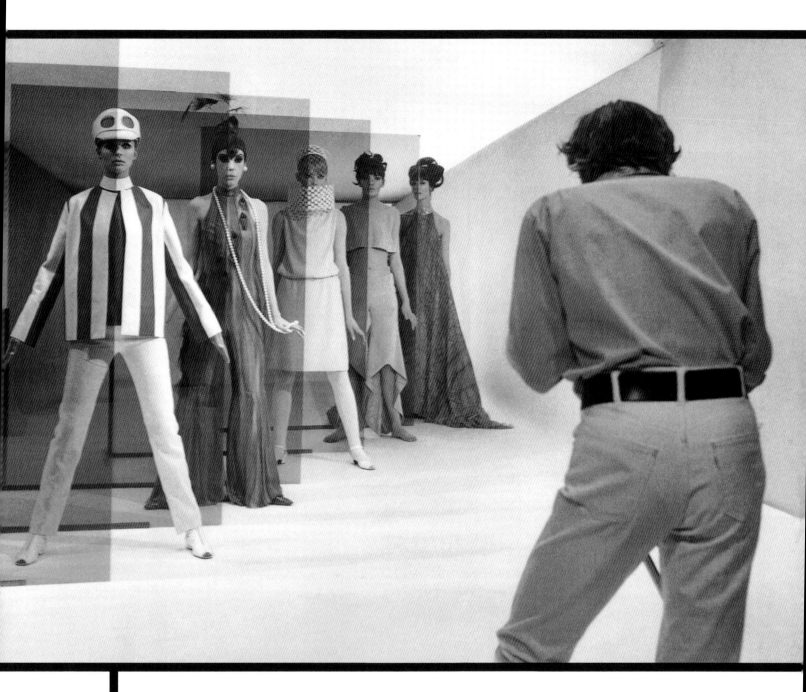

David Hemmings and Models

BLOW-UP, 1966 (BRITISH/ITALIAN CO-PRODUCTION), JOCELYN RICKARDS David Hemmings plays a Swinging Sixties fashion photographer who engages in orgies on seamless backdrop paper with models dressed and undressed in Mary Quant– and Rudi Gernreich–style clothes. Mary Quant, creator of the miniskirt, and Rudi Gernreich, who designed the Topless Swimsuit, revolutionized fashion of the sixties. The "Marcel Marceau" mimed tennis match in this film is worth the watch!

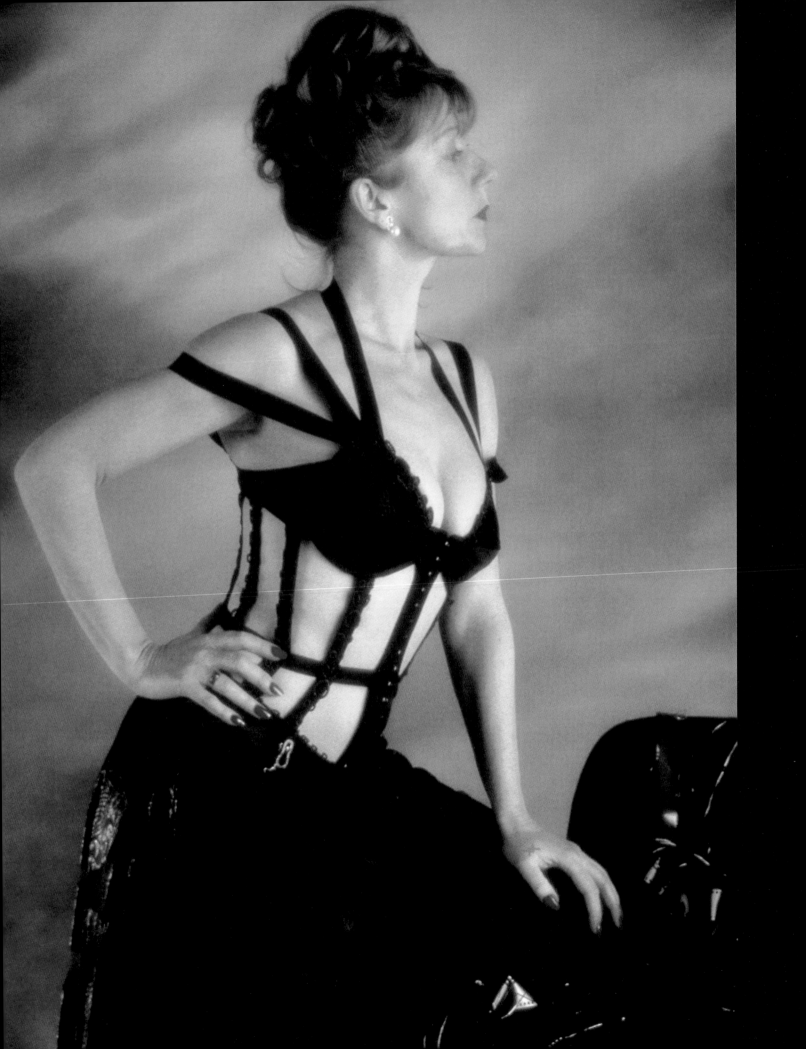

Helen Mirren

THE COOK, THE THIEF, HIS WIFE & HER LOVER, 1989 (BRITISH/ FRENCH/DUTCH CO-PRODUCTION), JEAN-PAUL GAULTIER Helen Mirren, the "thinking man's sex symbol," wears Gaultier's signature design: the corset. He also corseted Madonna for her Blonde Ambition Tour (1990).

Madonna

EVITA, 1996, PENNY ROSE Clotheshorse Evita Perón had closets filled with the couture of Christian Dior. After the film opened, the Metropolitan Museum of Art had a Dior exhibition, Estée Lauder had an Evita cosmetics line, and Madonna had a baby.

Alicia Silverstone

CLUELESS, 1995, MONA MAY Alicia Silverstone plays Cher, a trendy teenager so obsessed with clothing that in a holdup she tells the bad guy she won't lie on the ground in her red dress: "You don't understand. This is an Alaia—a totally important designer." In another scene, when Cher leaves on a date dressed in a trendy slip dress, her Dad asks, "What the hell is that?" Cher replies, "A dress." Dad: "Says who?" Cher: "Calvin Klein." Designer Mona May said that the dress was actually designed by Vivienne Tam. "I wanted to show how clueless Cher really was."

ULTIMATE ACCESSORIES

Accessories are the art objects we wear on our person . . .
witness the Roaring Twenties, when the supposedly
streamlined flapper might be wearing an art deco
cloche, beaded pocketbook, costume jewelry, patterned
stockings, ornate shoes, and a fringed shawl, not to mention
carrying a cigarette case, lighter, and a flask. . . .

— *Caroline Rennolds Milbank, 1992*

The Hollywood of old had it all: no ensemble was complete
without many of the accessories mentioned above. The most
important accessory by far was the hat, which made

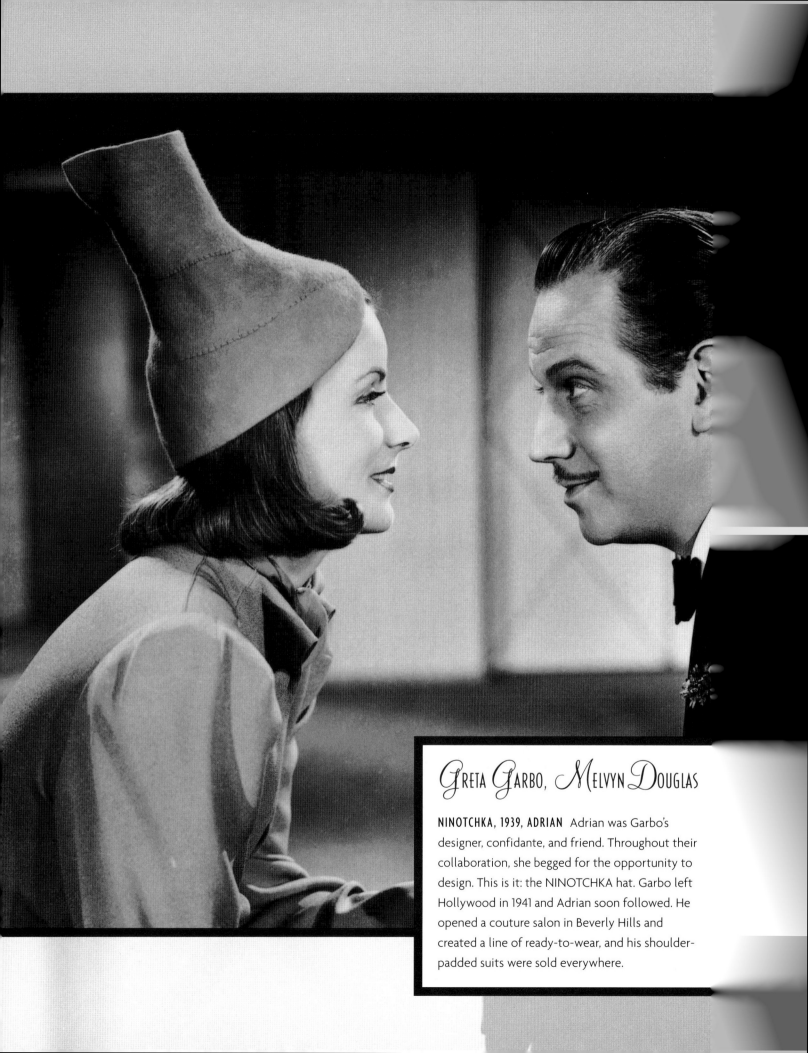

Greta Garbo, Melvyn Douglas

NINOTCHKA, 1939, ADRIAN Adrian was Garbo's designer, confidante, and friend. Throughout their collaboration, she begged for the opportunity to design. This is it: the NINOTCHKA hat. Garbo left Hollywood in 1941 and Adrian soon followed. He opened a couture salon in Beverly Hills and created a line of ready-to-wear, and his shoulder-padded suits were sold everywhere.

the difference between simply looking adequate and looking your best. During the thirties, it was impossible to be chic without one, and Garbo was the major influence. Because her costumes were mostly historical and could not be worn as modern attire, milliners copied her hats so the average woman, who could not afford the complete ensemble worn by her favorite star, could afford this one accessory.

Hats started to die in the fifties, but the kiss of death had appeared years before in the film SWING HIGH SWING LOW (1937). Both milliners and the public were shocked to see Carole Lombard enter a restaurant and remove her hat. Dilys E. Blum, costume curator of the Philadelphia Museum of Art, says, "Although the dictum of thirty years ago that a hat is an absolute prerequisite for the truly chic no longer holds, heads still turn at the sight of a woman wearing a hat."

Sunglasses, once a simple practicality, first became a fashion accessory when film stars began wearing them off screen in the strong California sun. Ivana Trump has a complete wardrobe of them. "I love sunglasses," she says. "They make me feel confident, alluring, stylish, and practical.

They are a must when I'm on my yacht, and they help me when I'm flying down a ski slope at eighty miles per hour. You can have very simple ones, or go all the way, with Hollywood glamour-diamonds that glitter and sparkle."

Since the early days of film, smoking and drinking have also been part of the allure of Hollywood. Nick and Nora Charles (THE THIN MAN series) always accessorized with 'tinis (as Sinatra called martinis) and cigarettes, but they were prohibited from endorsing any products. In 1934 the Hays Office ruled that stars could not endorse alcoholic beverages, even though Mary Pickford, America's sweetheart, once commented, "No one can convince me that the modern girl cares for nothing but cocktails, cigarettes, and Jazz."

Product placement in the movies is no longer subtle, and star endorsements are no longer banned. The effort to increase brand recognition through film has been financially lucrative for the film industry, increasing movie budgets. Hollywood's modern girl is allowed to smoke in nonsmoking areas as long as she flashes that red cigarette box every chance she gets (MY

BEST FRIEND'S WEDDING, 1997), and even aliens run away with cartons of the evil ones (MEN IN BLACK, 1997). Other examples of blatant product placement are Tom Hanks as Forest Gump eating Whitman Sampler chocolates and wearing his vintage Nikes, making two companies very happy.

Product placement is an established part of the Nike business. The company uses agents who guarantee a certain number of placements per year. They read the scripts, then solicit the studios. If the camera catches that label, it is worth a fortune to the manufacturer. "We are always praying for that butt shot," said a spokesperson for Lee Jeans. In 1997, five advertisers showed their products in the James Bond film TOMORROW NEVER DIES, a $98 million advertising campaign tied directly to the film. Janet Maslin of the *New York Times* wrote: "Indeed, despite Bond's mission to defeat the evil mogul, product plugs are the film's most serious business, especially since the audience may be bored enough to start looking at labels."

The ultimate product placement is the designer himself: Italian-born Nino Cerruti appears in THE HOLY MAN (1998), selling his wares on American TV. The film coincided with the opening of his new store on Madison Avenue in New York.

Calvin Klein dressed three stars in major releases for 1998: Nicole Kidman, Kristin Scott Thomas, and Gwyneth Paltrow, who also wore Donna Karan in GREAT EXPECTATIONS (1998). Klein said that he began this endeavor just for kicks, but as he enters the international marketplace, what better way to advertise than on the back of a movie star in a Hollywood film?

A star's clothing, tobacco, alcohol, and sunglass preferences are strongly influencing a new generation of the moviegoing public, even though this is far from subtle product placement. If this trend continues, no doubt commercials during movies will soon follow!

Greta Garbo

MATA HARI, 1932, ADRIAN Greta Garbo became the major millinery trendsetter of her day. For her, Adrian created the WOMAN OF AFFAIRS slouch, the SUSAN LENOX beanie, the MATA HARI skullcap, the PAINTED VEIL turban, and the AS YOU DESIRE ME pillbox, which he designed in 1932, long before Halston created one for Jackie Kennedy. In the twenties, Adrian studied in Paris with Paul Poiret, whose orientalism inspired Garbo's MATA HARI costumes—including this Byzantine cap of bugle beads with shoulder-dusting discs.

Mata Hari

1916 Paul Poiret designed cloak-and-dagger couture for Mata Hari, the Dutch-born spy who posed as a dancer in Paris. She was executed in 1917.

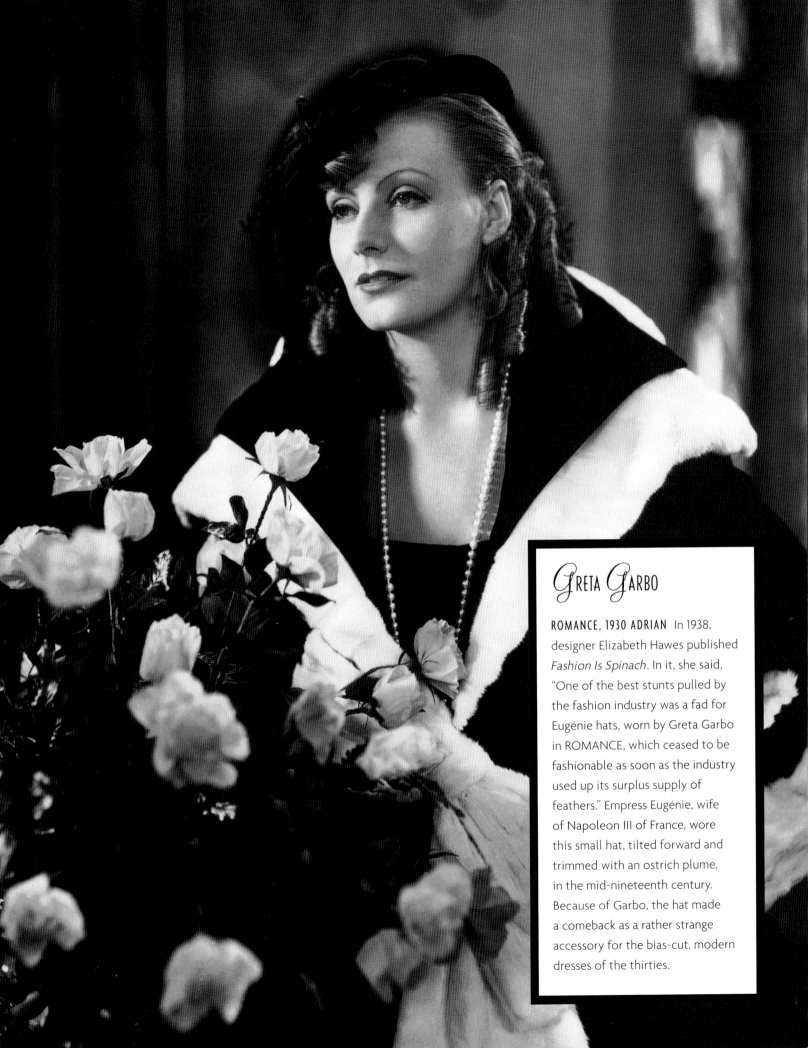

Greta Garbo

ROMANCE, 1930 ADRIAN In 1938, designer Elizabeth Hawes published *Fashion Is Spinach*. In it, she said, "One of the best stunts pulled by the fashion industry was a fad for Eugénie hats, worn by Greta Garbo in ROMANCE, which ceased to be fashionable as soon as the industry used up its surplus supply of feathers." Empress Eugénie, wife of Napoleon III of France, wore this small hat, tilted forward and trimmed with an ostrich plume, in the mid-nineteenth century. Because of Garbo, the hat made a comeback as a rather strange accessory for the bias-cut, modern dresses of the thirties.

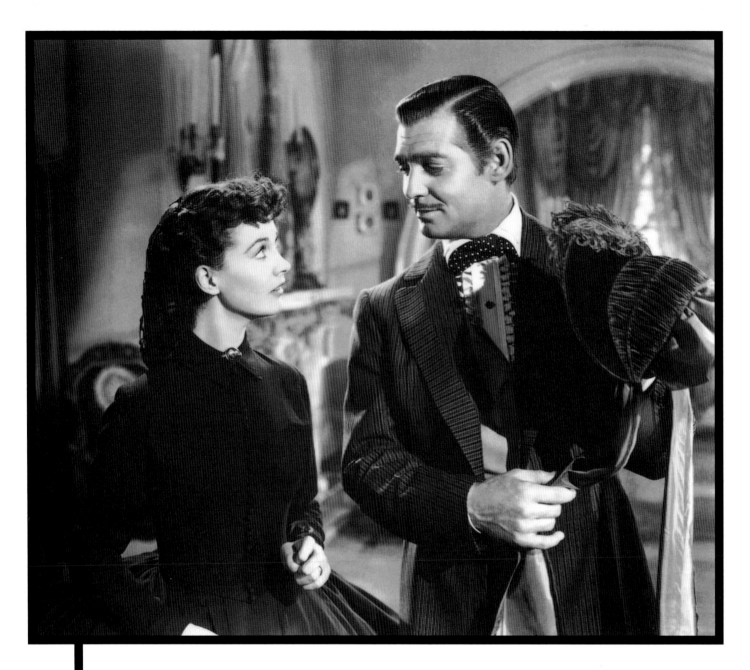

Vivien Leigh, Clark Gable

GONE WITH THE WIND, 1939, WALTER PLUNKETT Producer David O. Selznick insisted that
the hat Rhett brings Scarlett be an original. Thousands of dollars were spent on French
millinery designs as well as trips to Paris by Plunkett. The chosen hat was by John
Frederics, a New York milliner, who did not receive a screen credit. Plunkett traveled to
Atlanta to research the Civil War period and discovered that because buttons were not
widely available at that time, thorns were used to fasten clothing. He did likewise.

Kay Francis, William Powell

ONE WAY PASSAGE, 1932, ORRY-KELLY This movie was a doomed shipboard romance between a convicted murderer and a dying heroine. Transatlantic cruises were popular in the thirties, when Cuba and the Caribbean were new ports of call for Americans. A prerequisite part of the attire was the Panama hat, sporty and dapper and immediately trendy with the public. William Powell's average facial features did not set him apart as a heartthrob, but his beautiful voice and wardrobe, mostly his own, made him one of Hollywood's most popular leading men for thirty years. Powell's co-star, Kay Francis, arrived in Hollywood from New York's Broadway and Fifth Avenue, bringing a new look that women loved. She was the silver screen clotheshorse, always fashionable and posing with the pelvic thrust of a runway model.

Vincent Price, Gene Tierney

LAURA, 1944, BONNIE CASHIN Gene Tierney in the title role had two separate wardrobes: the film's original director, Rouben Mamoulian, designed the set and costumes, which were later scrapped by new director Otto Preminger. Bonnie Cashin, one of America's great designers, known mostly for her leathers and suedes, was responsible for the new costumes and this popular hat.

Paul Henreid, Ingrid Bergman, Humphrey Bogart

CASABLANCA, 1942, ORRY-KELLY During the war years, the film budget for costumes was limited, as was fabric, which was being diverted for military uniforms and parachutes. Therefore, small items like hats, such as Ingrid Bergman's, became fashion/movie trends. This film opened in November 1942, on the very day that FDR met with Winston Churchill and Charles de Gaulle in Casablanca. In later years, when Paul Henreid was asked what he remembered best about this film, he paraphrased Bogey and said, "The Germans wore gray and Miss Bergman wore blue."

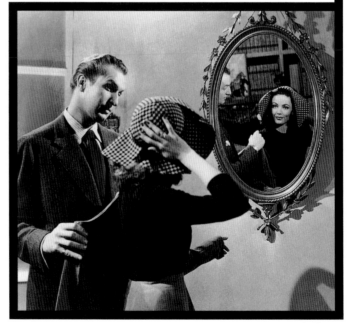

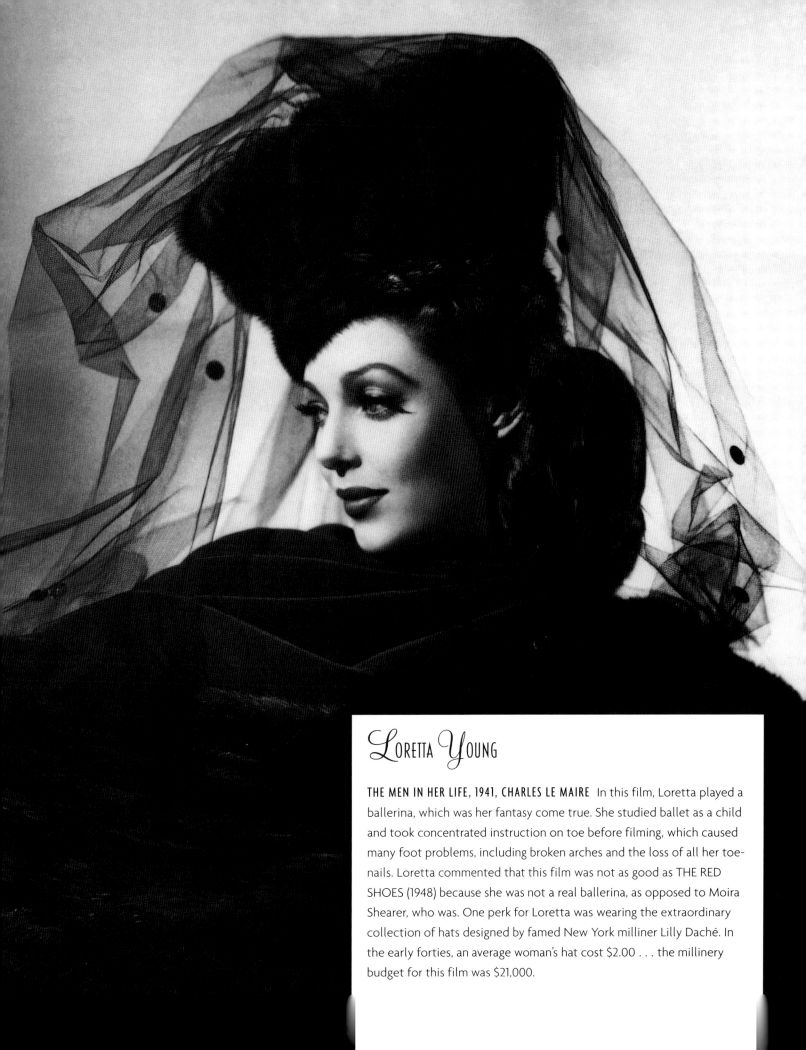

Loretta Young

THE MEN IN HER LIFE, 1941, CHARLES LE MAIRE In this film, Loretta played a ballerina, which was her fantasy come true. She studied ballet as a child and took concentrated instruction on toe before filming, which caused many foot problems, including broken arches and the loss of all her toenails. Loretta commented that this film was not as good as THE RED SHOES (1948) because she was not a real ballerina, as opposed to Moira Shearer, who was. One perk for Loretta was wearing the extraordinary collection of hats designed by famed New York milliner Lilly Daché. In the early forties, an average woman's hat cost $2.00 . . . the millinery budget for this film was $21,000.

Anjelica Huston

ENEMIES, A LOVE STORY, 1989, ALBERT WOLSKY Ron Silver's character gets involved with three very different women. Designer Wolsky commented, "Very few projects offer the costume designer the chance to create for three women, each one an entity: a Polish peasant, an educated concentration camp survivor, and a sexpot." Wolsky based Anjelica's forties look on the way his mother dressed during the war.

Barbra Streisand

ON A CLEAR DAY YOU CAN SEE FOREVER, 1970, CECIL BEATON AND ARNOLD SCAASI Beaton and Scaasi designed brilliantly for modern and flashback scenes with costumes to match. As with most Hollywood films, however, period or contemporary, dating this movie is easy—the giveaway is always the hair and makeup. Barbra wears a sixties beehive hairdo in one of the nineteenth-century sequences, but so did Liz Taylor as Cleopatra in the 1963 movie.

Marcello Mastroianni, Sophia Loren

READY-TO-WEAR (PRET-À-PORTER), 1994, CATHERINE LETERRIER Looking at Sophia and Marcello is a delight. The fashion world disagreed with director Robert Altman's interpretation of their industry as a piece of fluff. In reality, it is worth billions, employs millions, and clothes trillions!

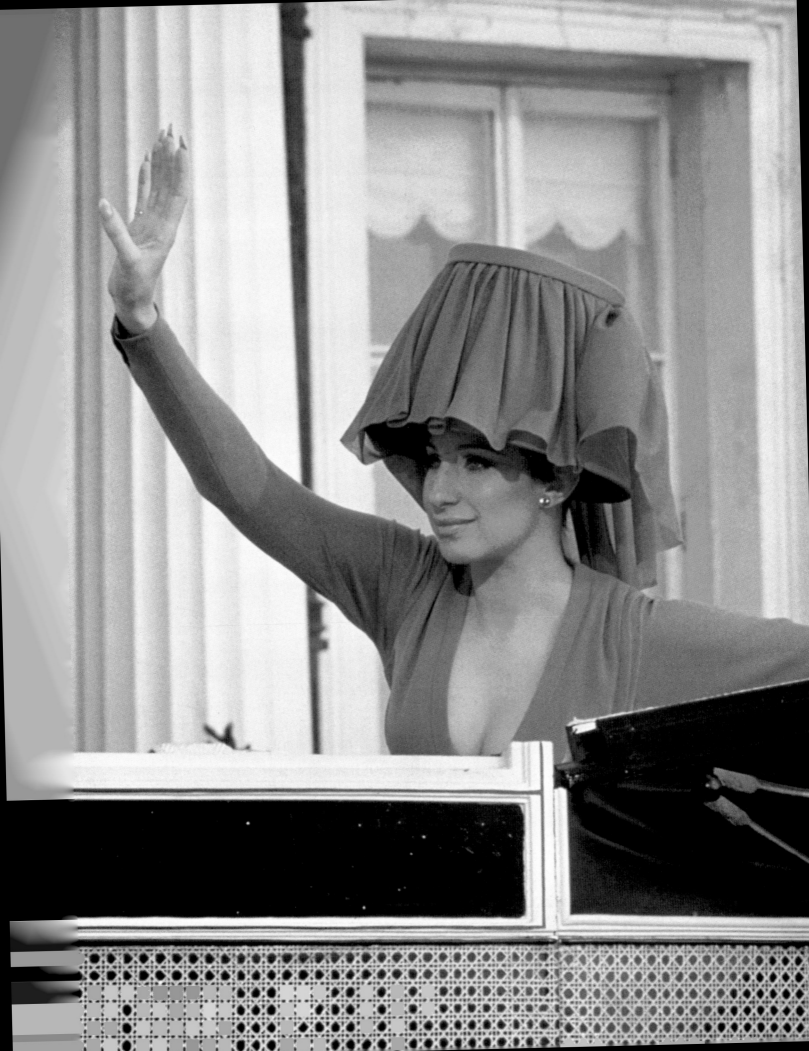

Audrey Hepburn

HOW TO STEAL A MILLION, 1966, HUBERT DE GIVENCHY There's an almost unrecognizable Audrey behind that sixties helmet hat and glasses, which are almost identical to the Gucci shades of the nineties. In one scene Peter O'Toole dresses Audrey as a scrubwoman and says, "At least it gives Givenchy a night off."

Mary Astor

C. 1940 Hiding behind shades early in Hollywood's history was synonymous with celebrity status. The darker the glasses, the more important the eyes hiding behind the lenses.

Tommy Lee Jones, Will Smith

MEN IN BLACK, 1997, MARY E. VOGT Ray-Ban's business increased by 300 percent after Tommy Lee Jones and Will Smith wore the Predator 2 model in this film, according to *WWD*. Jones and Smith's characters are responsible for monitoring alien activity on earth. Some of the camouflaged aliens include Isaac Mizrahi, Sylvester Stallone, and Newt Gingrich.

Dan Aykroyd, John Belushi

THE BLUES BROTHERS, 1980, DEBORAH NADOOLMAN On "Saturday Night Live," John and Dan used any old sunglasses for their routine, but for this film, designer Nadoolman let the guys select from a group of four dozen. John picked the kind worn by his idol, John Lee Hooker, who wore them on his album covers in the fifties. By 1980, those sunglasses had been discontinued, so Deborah searched every small drugstore to find the originals. John kept giving his pair away to pretty girls, keeping the designer forever shopping.

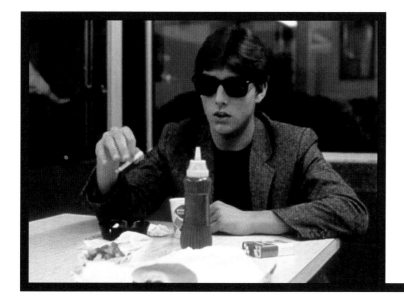

Tom Cruise

RISKY BUSINESS, 1983, ROBERT DE MORA Costume designer de Mora said that boxes of Ray-Bans were sent to the set as a promotional tie-in. He is asked about Tom Cruise's shades more often than about anything else.

Bette Davis, Joan Blondell, Ann Dvorak

THREE ON A MATCH, 1932, ORRY-KELLY Ann Dvorak leaves her husband for a gangster, takes up drinking, and doesn't get a life until her kidnapped child is returned. She should have known that three on a match was bad luck.

Franchot Tone, Joan Crawford

NO MORE LADIES, 1935, ADRIAN Crawford's role as a tough chain smoker had to be modified when she couldn't bring her cigarette to her mouth because of Adrian's gigantic collar. In MANHATTAN (1979) Woody Allen says, "I don't inhale, because it gives you cancer. But I look so incredibly handsome with a cigarette that I can't not hold one."

Paul Henreid, Bette Davis

NOW, VOYAGER, 1942, ORRY-KELLY Davis's character changes from an ugly duckling into a swan, transfigured by love and a sensational wardrobe, but the part everyone remembers is the scene where Henreid lights up two cigarettes at a time: one for him and one for Davis. What would have happened if Bette had brought some friends along for the ride?

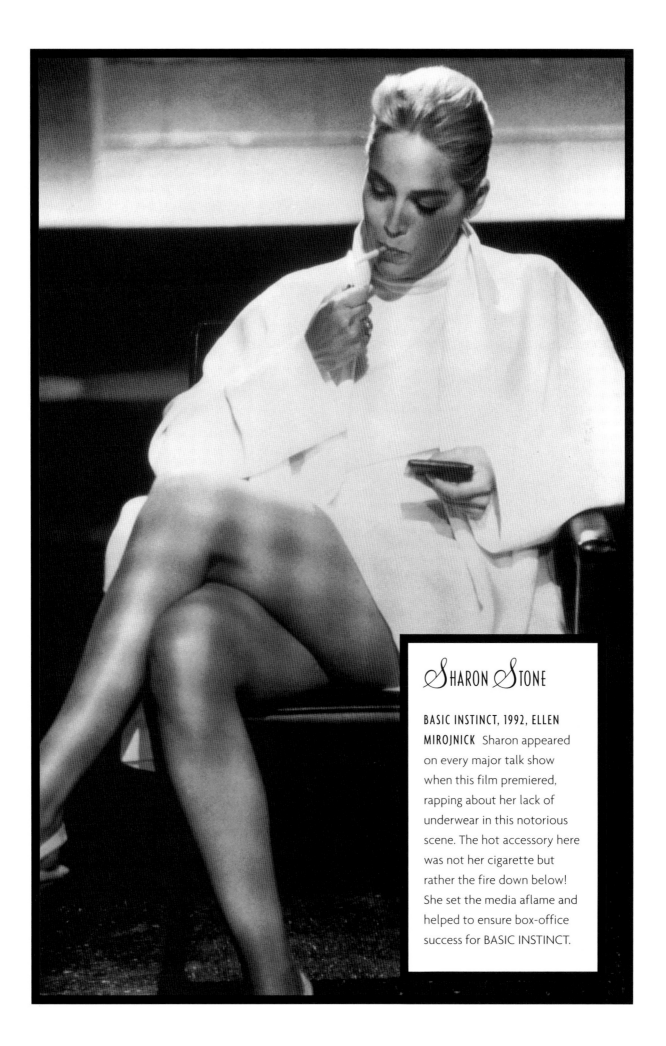

ℐharon ℐtone

BASIC INSTINCT, 1992, ELLEN MIROJNICK Sharon appeared on every major talk show when this film premiered, rapping about her lack of underwear in this notorious scene. The hot accessory here was not her cigarette but rather the fire down below! She set the media aflame and helped to ensure box-office success for BASIC INSTINCT.

Ingrid Bergman, Cary Grant

NOTORIOUS, 1946, EDITH HEAD Cary Grant plays Bergman's boss and operations director; she's a secret agent with a penchant for alcohol in this romantic, suspenseful film—the best of Hitchcock. The wine cellar is not only stylish, it is the pivotal setting in the movie.

William Powell, Myrna Loy, Henry Wadsworth

THE THIN MAN, 1934, DOLLY TREE Nick and Nora Charles were popular when corsages and inebriation were stylish. Pre–Nora Charles, Loy played minor Asian roles, as makeup artists could easily make her eyes look slanted. The first screen makeup was Max Factor's Greasepaint, used the in silver screen's first CLEOPATRA (1912).

Ronny Howard, Candy Clark, Charlie Martin Smith

AMERICAN GRAFFITI, 1973, AGGIE GUERARD RODGERS Director George Lucas asked costume designer Rodgers to use two of his favorite sixties looks: a blue-and-white checked shirt for Ron Howard and a madras for Richard Dreyfuss. Aggie found three identical madrases and used one shirt to make 1962-style collars on the other two, making sure that the colors lined up perfectly. After a few days of shooting, she took the shirts home to launder (the budget being what it was) and was horrified when she realized that madras "bleeds." She confessed all to Dreyfuss and asked that he change his undershirt often, as the two shirts could not be washed. They shot for twenty-eight consecutive days.

WE'RE H A HEAT WAVE

Hot and cold and lukewarm: these terms describe some of the screen's favorite costumes. The hottest clothes have always been the sexiest, depending on their wearer. The warmest, and now perhaps the most controversial, are the furs, opulence being so important in films of the thirties that they were even shown worn in the bedroom. And, to keep cool under the blazing sun and around the pool, the swimsuit emerged as a fashionable garment, first popularized and glamorized by Hollywood.

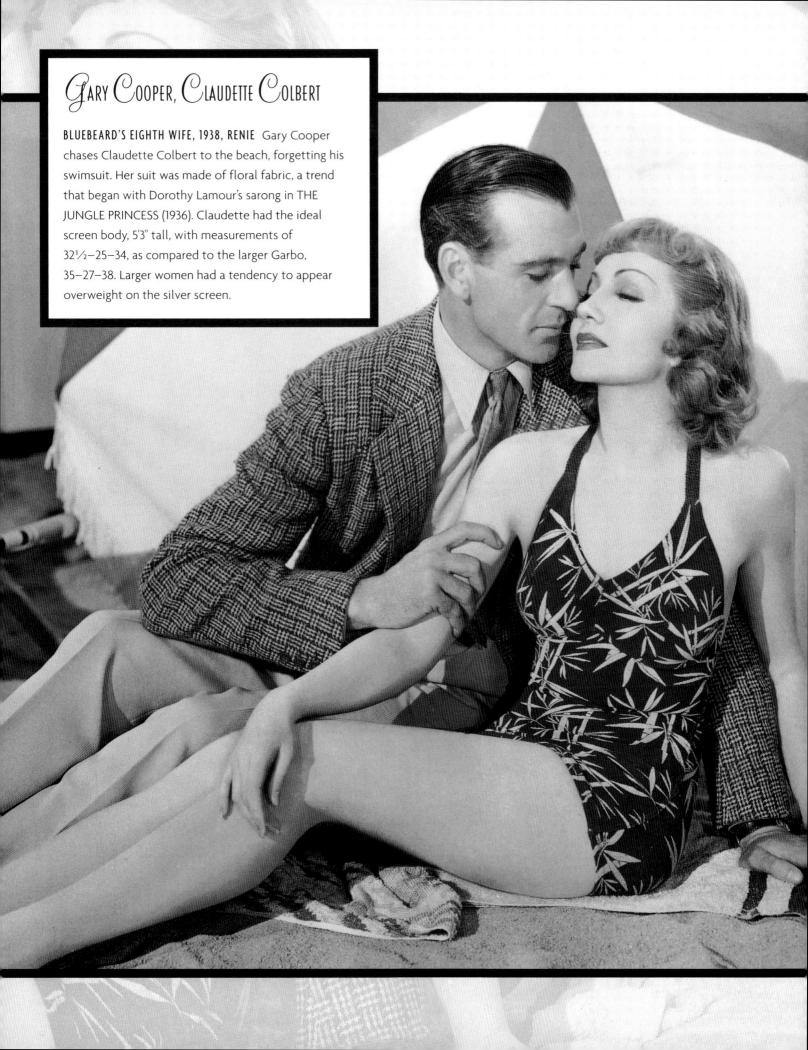

GARY COOPER, CLAUDETTE COLBERT

BLUEBEARD'S EIGHTH WIFE, 1938, RENIE Gary Cooper chases Claudette Colbert to the beach, forgetting his swimsuit. Her suit was made of floral fabric, a trend that began with Dorothy Lamour's sarong in THE JUNGLE PRINCESS (1936). Claudette had the ideal screen body, 5'3" tall, with measurements of 32½–25–34, as compared to the larger Garbo, 35–27–38. Larger women had a tendency to appear overweight on the silver screen.

From its inception in the 1700s, when worn by Martha Washington, through the sixties, the swimsuit tells the story of women's liberation, from bloomers to bikinis with pit stops along the way. Hollywood added glamour to what had been a functional piece of clothing. Turn-of-the-century women were encumbered with layers of fabric, occasionally held in place by weights, stockings, parasols, capes, and beach shoes. Skin was nowhere to be seen, nor, in many instances, was water, since the beach was re-created in the studio. Women decorated the shoreline, as swimming was forbidden for "ladies." In 1923 *Vogue* magazine stated that "swimming has a way of increasing girth in an amazingly short time." Real beaches had dress codes, dictating how much ankle and wrist could be shown. Hollywood also had its rules: In 1921, for example, film censors decreed that women's swimsuits shown on the screen could not be one-piece. That did not mean bikinis could be worn (they made their first appearance much later); it meant that skirts and stockings had to cover the legs.

Movies were promoted by photos of the stars wearing swimsuits, even if the film didn't include a beach scene. Some of these pin-up shots were made into posters, and those of Betty Grable and Bo Derek sold into the millions. Men were not exempt: Johnny Weissmuller and Ronald Reagan posed in swimsuits, The pin-up later gave way to the centerfold, without the swimsuit at all. It is rare to find stars romping in bathing suits in today's movies. Since the elimination of the Hays Office in 1966, there is so much skin showing on the screen that the bathing beauty is no longer a draw.

Last century's women were fleshy and rounded, but during the Jazz Age, women became more athletic and started to diet, trimming what had been the ideal body. For example, the ideal height and weight measurements belonged to Claudette Colbert, although she was rarely seen in a swimsuit. Today's ideal woman is even slimmer, but more muscular, showing off her hours of work-outs and work-out attire, à la Demi Moore in G.I. JANE (1997).

Hot clothes on the screen were made even hotter by Hays Office edicts. The "sweater warnings" that appeared after Lana Turner made sweaters famous, and "breast warnings" after the release of THE OUTLAW (1943), conceded that women's breasts could be hinted at but not "demonstrated" (whatever that meant).

THE DIVORCEE (1930) was considered a sexy movie, and Norma Shearer's costumes were called "too hot to handle." The heat stemmed from the fact that Norma played a divorcee, a rather controversial topic that was contrary to family values of that period.

Pressure has definitely been on the fur industry during the last decade. If today's anti-fur animal activists had lived in the thirties, when lavish furs were the vogue, movies would have had a completely different look. Once upon a time the movies flirted with round-the-clock furs, starting with fur-trimmed breakfast negligees. Daytime chic meant furs for all classes. The deprived often had fur-trimmed coats and the more fortunate may have worn fur suits or fox flings complete with dangling paws and staring glass eyes. Like other costumes, many copies were made at exorbitant prices, such as the $20,000 silver fox wrap worn by a model in the ROBERTA fashion show sequence (1935). In LADY IN THE DARK (1944), one of Hollywood's most expensive films of the forties, Ginger Rogers wore a floor-length mink ensemble; swirls of red and gold sequins decorated the mink skirt. Ginger complained that the costume gave her electric shocks.

Faux furs of recent years have given way to real ones, thong bikinis have been replaced by the maillot and dressmaker swimwear, and glitzy "Dynasty"-type evening attire has been replaced by figure-hugging bias-cut gowns and slip dresses, exaggerating the firm and not-so-firm bodies of today. Hollywood is filming these images and creating new ones for future generations to see the way the stars dress and undress on and off the silver screen.

Dolores Del Rio

IN CALIENTE, 1935, ORRY-KELLY

Dolores is a dancer in this Busby Berkley musical in which she wears satin Harlowesque gowns and Spanish swinging fringes, and swims in the two-piece bathing suit she introduced to the movies. The Mexican-born actress began her career in the silent twenties and was mostly typecast in exotic roles. Orson Welles, one of her many lovers, said she was "the most beautiful woman I had ever seen."

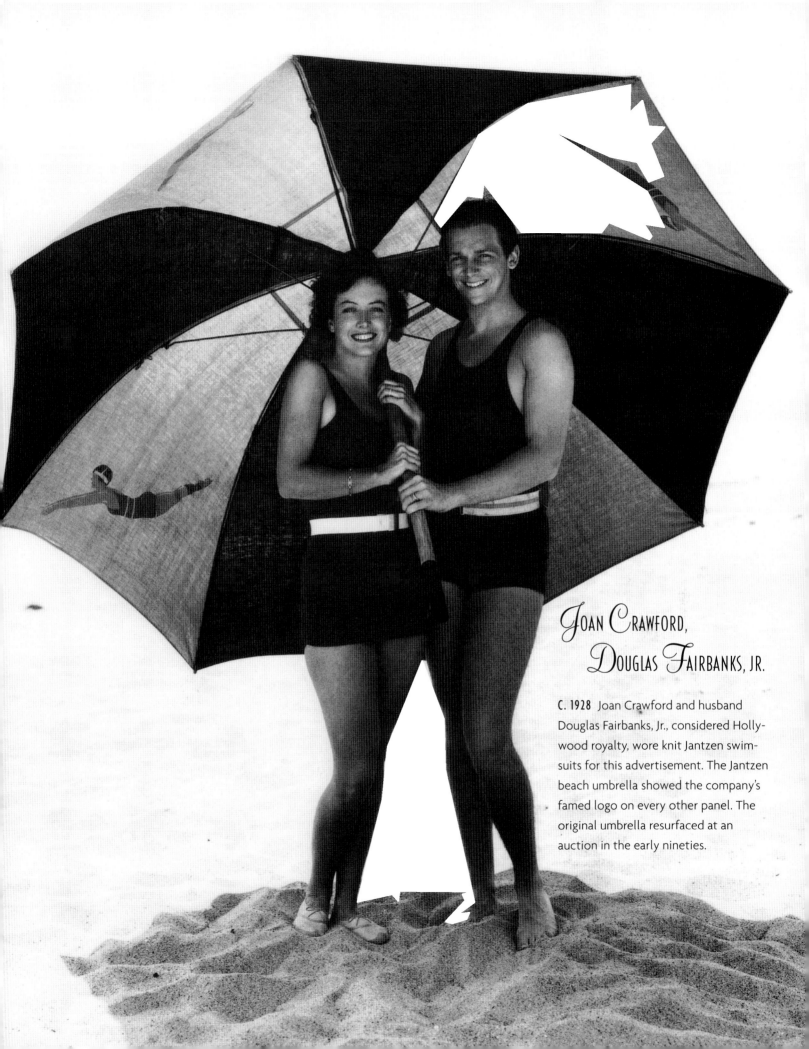

Joan Crawford,
Douglas Fairbanks, Jr.

C. 1928 Joan Crawford and husband
Douglas Fairbanks, Jr., considered Holly-
wood royalty, wore knit Jantzen swim-
suits for this advertisement. The Jantzen
beach umbrella showed the company's
famed logo on every other panel. The
original umbrella resurfaced at an
auction in the early nineties.

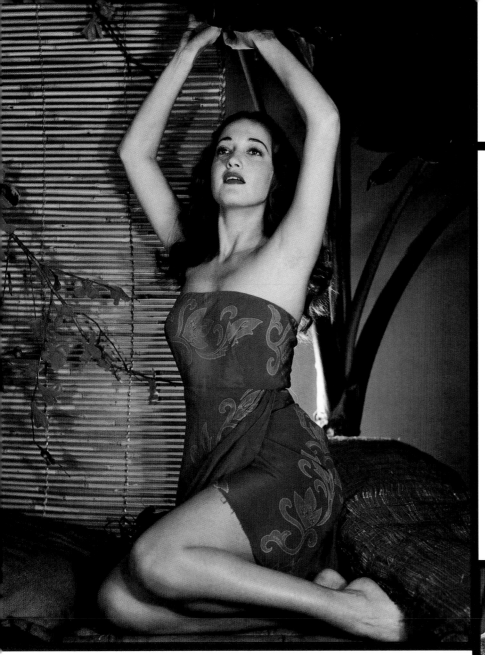

Dorothy Lamour

JUNGLE PRINCESS, 1936, EDITH HEAD In JUNGLE PRINCESS, Dorothy wore the first sarong in motion pictures. Her costume started the trend for tropical fabrics that lasted a decade. In fact, President Harry S. Truman appeared on the cover of *Life* magazine wearing a wild Hawaiian shirt in 1951, perpetuating the trend that had started in the Hollywood jungle. When Edith was asked about her inspiration, she admitted it was an improvisation: "Just a piece of fabric fastened with a diaper pin."

Melvyn Douglas, George Cukor, Greta Garbo

TWO-FACED WOMAN, 1941, ADRIAN "GARBO SWIMS!" This was Greta Garbo's last film and also the last film for designer Adrian as head of MGM's costume department. Adrian, who had always been given an unlimited budget and a free hand at design, was held held back by director George Cukor. Wartime limited the funds, and for the first time, Cukor rejected the original costumes. Adrian later said that they tried to make Garbo into a sweater girl. "When the glamour ends for Garbo, it also ends for me. When Garbo walked out of the studio, glamour went with her, and so did I."

Esther Williams

BATHING BEAUTY, 1944, IRENE AND IRENE SHARAFF Hollywood was responsible for turning a functional piece of clothing, the swimsuit, into a fashion statement. The California swimsuit manufacturers copied the movies' glamorous swimwear for the general public. This began in the early thirties when a young, out-of-work silent film star, Fred Cole, persuaded his parents, owners of the West Coast Knitting Mills, to make brightly colored swimsuits instead of their usual socks and scarves. The company eventually changed its name to Cole of California. This film is Esther's swimming debut.

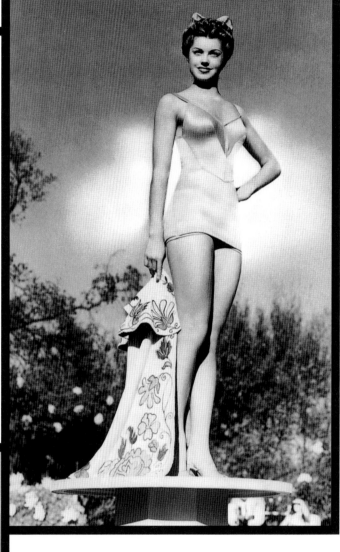

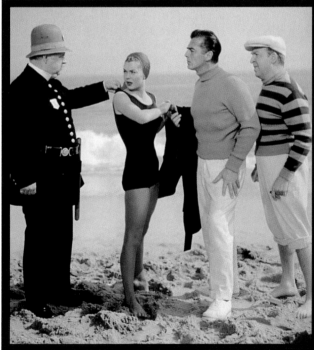

Esther Williams, Victor Mature

MILLION DOLLAR MERMAID, 1952, WALTER PLUNKETT AND HELEN ROSE This film tells the story of Annette Kellerman, the Australian swimmer who attempted to cross the English Channel in 1909. She wore a one-piece knit swimsuit without a bathing corset or stockings. When she emerged from the water, blankets were held to screen her body from the public's view. Kellerman bankrolled this film, her autobiography. Its original title was THE ONE-PIECE BATHING SUIT.

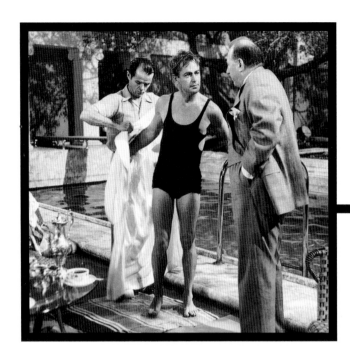

Alan Ladd

THE GREAT GATSBY, 1949, EDITH HEAD The first GREAT GATSBY was a silent film in 1926; the second starred Alan Ladd, Betty Field, and MacDonald Carey. Ladd's swimsuit was typical of those from the period: made of wool and covering the breast bone. It was also smelly, itchy, baggy, and prone to moth attacks.

Robert Redford

THE GREAT GATSBY, 1974, THEONI V. ALDREDGE AND RALPH LAUREN FOR ROBERT REDFORD Robert Redford as Jay Gatsby wears twenties swimwear. Someone on set got carried away with the pool scene and encouraged the cast to jump into the water, fully attired in cocktail clothes: tuxes and rare beaded flapper dresses. Wet, in this case, was far from wonderful.

Betty Grable

1951 The Pin-up Queen, Betty Grable, in front of her famous World War II pin-up shot, which sold over five million copies. Twentieth Century Fox insured Betty's gams with Lloyds of London for a cool million. Her backward pose was intended to hide her protruding tummy: Grable delivered a baby girl a few months after this photo was taken.

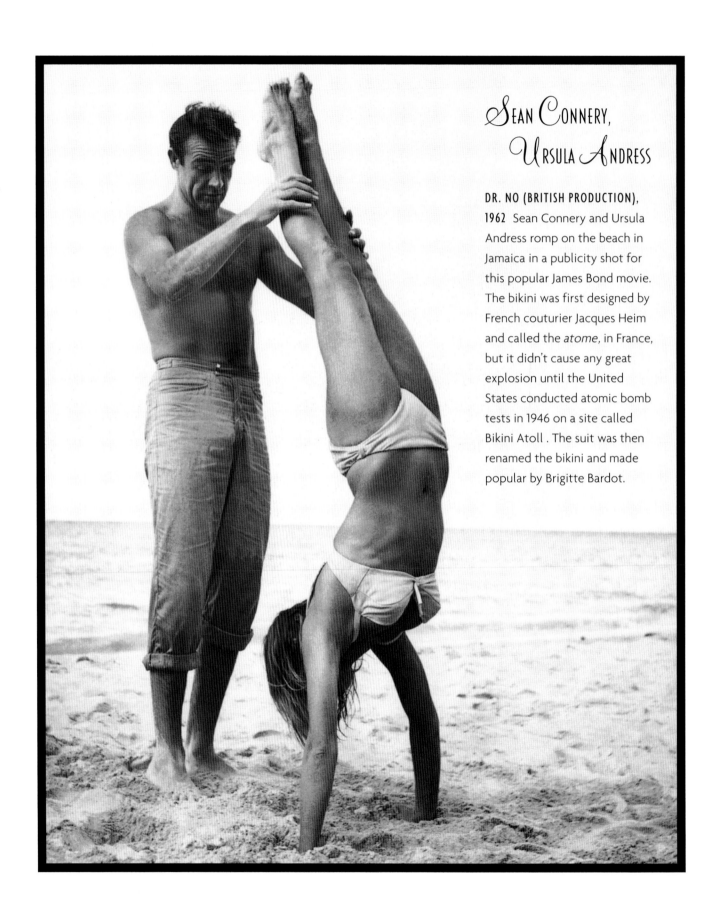

Sean Connery, Ursula Andress

DR. NO (BRITISH PRODUCTION), 1962 Sean Connery and Ursula Andress romp on the beach in Jamaica in a publicity shot for this popular James Bond movie. The bikini was first designed by French couturier Jacques Heim and called the *atome,* in France, but it didn't cause any great explosion until the United States conducted atomic bomb tests in 1946 on a site called Bikini Atoll . The suit was then renamed the bikini and made popular by Brigitte Bardot.

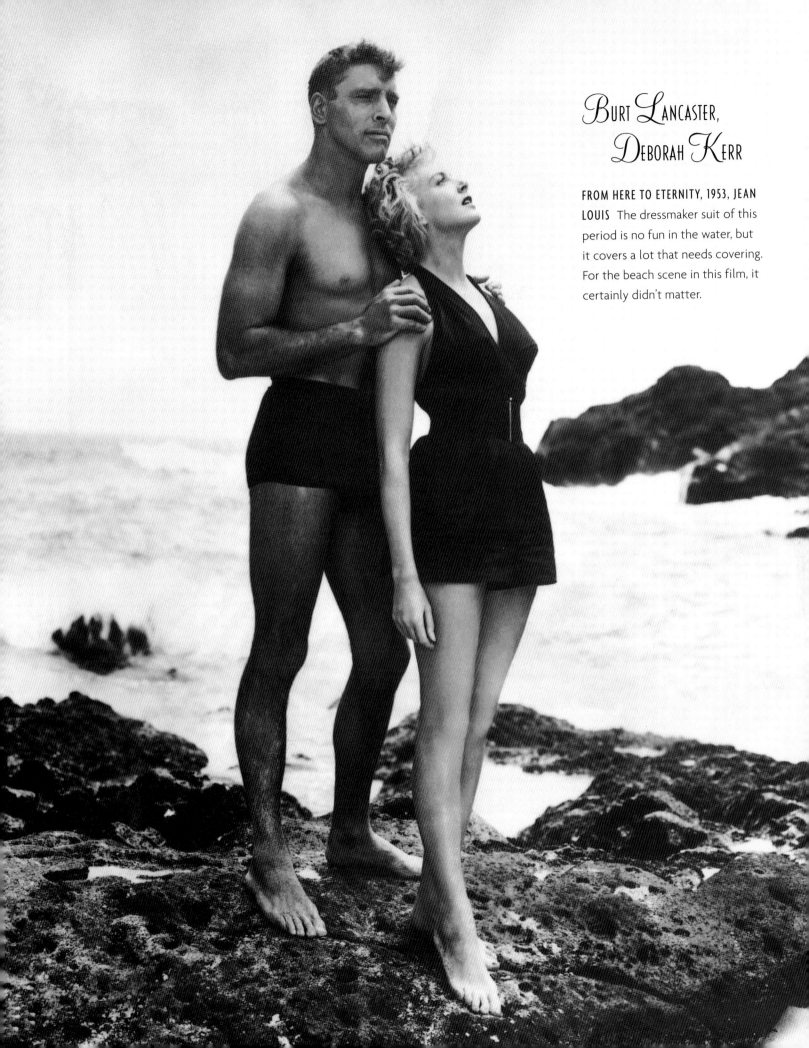

BURT LANCASTER, DEBORAH KERR

FROM HERE TO ETERNITY, 1953, JEAN LOUIS The dressmaker suit of this period is no fun in the water, but it covers a lot that needs covering. For the beach scene in this film, it certainly didn't matter.

Marilyn Monroe

BUS STOP, 1956, TRAVILLA Marilyn's costumes from this film, or from any film for that matter, sell for exorbitant prices at auction houses dealing with collectibles in the nineties. This blouse alone sold for $7,500 in 1993. The extravagance of the costumes in early films initiated wardrobe recycling.

Susan Hayward

WITH A SONG IN MY HEART, 1952, CHARLES LEMAIRE
Look familiar???

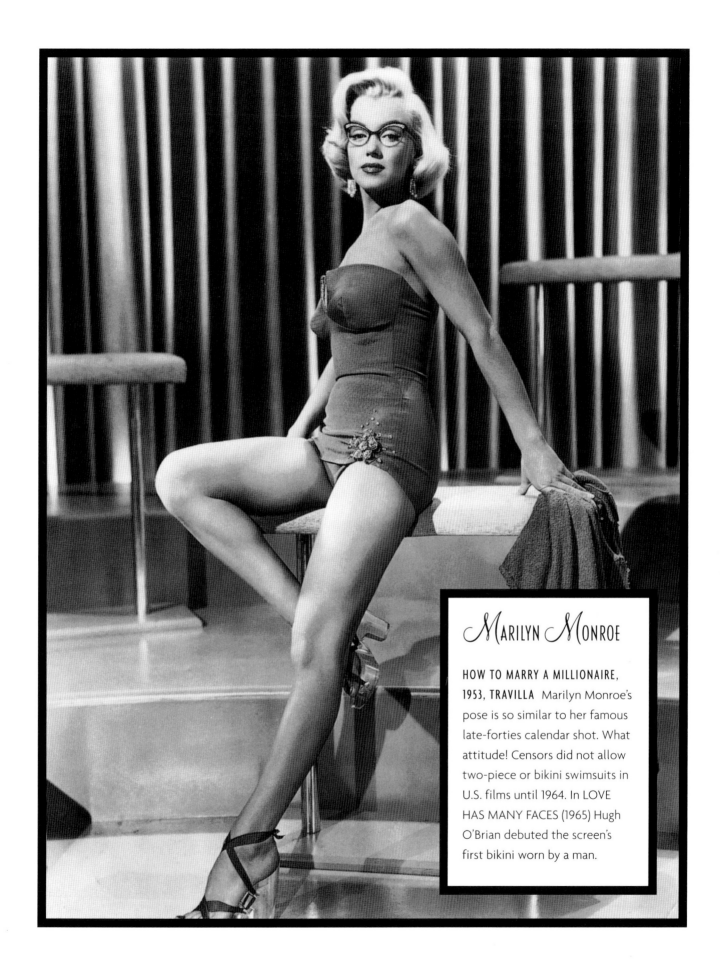

Marilyn Monroe

HOW TO MARRY A MILLIONAIRE, 1953, TRAVILLA Marilyn Monroe's pose is so similar to her famous late-forties calendar shot. What attitude! Censors did not allow two-piece or bikini swimsuits in U.S. films until 1964. In LOVE HAS MANY FACES (1965) Hugh O'Brian debuted the screen's first bikini worn by a man.

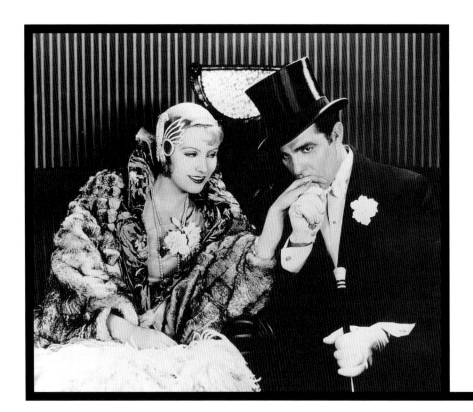

\mathcal{G}reta \mathcal{G}arbo, \mathcal{A}ntonio \mathcal{M}oreno

THE TEMPTRESS, 1926, ANDRE-ANI AND MAX REE This is Garbo's second film made in Hollywood. Here is the pre-Adrian Garbo: overdressed, overfurred, overjeweled, and smiling. "CRITICS LAUGHED," and until Adrian gave her a new look, they continued to laugh.

\mathcal{C}ary \mathcal{G}rant, \mathcal{M}arlene \mathcal{D}ietrich

BLONDE VENUS, 1932, TRAVIS BANTON
In BLONDE VENUS, one of Dietrich's favorite films, she played a mother, a prostitute, a night-club singer, and an angel, all exquisitely attired. Costume designer Banton kept Marlene's body as mysterious as her accent by totally covering her in lavish costumes such as this beaded and sable-trimmed ensemble with the unexpected twist of a satin beret.

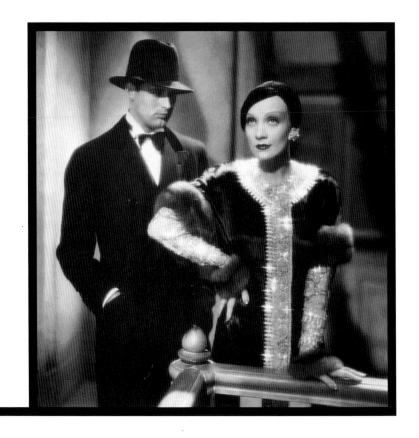

Betty Grable, June Haver

THE DOLLY SISTERS, 1945, ORRY-KELLY Betty Grable, one of America's biggest stars of the forties, and June Haver, who was being groomed to succeed her, portrayed the Dolly Sisters, who were real-life vaudvillians. Betty wanted their costumes to look modern, not like the turn of the century. When designer Orry-Kelly dressed Grable again for MOTHER WORE TIGHTS (1947), Betty insisted on showing lots of leg: nude stockings, pastel pumps, and slit skirts, once again avoiding historical accuracy but giving the public what they wanted to see.

William Holden, Gloria Swanson

SUNSET BOULEVARD, 1950, EDITH HEAD After a sixteen-year hiatus, Gloria Swanson returned to the silver screen. Her co-star, William Holden, commented, "In SUNSET BOULEVARD, I had to sit on Gloria Swanson's bed with one foot firmly on the floor and my overcoat on. Hell, I was living with her in the film. Everybody in the audience knew I was a kept man. So why did they have to be so modest?" The famous Salome scarf worn by Swanson in the film sold for $10,000 in 1983 to a fan buying a piece of Hollywood at any price.

Carole Lombard

TWENTIETH CENTURY, 1934, TRAVIS BANTON Carole Lombard accessorized with real fur. Faux fur allowed the same look in the early nineties, but a few years later *Vogue* magazine started a trend toward bringing back the real stuff. Banton designed most of Lombard's clothes, both on and off the screen.

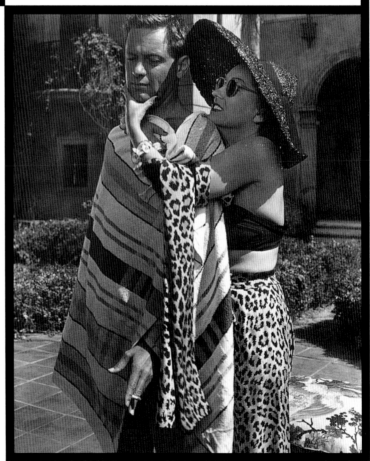

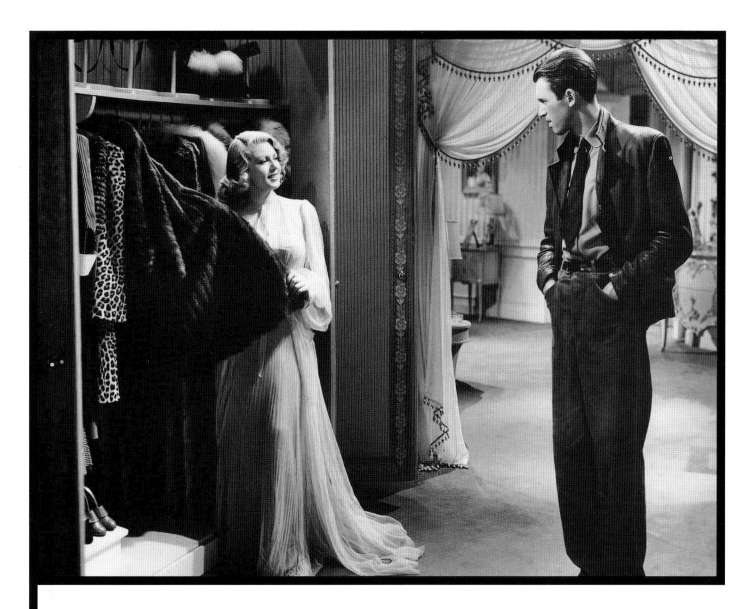

𝓛ana 𝓣urner, 𝓙ames 𝓢tewart

ZIEGFELD GIRL, 1941, ADRIAN "Look! Seven fur coats," Lana tells her boyfriend, Jimmy Stewart. This was the ultimate wartime fantasy: a chicken in every pot and a fur or two in every closet.

𝓜artha 𝓗yer

THE CARPETBAGGERS, 1964, EDITH HEAD Fox fur covering a foxy lady! Times change— once a woman's furs and jewels indicated her man's financial status. Today's successful woman can afford to buy her own status symbols.

Raquel Welch, John Richardson

ONE MILLION YEARS B.C. (BRITISH PRODUCTION), 1966, CARL TOMS Prehistoric woman never looked so good!

Loretta Young

CAFÉ METROPOLE, 1937, ROYER Loretta Young's stunning cape was draped and bordered in white fox. Loretta could look graceful in any difficult costume, no matter the weight and style, because of hours of practice at every aspect of filmmaking, including floating down staircases and in and out of doors. For eight years, in the fifties and through the early sixties, Loretta's beauty of movement was still apparent as she twirled into our homes and hearts on her TV show. She was early television's most respected female star and the first actress to win both an Oscar (1947) and an Emmy (1955).

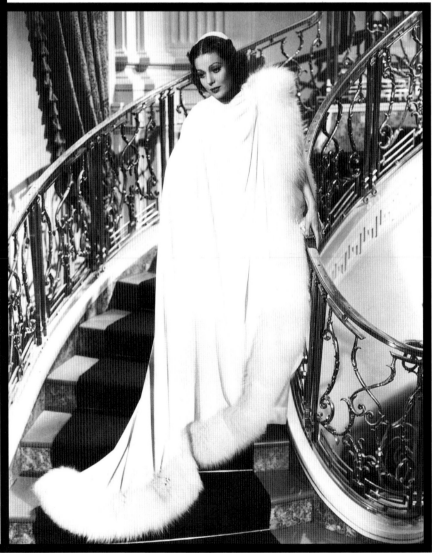

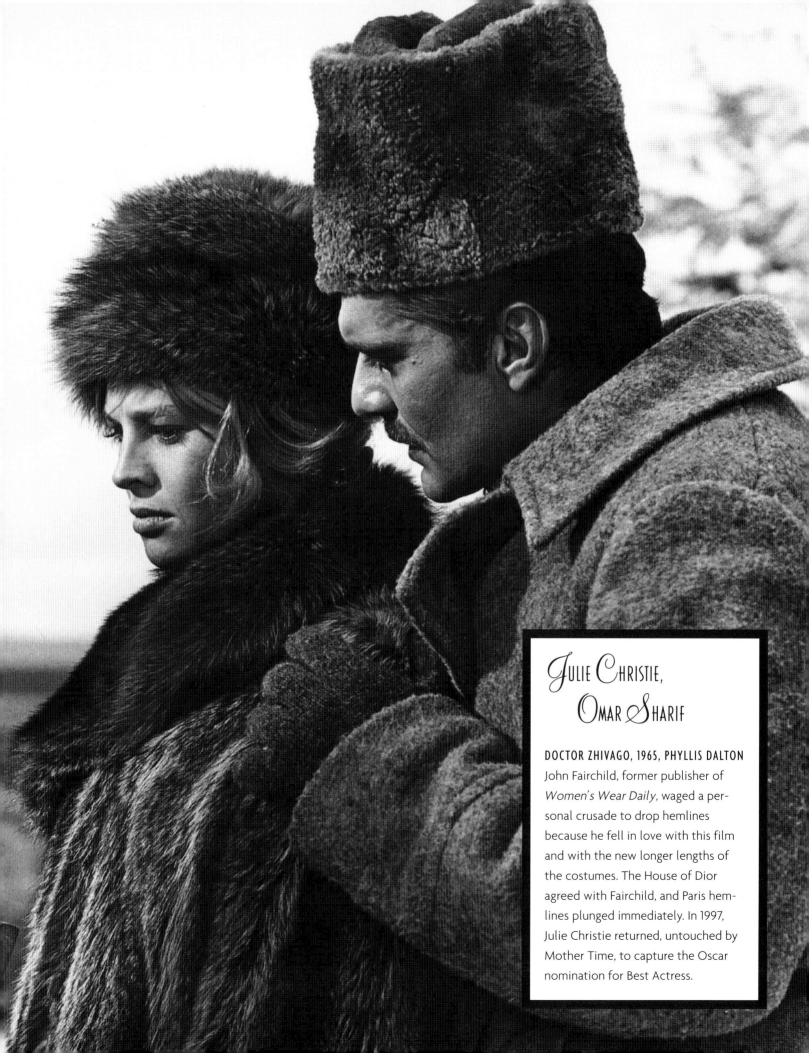

Julie Christie, Omar Sharif

DOCTOR ZHIVAGO, 1965, PHYLLIS DALTON

John Fairchild, former publisher of *Women's Wear Daily,* waged a personal crusade to drop hemlines because he fell in love with this film and with the new longer lengths of the costumes. The House of Dior agreed with Fairchild, and Paris hemlines plunged immediately. In 1997, Julie Christie returned, untouched by Mother Time, to capture the Oscar nomination for Best Actress.

Norma Shearer

Shearer wanted to play the sensuous role of THE DIVORCEE (1930) and, although she was heavily connected (her husband, Irving G. Thalberg, was vice president and supervisor of production at MGM), Irving didn't think she could play anything but comedy. She persuaded her friends to help. Photographer Hurrell took seductive photos of her and costume designer Adrian provided the sultry clothes. Thalberg finally said yes to the part, and Shearer won the Oscar for Best Actress. The Academy did not award an Oscar for costume until 1948, when the winner for black-and-white picture was JOAN OF ARC, starring Ingrid Bergman. Until 1967, there were two costume categories: for black-and-white and color pictures.

Clark Gable, Jean Harlow

RED DUST, 1932, ADRIAN Clark Gable's hand creeps up the Blonde Bombshell's skirt in this pre-Code film that has today's attitude toward sex: more is more. Adrian deliberately used no fastenings on Harlow's clothes so that when she moved, her dresses would fall open.

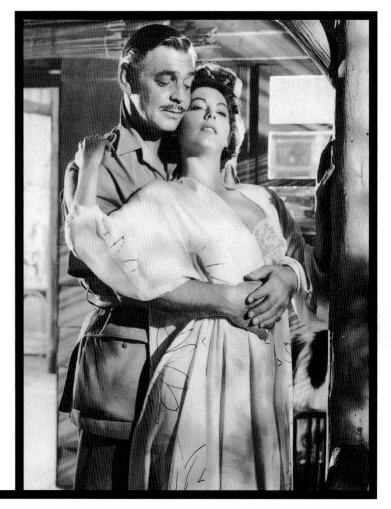

Clark Gable, Ava Gardner

MAGAMBO, 1953, HELEN ROSE This movie is the remake of RED DUST, with Gable in another ménage-à-trois, this time with Ava Gardner and Grace Kelly. Men like Gable maintained their screen sexuality into middle age, although women were put out to pasture after turning thirty. In 1982, Lillian Gish reminisced, "When I was making films, Lionel Barrymore first played my grandfather, later he played my father, and finally he played my husband. If he had lived, I am sure I would have played his mother. That's the way it is in Hollywood. The men get younger and the women get older."

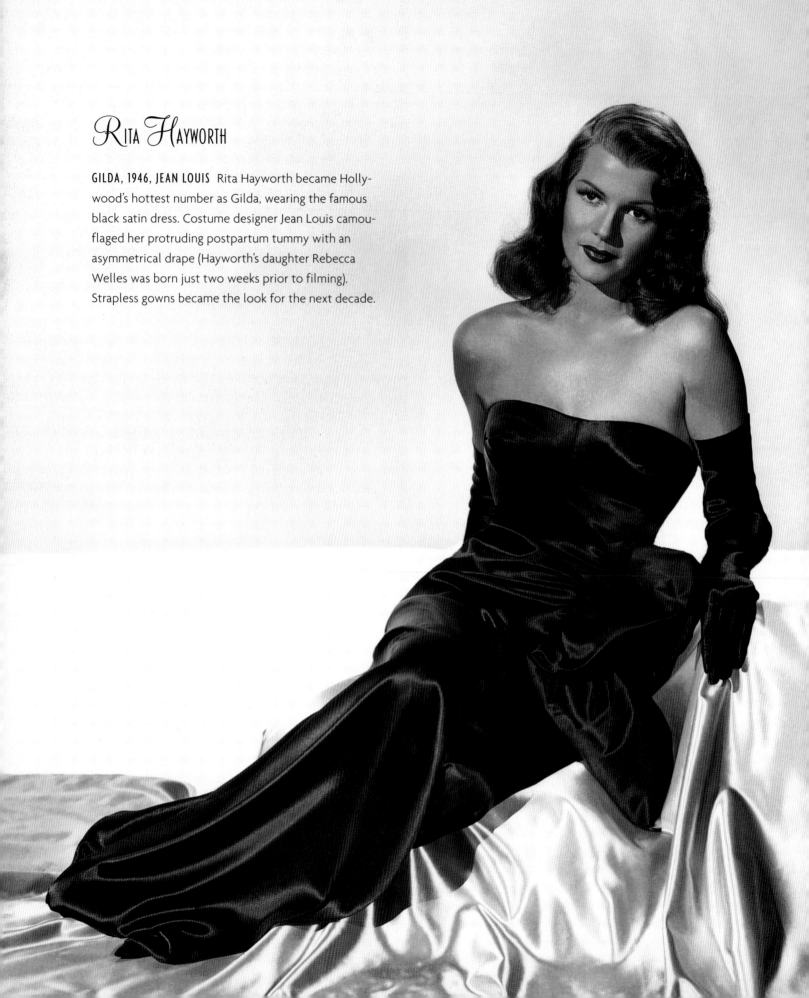

Rita Hayworth

GILDA, 1946, JEAN LOUIS Rita Hayworth became Hollywood's hottest number as Gilda, wearing the famous black satin dress. Costume designer Jean Louis camouflaged her protruding postpartum tummy with an asymmetrical drape (Hayworth's daughter Rebecca Welles was born just two weeks prior to filming). Strapless gowns became the look for the next decade.

Marilyn Monroe

SOME LIKE IT HOT, 1959, ORRY-KELLY Hollywood's designers used a fabric called "souffle" to give the illusion of bare skin. In this film, Marilyn objected to the lack of sequins covering the illusionary fabric and told costume designer that her character, Sugar, would never have gone out with her breasts exposed. More sequins were added.

Marilyn Monroe

(AT JOHN F. KENNEDY'S BIRTHDAY CELEBRATION) MAY 19, 1962 Three years later, Marilyn asked Jean Louis to design her now-famous dress, similar to the one in SOME LIKE IT HOT, so she could look smashing while she sang "Happy Birthday Mr. President." Designer Louis also designed Marlene Dietrich's Las Vegas comeback dress—with the addition of a padded derriere. Marlene was in her fifties in the fifties, but her audiences swooned at her sex appeal and costumes.

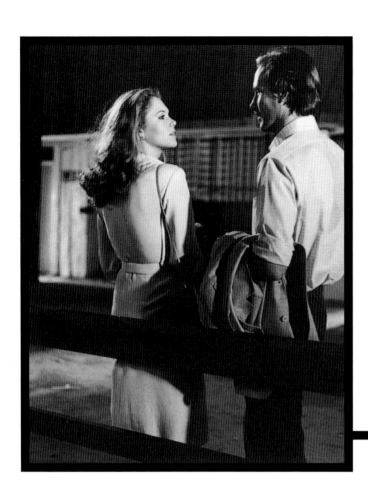

Kathleen Turner, William Hurt

BODY HEAT, 1981, RENIE In her film debut, Kathleen Turner uses her body, her husky voice, and seductive dressing to persuade William Hurt to bump off her husband. She became a star!

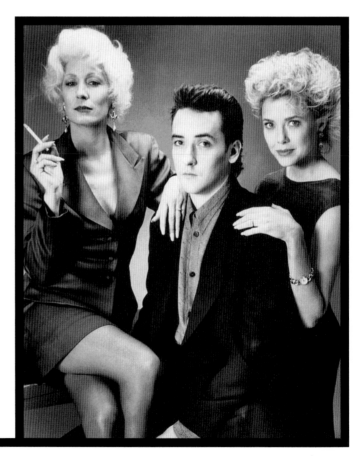

Anjelica Huston, John Cusack, Annette Bening

THE GRIFTERS, 1990, RICHARD HORNUNG In THE GRIFTERS both Anjelica Huston and Annette Bening have hot bodies and great, sexy clothes. They portrayed the mother and girlfriend of John Cusack, proving that the generation gap in dressing that once existed does no longer.

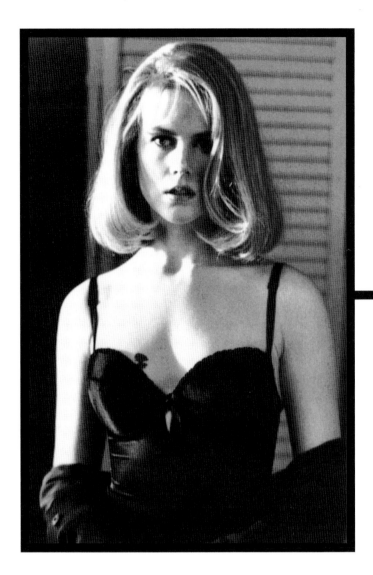

Nicole Kidman

TO DIE FOR, 1995, BEATRIX PASZTOR In this black comedy, featuring colorful Chanel-style suits, Nicole, a small-town TV weather lady, borrows the tattoo from the carney lifestyle and makes it a fashion statement, stopping at nothing to further her career.

Jamie Lee Curtis

TRUE LIES, 1994, MARLENE STEWART Director James Cameron, known for popular action films such as THE TERMINATOR, entered a new field with this film: action costuming. In one scene, Jamie Lee Curtis rips off the ruffled top, bottom, and sleeves of her dress, then slicks back her conservative housewife hairdo, creating a femme fatale for *Arnold*.

And They L

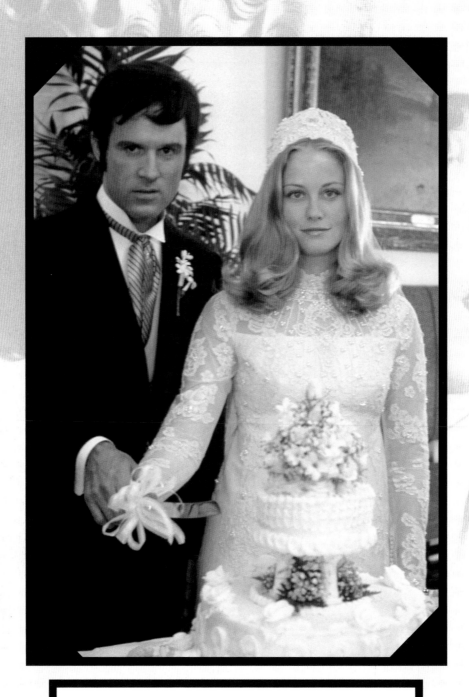

Cybill Shepherd, Charles Grodin

THE HEARTBREAK KID, 1972, ANTHEA SYLBERT

HAPPILY EVER AFTER

Elsa Lancaster, Boris Karloff

BRIDE OF FRANKENSTEIN, 1935

Bailey, Margaret J. *Those Glorious Glamour Years*. New York: Citadel Press, 1982.

Blum, Daniel. *A New Pictorial History of the Talkies*. New York: G. P. Putnam's Sons, 1968.

—— *A Pictorial History of the Silent Screen*. New York: G. P. Putnam's Sons, 1953.

Blum, Dilys E. *Ahead of Fashion: Hats of the 20th Century*. Phildadelphia: Philadelphia Museum of Art, 1993.

Brown, Gene. *Movie Time*. New York: Simon and Schuster MacMillan Company, 1995.

Cerruti, Nino. *Cinema and the Stars*. New York: Rizzoli International Publications, 1994.

Chierichetti, David. *Hollywood Costume Design*. New York: Crown Publishers, Inc., 1976.

Crawley, Tony. *The Wordsworth Dictionary of Film Quotations*. Edinburgh: W&R Chambers Ltd., 1994.

Etherington-Smith, Meredith, and Jeremy Pilcher. *The "IT" Girls*. New York: Harcourt Brace Jovanovich Publishers, 1986.

Gabler, Neal. *An Empire of Their Own*. New York: Crown Publishers, Inc., 1988.

Greer, Howard. *Designing Male*. New York: G. P. Putnam's Sons, 1949.

Hawes, Elizabeth. *Fashion is Spinach*. New York: Random House, 1938.

Head, Edith. *The Dress Doctor*. Boston: Little, Brown & Co., 1959.

"The Hollywood Fashion Machine." Television program. American Movie Classics, 1995.

Irwin, William Henry. *The House That Shadows Built*. New York: Arno Press and the *New York Times*, 1970.

Join-Dieterle, Catherine. *Givenchy*. Paris: Musées de Paris, 1991.

Kobal, John. *People Will Talk*. New York: Alfred A. Knopf, 1985.

La Vine, W. Robert. *In a Glamorous Fashion*. New York: Charles Scribner's Sons, 1980.

Martin, Richard, and Harold Koda. *Jocks and Nerds*. New York: Rizzoli International Publications, 1989.

McGilligan, Patrick. *George Cukor*. New York: St. Martin's Press, 1991.

Milbank, Caroline Rennolds. *Chic to Chic: 100 Years of Fashion Accessories from the Collection of Sandy Schreier*. Detroit: The Detroit Institute of Arts, 1992.

—— *Couture: the Great Designers*. New York: Stewart, Tabori & Chang, 1985.

—— *New York Fashion*. New York: Harry N. Abrams, Inc., 1989.

Maeder, Edward. *Hollywood and History*. Los Angeles: Los Angeles County Museum of Art, 1987.

Monaco, James. *The Movie Guide*. New York: Putnam Publishing Group, 1992.

O'Hara, Georgina. *Encyclopedia of Fashion*. New York: Harry N. Abrams, Inc., 1986.

Schnurnberger, Lynn. *Let There Be Clothes*. New York: Workman Publishing, 1991.

Thomas, Bob. *Thalberg*. New York: Doubleday & Company, Inc., 1969.

Thomson, David. *A Biographical Dictionary of Film*. New York: Alfred A. Knopf, 1995.

Springer, John, and Jack Hamilton. *They Had Faces Then*. Secaucus, New Jersey: Castle Books, Inc., 1974.

Prichard, Susan Perez. *Film Costume*. Metuchen, New Jersey: The Scarecrow Press, 1981.

Leese, Elizabeth. *Costume Design in the Movies*. New York: Frederick Ungar Publishing Co., 1977.

David Appleby: EMMA, p. 24; EVITA, p. 129

Linda R. Chen: PULP FICTION, p. 25, 92

Roger W. Cowans: LOVE FIELD, p. 4

Mark Fellman: ROMY AND MICHELLE'S HIGH SCHOOL REUNION, p. 79; DUMB AND DUMBER, p. 97

E. Georges: READY-TO-WEAR, p. 140

Melinda Sue Gordon: MEN IN BLACK, p. 143

Arthur Grace: MRS. DOUBTFIRE, p. 109

Brian Hamill: DISCLOSURE, p. 77; BIG, p. 96

Kerry Hayes: TO DIE FOR, p. 173

David LaChapelle: CLUELESS, p. 129

Blake Little: AUSTIN POWERS, INTERNATIONAL MAN OF MYSTERY, p. 97

Elise Lockwood: THE ADVENTURES OF PRISCILLA, QUEEN OF THE DESERT, p. 108

Merrick Morton: L.A. CONFIDENTIAL, p. 8

Byron Newman: THE COOK, THE THIEF, HIS WIFE & HER LOVER, p. 128

Michael O'Neil: THE AMERICAN PRESIDENT, p. 78

Zade Rosenthal: TRUE LIES, p. 173

Andy Schwartz: THE FIRST WIVES CLUB, p. 78; WALL STREET, p. 90

Lorey Sebastian: THE BIRDCAGE, p. 108

Peter Sorel: DICK TRACY, p. 96

Michael Tacket: FARGO, p. 79

Donna Terek: back cover

K. Wright: THE WEDDING SINGER, p. 57